D1242749

The Sculpture of Henri Matisse

The Sculpture of

ALBERT E. ELSEN

Henri Matisse

HARRY N. ABRAMS, INC., PUBLISHERS, NEW YORK

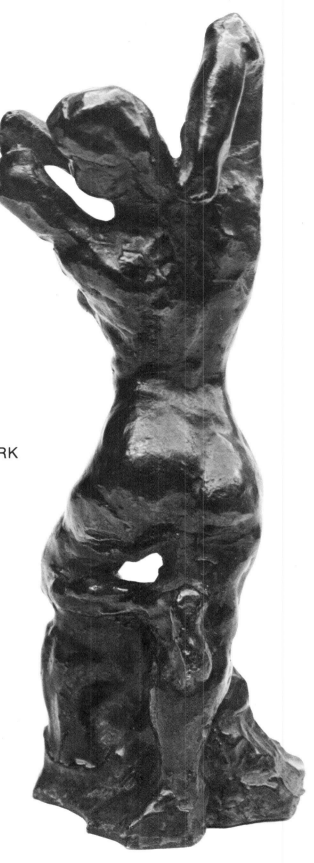

Standard Book Number: 8109–0282–6

Library of Congress Catalogue Card Number: 72–135915

All rights reserved. No part of the contents of this book
may be reproduced without the written permission of the
publishers,Harry N. Abrams, Incorporated, New York

Printed and bound in Japan by Toppan Printing Co., Ltd.

To Alfred Barr for his pioneering
research on Matisse

To Mme Georges Duthuit (Marguerite Matisse)
for helping to make this book possible

Acknowledgments

The research for the articles which led to this book was largely
made possible by a Guggenheim Fellowship to study the beginnings
of modern sculpture—carried out in England in 1966 and 1967—and
a Carnegie Corporation of New York grant given through the
Department of Art at Stanford University for the summer of 1968.
Greatly appreciated was the confidence shown by Phil Leider,
Editor of *Artforum,* who published my four articles on the sculpture
of Matisse. Their subsequent revisions depended heavily upon
the information and photographs generously supplied to me by
Mme Georges Duthuit. Pierre and Jean Matisse were most helpful
in answering certain questions. For putting me in touch with
important material and people who could contribute to this book,
strong thanks are due to Pierre Schneider, Bernard Karpel, William
S. Lieberman, and Jean Adhémar.

Special thanks are due to Meg Potter, of the Museum of Modern
Art, and Gerald Nordland, Director of the San Francisco Museum of
Art, for showing me sculptures, painting, and a ceramic formerly in
the Stein Collection and previously unknown to me. Dorothy
Seiberling, Art Editor of *Life* magazine, brought to my attention the
curious version of *Jeannette I* and the painted ceramic panel of the
Crucifixion.

My Stanford colleagues, Lorenz Eitner, Isabelle Raubitschek, and
Gerald Ackerman, helped solve some vexing problems. Many
insights into Matisse's modeling were shared with me by Sidney
Geist and James Rosati. As so often in the past, I was the chief
beneficiary of long conversations about Matisse with Leo Steinberg.
Mlle Colette Audibert, conservatrice of the Musée Matisse in Nice-
Cimiez, was responsible for my obtaining the excellent photographs
of so many important works from that museum.

Many people went out of their way to assist in obtaining visual
material for this book, including Mrs. Sidney Brody of Los Angeles,
Chairman of the UCLA Arts Council, Victor Waddington of London,
Charles Feingarten, and Abram Lerner. There is no finer assistance
in obtaining photographic material offered by any publisher than
what can be provided by Mrs. Barbara Adler and Miss Nancy
Glassner. Special thanks must go to Kirk Varnedoe for his
photography, and for helping to put the manuscript into a more
literary shape the heroism of Ella Covert should not go unrecognized.

The dating of Matisse's sculpture I owe largely to the Matisse
family, either directly or through their catalogues.

Stanford, California, 1971

Contents

1 Matisse and his sculpture class in the old Convent
du Sacre Coeur, Boulevard des Invalides. The model
is possibly Bevilaqua. 1909

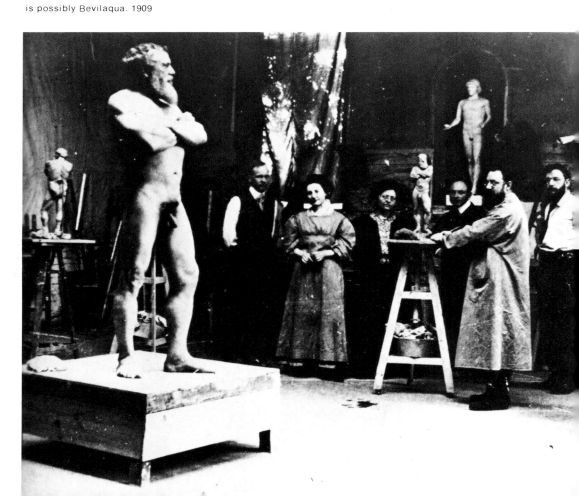

If Matisse were survived only by his sculptures, their quality would assure his standing as a major artist. To know Matisse as a painter and draftsman alone is to have an imperfect understanding of the man as an artist and the mutuality that existed between his means. Our knowledge of his modeling has been improved in the last decade by several exhibitions that have given exposure to a large number of his sculptures.[1] It is a mark of Matisse's personal esteem for his modeling that early in his career, and frequently during his long life, he exhibited sculptures in public salons and private galleries, where occasionally they outnumbered his paintings. He enjoyed having himself photographed for posterity while working on or viewing one of his statuettes. The imperfect recounting of their history to Alfred Barr was due to Matisse's forgetfulness in old age, and should not cause us to underestimate their value to him.

Paradoxically, it is the late paper cutouts, such as the large *Snail* in the Tate Gallery, and not Matisse's modeled forms, which today seem most prophetic and relevant to those artists in England and America who see sculpture as ideally stripped to essentials, such as flat, colored planes in simple relationships, and who do not emphasize an aesthetic based on the sculptural process.[2] At the end of his life Matisse saw in the paper cutouts a new fusion of drawing, color, and carving.

While recognizing its similarity to painting, Matisse always thought of modeling as distinctive. As late as 1950, four years before his death, he posed and modeled a woman according to personal conventions for making sculpture over a fifty-year period. We gain nothing from approaching Matisse's work as a painter's view of sculpture or as sculpture aspiring to the effects of painting. Between 1900 and 1913, the first of two periods of the artist's greatest sculptural productivity (the second being 1922–32), Matisse was deeply involved with the issues that concerned the course sculpture should take as an alternative to the directions seen in the work of the conservatives and Rodin. Matisse opted to continue modeling, which separated him from younger revolutionaries such as Archipenko, Brancusi, Duchamp-Villon, Picasso, and Lipchitz. As a consequence, with the exception of Alfred Barr and Sir Herbert Read, historians have generally not been disposed to focus upon this aspect of his work, which exerted no influence on other important sculptors who were his contemporaries. This book is intended to inquire more closely into the character of Matisse's sculpture and its relation to his painting and drawing than has been attempted in previous studies.

The credentials of Matisse as a sculptor are impressive. Already trained as a painter, he realized in the late 1890s that he had to reeducate himself in order to become a sculptor. Although abbreviated, his self-education followed the conventional pattern of making art from art in the studio and the Louvre, studying human and animal anatomy, consulting more experienced artists such as Rodin and Bourdelle, and undertaking between 1900 and 1903 a

2 *Gustave Moreau's Studio.*
1895.
Oil on canvas,
25 5/8 × 31 7/8".
Whereabouts unknown

3 *Old Man.*
1891.
Graphite,
24 3/8 × 19".
Musée Matisse, Nice-Cimiez

"masterpiece" or free-standing figure to signal the achievements of his apprenticeship. By 1908 Matisse felt sufficiently self-assured to teach sculpture, exhibited thirteen pieces in that year, and in the next undertook a large-scale relief. By the end of his life he had made more than seventy sculptures.

In Gustave Moreau, Matisse had an outstanding teacher who early provided him with an example of a painter who occasionally made sculpture in conjunction with his paintings. (Degas, Bonnard, and Gérôme would have been other exemplars.) These small studies, given such literary titles as *Hercules* and *Lucretia*, were paraphrases of postures from art, which may not have been lost upon Matisse. In one of his paintings of Moreau's studio, done about 1895 (plate 2), there is visible behind the live model a large plaster cast of an ancient sculpture.[3] Matisse may have derived the idea of using his own sculptures in still-life paintings from this academic experience.[4] He had been trained to draw from casts of ancient statuary as well as the model. Some of his student sketches are in the Matisse Museum at Cimiez, near Nice, including one of an aged model (plate 3), done while Matisse was at the Académie Julian in 1891, and several made either in the Louvre or the Cour Yvon at the École des Beaux-Arts (plates 4–6, 8). They show that he could do an academically acceptable and finished sketch, complete with wrinkled stomach, from a large sculpture or the human body. The occasional darker accenting in the silhouette of an area of anatomical stress was replaced not long thereafter by more arbitrary aesthetic and expressive judgments. Although undistinguished by comparison with academic drawings of other students at the time, in retrospect these early sketches provide precious evidence of the origins of Matisse's

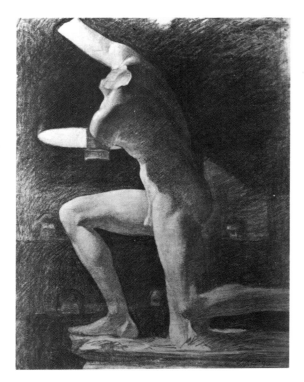

4 *Study of a Cast of the Capitoline Niobid.*
1890–92.
Charcoal.
Private collection, Paris

5 *Studies from Ancient Sculptures.*
1890–92.
Graphite,
22 ¾ × 15".
Musée Matisse, Nice-Cimiez

6 *Drawings from Ancient Sculptures.*
1890–92.
Graphite,
22 ¾ × 15".
Musée Matisse, Nice-Cimiez

8 *Drawing After Lysippus' Hermes Adjusting His Sandal.*
1890–92.
Graphite,
24 3/8 × 18 1/2″
Musée Matisse, Nice-Cimiez

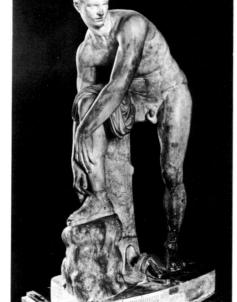

7 LYSIPPUS. *Hermes Adjusting His Sandal.*
Fourth century B.C.
Marble, Roman copy.
The Louvre, Paris

practice of working in modalities and disciplining himself to rework the same subject. It is ironic, but not unusual, that as in the case of many important nineteenth- and early twentieth-century artists, Matisse's flexibility of style should at first have been encouraged and developed by his academic instructors. (They also showed him what his art should not be.) The classical postures of his early sketches expose, too, the root of his lifelong commitment to traditional arrangements of the body. While he rejected academic suppression of imagination and feeling, Matisse was never to lose the habit and love of drawing from museum art, as shown in Marc Vaux's photograph of the artist sketching from an archaic Greek *kouros* in the Louvre about 1946 (plate 9).

Drawing as the common basis for sculpture and painting was dogma not only for the École des Beaux-Arts, but also for such liberal teachers as Moreau, Rodin, and Matisse. When in 1908 Matisse set up his own art school in a former convent behind Rodin's Hôtel Biron, he continued an old tradition by placing in a niche of the main classroom a plaster cast of an ancient sculpture, the *Apollo Piombino,* obtained from the Louvre's Department of Casts (plate 1).[5] That this was more than a token concession to convention is revealed through Sarah Stein's class notes containing Matisse's references to this sculpture during his demonstrations and critiques.[6] Matisse favored the early classical Apollo because it was in keeping with his ideas and taste regarding clarity of form gained at the expense of anatomical information. In the Cimiez museum stands the large plaster cast of the *Cleobis,* or *Biton,* of the sixth century B.C. in the museum at Delphi, which was transferred from Matisse's studio after his death (plate 10).

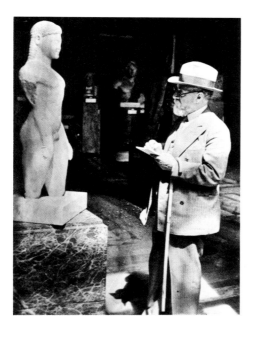

9 Matisse drawing from an archaic Greek *kouros* in the Louvre. c. 1946

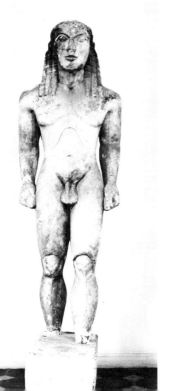

10 Plaster cast of the *Biton,* from the Delphi Museum. Sixth century B.C. 8 ½' high. Musée Matisse, Nice-Cimiez

The Early Sculpture

Contrary to what has generally been written about Matisse, his first venture into sculpture was not the copy after Barye's *Jaguar Devouring a Hare*, but rather a pair of small, closely studied portrait medallions of a woman, done in 1894 (plates 11–12). Presumably, the sequence of these medallions begins with the one in shallower relief, with the blonder lighting effects, and continues to the second and more sharply defined version in which the profile is more incisively drawn. In the latter the muscles around the eyes are accentuated, and there is a crisper rendering of the hairdo. These changes, along with increased variation in the form of the neck, give the head more character and surface variety. At the same time Matisse was making paintings inspired by or copied after the old masters, and conceivably the medallion portraits were done in the same vein or as an extension of his studies in drawing.

Matisse, hoping to obtain criticism for his drawing, met Rodin probably in 1898. Matisse's own account of the meeting tells us how

11 *Profile of a Woman*.
1894.
Bronze medallion,
10″ in diameter.
Private collection, Paris

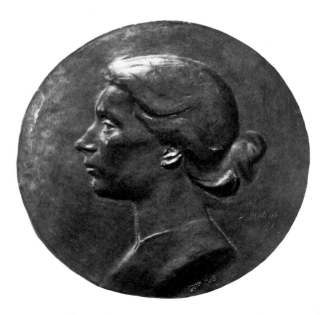

12 *Profile of a Woman* (second version?).
1894.
Bronze medallion,
10″ in diameter.
Private collection, Paris

he became aware of their differences on this first encounter:

I was taken to Rodin's studio in the rue de l'Université, by one of his pupils who wanted to show my drawings to his master. Rodin, who received me kindly, was only moderately interested. He told me I had "facility of hand," which wasn't true. He advised me to do detailed drawings and show them to him. I never went back. Understanding my direction, I thought I had need of someone's help to arrive at the right kind of detailed drawings. Because, if I could get the simple things (which are so difficult) right, first, then I could go on to the complex details; I should have achieved what I was after: the realization of my own reactions. My work discipline was already the reverse of Rodin's. But I did not realize it then, for I was quite modest, and each day brought its revelation. I could not understand how Rodin could work on his St. John by cutting off the hand and holding it on a peg; he worked on details holding it in his left hand, . . . anyhow keeping it detached from the whole, then replacing it at the end of the arm; then he tried to find its direction in accord with his general movement. Already I could only envisage the general architecture of a work of mine, replacing explanatory details by a living and suggestive synthesis.[7]

Matisse's admiration for Rodin was so strong, however, that in 1898 he acquired from Ambroise Vollard the great sculptor's plaster portrait bust of Henri Rochefort (plate 13). Some time thereafter Matisse did a drawing of the bust, probably in the period of his drawn self-portrait of 1900, now in the Matisse museum in Nice (plate 14).[8] The twentieth-century character of the drawing comes from Matisse's imposition of a new aesthetic structure upon the head. The drawing accents do not accord with the psychological stresses of the plaster. Without loss of the subject's individuality, there is a tangible stiffening and purifying of some of the curved contours of the head and neck, an overall narrowing and tightening of the bust. Those details Rodin had so patiently explored and transmitted to his clay are at best barely indicated in the drawing. This is a dramatic illustration of Matisse uncomplicating Rodin's art, minimizing "explanatory details" in favor of a "living and suggestive synthesis."

The copying of another sculptor's work by Matisse between 1899 and 1901 was not surprising, but the selection of Barye's morbid theme *(Jaguar Devouring a Hare)* seems unexpected today, when it is not remembered that this work was held in high esteem by nineteenth-century artists. In the French art of the last century those sculptures which dealt most extensively and brutally with sadism were often produced by *animaliers* such as Frémiet, Barye, and Cain Brutality is the theme least identified with Matisse's art, and his biographers see his reworking of Barye's sculpture as a formal exercise. They also imply that Matisse dissected a cat to further his understanding of the piece, but, as Aragon points out, Matisse procured an already dissected cat from a *"préparateur des*

13 RODIN. *Portrait of Henri Rochefort.*
1884.
Bronze,
22 ¾″ high.
Whereabouts unknown

14 *Drawing After Rodin's Portrait Bust of Henri Rochefort.*
1900 (?).
Conté crayon.
10 ¼ × 5 ¾″.
Musée Matisse, Nice-Cimiez

18

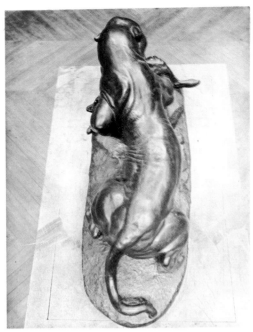

15 BARYE.
Jaguar Devouring a Hare
(view from above).
1852.
Bronze,
16 ⅞ × 36 ¼″.
The Louvre, Paris

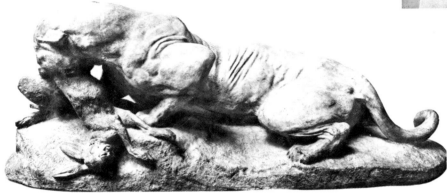

16 BARYE. *Jaguar Devouring a Hare* (left side view)

Beaux-Arts."⁹ Unquestionably Matisse was taken with the expressiveness of the recumbent animal's back when seen from above (plate 15). Barye's sculpture, however, achieves most of its intended drama when seen from the left side at about eye level (made possible by a pedestal), so that the jaws enveloping the hare are fully visible (plate 16).

For two years Matisse studied this sculpture while attending an evening course at the École Communale de la Ville de Paris. Two drawings left as part of a donation for a small museum of his work at his birthplace, Le Cateau, may have derived from work at this school and show different types of motif reconnaissance (plates 17, 19). One of the two studies after Barye's sculpture is a contour drawing which helped Matisse discover where the bones protruded into the animal's silhouette and how the animal's left paws were braced. The second treats the complex actions of the main masses of the back when seen from the rear and a little above. As with the sculpture he was to make, Matisse's drawings show no concern with such explanatory details as the folds of the muscles. Both in the drawing and modeling he wanted animal feeling, the total gesture of gripping and twisting. This was his first sculptural encounter with the arabesque: the expressive twisting of the body in depth (plates 18, 20–21). Matisse told Raymond Escholier that he "identified with the passion of the wild beast expressed by the rhythm of the

17 *Drawing After Barye's Jaguar Devouring a Hare.*
1899.
Pen and ink.
Musée Matisse, Le Cateau–Cambrésis

18 *Jaguar Devouring a Hare*
(after Barye; left side view).
1899–1901.
Bronze.
9 × 22 ½".
Private collection. Paris

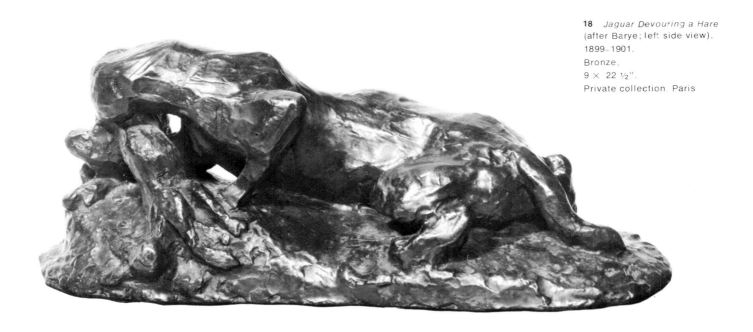

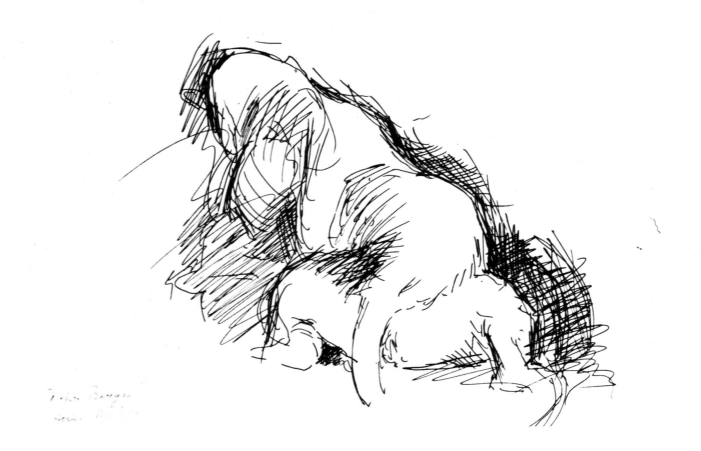

19 *Drawing After Barye's*
Jaguar Devouring a Hare.
1899.
Pen and ink.
Musée Matisse, Le Cateau-Cambrésis

masses," and in 1908 he enjoined his students to empathize with the model's postures.[10] To consider his copy as a disinterested study of form, a sanitized, aesthetic interpretation of a violent theme, seems wide of the mark. From this experience with the dramatic, achieved by muscular as well as oral action, Matisse may have learned what he did not believe was appropriate for his sculpture. On many future occasions, brutality would characterize the way he would shape, twist, and cut his figures in the most passive poses.

The only other sculpture of an animal made by Matisse, his small *Horse* of 1901, makes no attempt to image the subject's potential violence and movement (plate 22). Unlike Degas, Matisse did not show a racehorse rearing or galloping, but instead braced the stallion's four legs (only one of which remains), while searching out the strong inflections of the major masses. The duality of the two animal poses, the stationary and symmetrical on the one hand, the active and asymmetrical on the other, was prophetic of what he was to do with the human form from the beginning.

In writing about the long study of the *Jaguar,* Louis Aragon commented that Matisse "spent two years . . . at first with his eyes, with that which he saw, then with the eyes closed, with the notions of volume which alone influenced his touch."[11] Barye also taught Matisse the importance of a basic internal anatomical accuracy, and while the younger artist muted his knowledge of musculature, he continued the original stress upon the joints which established the stance and disposition of the jaguar's weight. This structural consciousness is what connects the *Jaguar Devouring a Hare* with the later sculptures of the *Reclining Nude* and the *Serpentine.* It was not alone for reasons of economy in modeling that Matisse departed from Barye's minute descriptiveness: he was equally concerned that the eye should not be distracted from the overall

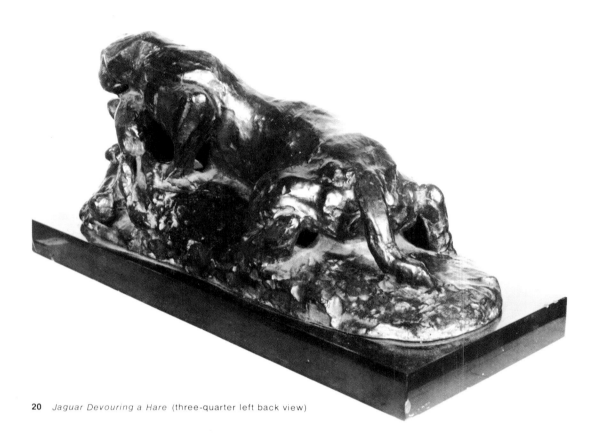

20 *Jaguar Devouring a Hare* (three-quarter left back view)

21 *Jaguar Devouring a Hare* (three-quarter right front view)

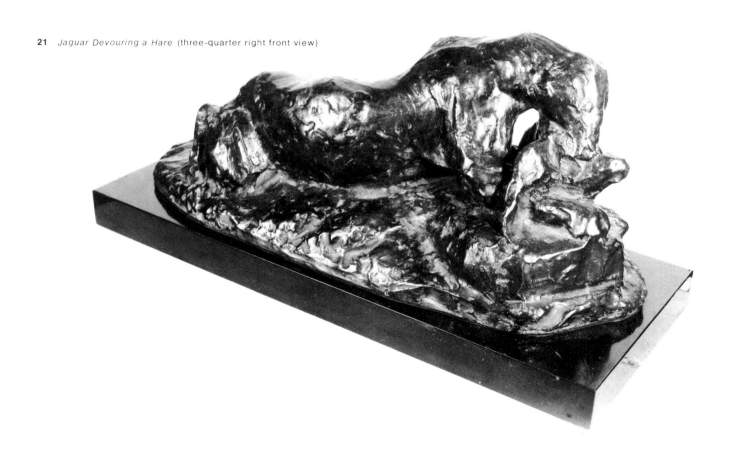

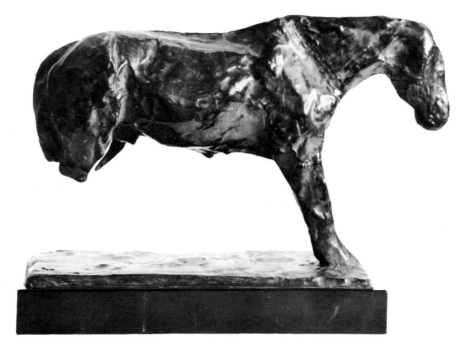

22 *Horse* (right side view).
1901.
Bronze,
6 ¾″ high.
Collection Mr. and Mrs. Paul Mellon, Upperville, Va.

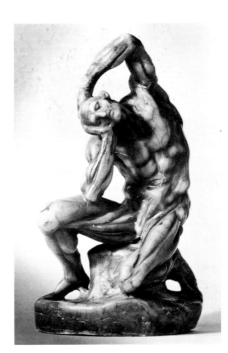

23 Florentine. *Écorché*.
c. 1560.
Wax,
9 ⅞″ high.
Staatliche Museen (Preussischer Kulturbesitz,
Skulpturenabteilung), Berlin

gesture and continuity of his sculptural form. His own facture reveals that by 1900 Matisse had found personal alternatives to the modeling construction used by Rodin and Bourdelle, the two sculptors he sought out for advice. He had rejected the closely imitative mode of the portrait medallion.

In 1903 Matisse undertook a paraphrase of a sixteenth-century *Écorché,* which at the time was believed to have been done by Michelangelo (plate 23). Plaster casts of the *Écorché* were frequently found in artists' studios, and Cézanne drew from one of these. The *Écorché* gave Matisse an accurate picture of the muscle-tendon system of the body, as the dissected cat had when he was at work on the *Jaguar.* The robust, muscular contours and flexed joints are kept, but his reworking of the subject (plates 24–25) shows that he was not interested in the pathetic compression of the head by the hands, for the hands were either not modeled or removed, and the face was left undefined. Rather than follow the smooth patterns of the flayed anatomy, Matisse felt compelled to introduce new modeled accents, unpredictable in their dispersal. The original energy of the contorted figure was matched by that of Matisse's reforming touch. Anatomy was something he wanted to learn and forget, or to use only that part which he needed. Least of all did he want to imitate Michelangelo's and Rodin's dramatization of musculature. Beneath the unpredictably activated surface of Matisse's *Écorché,* there is the strong implication of the solid, articulated core of the body. The long planes that bridge the thigh region of the figure's left leg, for example, are not rounded muscles but flattened surfaces, made from previously modeled shapes that

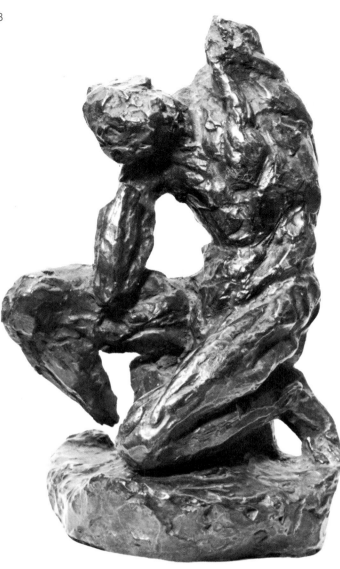

24 *Écorché (Flayed Man).*
1903.
Bronze,
9' high.
Collection Victor Waddington, London

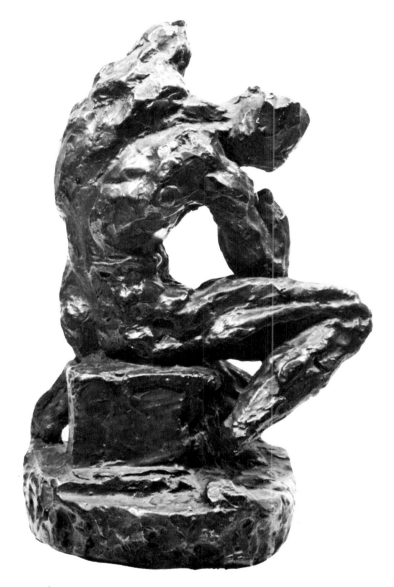

25 *Écorché* (back view)

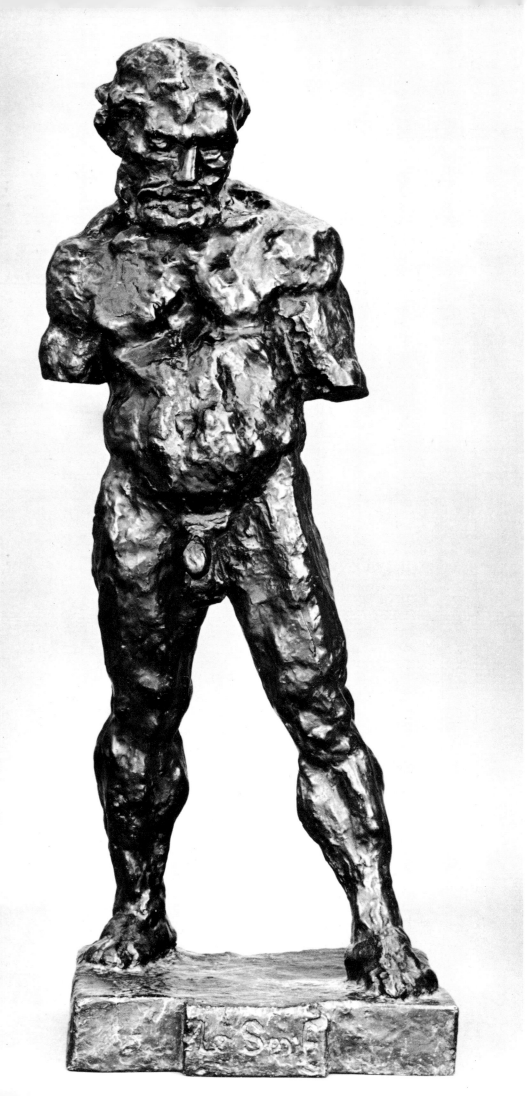

26 *The Serf* (front view).
1900–1903.
Bronze,
37 ³⁄₈" high.
Joseph H. Hirshhorn Collection

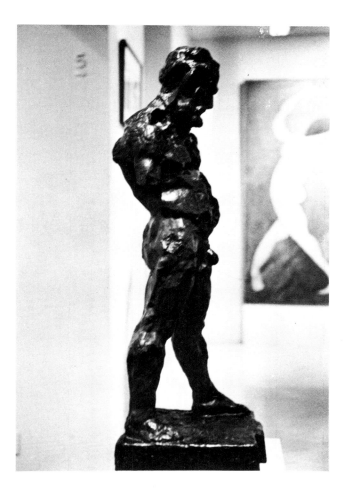

27 *The Serf* (righ: side view).
The Museum of Modern Art, New York City.
Mr. and Mrs. Sam Saiz Fund

were cut away. Both the editing out of parts of limbs and the surface treatment serve physically and visually to compact the figure, which is animated rather than dissolved by its bristling overall highlights. Linking the *Écorché* with *The Serf,* on which he was presumably working at the same time, is Matisse's impulse to augment the figure's appearance of physical density, weight, and grave mood, while denying conventional rhetoric.

The Serf

The studio was not only the locus of Matisse's work as a sculptor; throughout his art there is an unusual explicitness about the relation of his subject matter to its origins in the studio. The kneeling *Écorché* was well known as a studio prop. Even in the case of *The Serf* (plates 26–27), Matisse's figure sculpture preserves its derivation from a studio stance, rather than a natural pose or simulated historical situation, as in Rodin's *The Burghers of Calais.* At the time of *The Serf,* salon sculptors, by the addition of props, costumes, and titles,

29 *Male Model Walking (Bevilaqua).*
c. 1900.
Oil on canvas.
Whereabouts unknown

28 *Male Model.*
c. 1900.
Oil on canvas,
39 ¾ × 28 ¾".
Private collection

tried to disguise the identity of the model and the studio situation that gave rise to the sculpture's making. The title of *The Serf* was Matisse's one concession to this tradition; in his avoidance of props he demonstrated a fresh candor with respect to the identity of his motifs. With the almost complete departure of the male model from Matisse's figural work after 1906 (*The Crucifix* of 1950 being the one exception) came the nearly total dismissal of what might be called allusive or literary titles. Maillol, with whom Matisse became friendly in 1904, also gave up the male form after about 1908. Both artists preferred to forsake the greater dramatic possibilities of masculine bodies for the beauty achievable with the feminine form. Among the many ramifications of this candor, and more important than labeling, was the preservation of evidences of how the works were made.

The choice of the title, *The Serf,* may have come after the work was begun, but it was made before the bronze casting, as is shown by its inscription on the base of the plaster in an area especially prepared to receive it. The paintings of the same model made at the same time do not bear this title, which may have been suggested by the peasant origin of the subject, his powerful physique, and the vogue in the late nineties for sculptures of workers and peasants (plate 29). These were seen in public exhibitions by such artists as Meunier, Dalou, Rodin, and Minne. At least two authors have mistranslated the title as "The Slave," which introduces uncalled-for pathetic associations and historical misunderstanding.[12] Just as misleading are attempts to characterize the figure as "heroic." Slouched shoulders and an extended stomach hardly make this figure a candidate for heroism, and Matisse was much too aware of postural meanings in the history of art to have missed the point (plate 28). Sidney Geist points out the large proportion of the head in

30 *Male Model.*
c. 1900.
Pen and ink,
12 ¼ × 9″.
The Solomon R. Guggenheim Museum, New York.
Thannhauser Collection

relation to the body, about one to six, "which Matisse was able to get away with." The bracing of the feet and slack posture of the torso speak of an *académie,* a stock academic studio pose, which the model had to strike for hours. Louis Aragon estimated that Matisse spent more than two thousand hours working on this piece.[13] The resulting combination of resignation, fatigue, and durability on the part of the model, Bevilaqua, could have inspired the sculpture's name.

The inordinate amount of time Matisse spent on this sculpture may have been due to his recent commitment to the figure in painting and the desire to master its construction from every approach. He did several canvases around 1900 in which the male and female model in studio poses are the sole focus. In those of the male model, who was posing for *The Serf,* the arbitrary flat shaping of the background planes and their fitting together was an extension of what he was doing to the surfaces of the body. The sketch of Bevilaqua in the Thannhauser Collection (plate 30) was more probably a study for a painting than a sculpture because of the way the arms project outward from the body, but it gives us an idea of how drastically Matisse changed the proportions of his subject in sculpture.[14]

The fact that there are no preliminary modeled sketches or other versions indicates that, like a palimpsest, this one sculpture was used by Matisse to work and rework his ideas with regard to anatomy and facture.[15] The absence of differing scale versions of *The Serf* in itself reveals a difference between Matisse and sculptors like Rodin, Bourdelle, and Maillol, who scaled up their studies for the final version, and then, as in Rodin's case, enlarged or reduced the

finished work for commercial purposes. Although writing about the unalterable relationship of conception to scale in painting, Matisse could have been commenting with equal truth upon sculpture when in 1908 he said, "An artist who wants to transpose a composition onto a larger canvas must conceive it over again in order to preserve its expression; he must alter its character and not just fill in the squares into which he has divided his canvas."[16] Contemporary procedures for enlarging a sculpture, being mechanical (the use of compasses), were even more impersonal than those used by painters.

SCULPTURAL SOURCES FOR THE SERF

Meyer Schapiro has likened *The Serf* to a Hellenistic Hercules, which in view of Matisse's knowledge of statuary in the Louvre would have been a comparison of which he was aware:

There is an early Serf . . . a short, bronze nude, of an irregular muscularity that imposes an endlessly broken contour on any view of the figure. The surface is corrugated by muscles to such a degree that no flat surface can be isolated and in consequence no simple curve or straight line. He is an exaggerated Hellenistic Hercules— whose musculature represents innumerable mean labors, not a potential heroic or athletic prowess—with a modern feeling in the surfaces, in a slight tension in the posture, and in the shadowed, downward glance. The multiplication of small muscles is the plastic equivalent in this work to subdivided flecking and pointillism in painting. In classic art such minute division of a plastic surface was never attained; the muscular Hellenistic figures evolved rhythmical contours, great sweeping curves and a clear contraposto of the larger swaying masses of the figure. In Matisse this contour is without a large rhythmical form; only dents and minute bulges. The quality of the figure inheres in the expression of a dumb meditation and burdened strength by an immense complexity of light and shade and a restlessness of surface produced by the knotting of coarse muscles. It is a development within Rodin's sense beyond Rodin.[17]

In the Matisse literature *The Serf* is more commonly paired with Rodin's *The Walking Man* (plate 31), exhibited in its original small scale of about three feet in Paris beginning in June of 1900, when Rodin had the first one-man sculpture retrospective in history. Allegedly, Rodin's striding figure influenced the pose of *The Serf*.[18] According to Alfred Barr, *The Serf* was begun in the winter of 1900, but adding to the case for a connection between these two sculptures is the fact that Matisse's model, known in 1900 as Bevilaqua, was in fact the Abruzzi peasant formerly named Pignatelli, who came to Rodin's studio in 1877 or 1878 and posed for the legs of *The Walking Man,* and then its enlargement into the *John the Baptist*.[19] (The torso without legs existed by itself before 1878.) Following the success of this last sculpture in the Salon of 1880, Pignatelli found ready

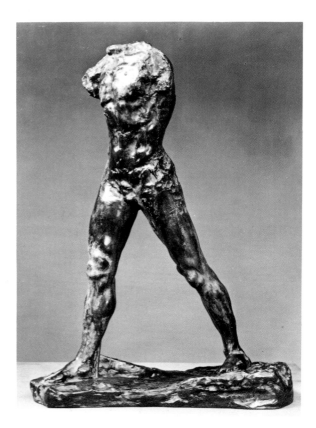

31 RODIN. *The Walking Man.*
1875–78.
Bronze,
33 ½" high.
The Metropolitan Museum of Art, New York City.
Gift of Miss G. Louise Robinson, 1940

employment among young sculptors who thought that by using Rodin's model they could fathom some of the great artist's secrets. It is a matter of fact that Matisse was conscious of Bevilaqua's connection with Rodin and talked with the model about Rodin's work methods.

The stance of *The Serf* is metaphorically that struck by Matisse with regard to the sculpture of Rodin. In contrast to *The Walking Man, The Serf* has a fixed, immobile posture, the weight almost evenly divided between the two legs, which diagonally straddle the base. One of the issues to which certain sculptors addressed themselves even before 1900 was whether free-standing sculpture should continue to create the illusion of movement. *The Walking Man* was an affirmation of the tradition which saw the "role" and "triumph" of sculpture as the animation of inert material and the creation of an illusion whereby the modeled figure appears to move before our eyes.[20] By placing both feet of *The Walking Man* on the ground, Rodin was showing the beginning and end of the act of taking a single stride. It was a résumé of movements undertaken at different times. Rodin wanted the viewer to observe the figure from all sides, to see its weight transferred forward off the back foot with the appearance of losing, and then recovering, its balance. From the back the figure seems to launch itself upward and forward, while from the front there is a decided braking action as the weight comes down on the lead foot. From every side Matisse's figure is solidly rooted to the base, unlike his paintings of Bevilaqua done at this time, and nowhere is there a suggestion of weight shifting, as in the upper torso of *The Walking Man.* In his *Notes of a Painter* Matisse took the position that there should be no illusion of movement in free-standing sculpture, and that immobility was crucial to achieving a superior form of beauty: "In abandoning the literal representation of movement, it is possible to reach toward a higher ideal of beauty. Look at an Egyptian statue. It looks rigid to us; however, we feel in it the image of a body capable of movement and which despite its stiffness is animated. . . . Movement in itself is unstable and is not suited to something durable like a statue unless the artist has consciously realized the entire action of which he represents only a moment."[21]

Similar views were expressed by the sculptor Adolf Hildebrand in 1893. His *On the Problem of Form in Sculpture,* originally published in German, was published in French in 1907. Hildebrand, Gauguin, and Maillol all agreed that simulated movement should be confined to relief sculpture. Far from being an imitation of *The Walking Man, The Serf* was made in reaction to what it stood for.

The absence of the forearms of *The Serf* shows that Matisse did accept Rodin's revolutionary premise, exemplified in *The Walking Man,* that a complete sculpture need not presuppose the human form intact.[22] In this connection it may be argued that the armless and headless *Walking Man* influenced Matisse in the making of a partial figure. An old photograph, taken about 1908 by one of Matisse's students, Hans Purrmann, shows Matisse posed before the plaster

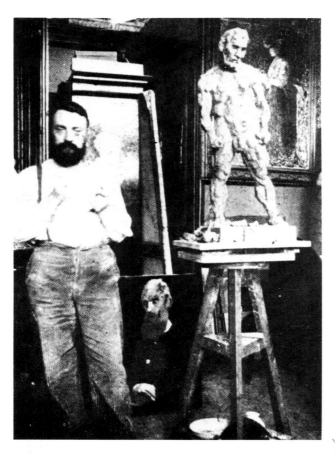

32 Matisse in his studio with *The Serf*.
c. 1908

version of *The Serf* in which the forearms are still attached (plate 32).
Thus Matisse's original vision of the "general architecture" of this
sculpture comprised the entire figure. We have been told that the
forearms were lost because of an accident either before or during
casting.[23] The firm construction of the arms, the resting of the hands
on the thighs (as if following academic advice to prevent damage to
the arms by accidents, Matisse had fastened them to the sides of the
body), makes the account of an accident to the plaster less credible.
It is more likely that Matisse decided at some point before casting to
cut away the arms—a knife at least trued the area of separation—
perhaps to liberate the silhouette of the thighs, as Rodin had often
done in his partial figures. While *The Walking Man* may have been in
the back of his mind as a rationale for his editing, so were decidedly
personal views on what constituted expression in sculpture as well
as painting.

THE SERF AND A NEW EXPRESSIVENESS IN SCULPTURE

Matisse's contribution to the modern view of expression in art involved
affirming the validity of the nondescriptive marks of a sculpture's
making, which on the one hand served as carriers of the artist's
feeling and aesthetic judgment and on the other forced attention to
the totality or context of the work seen as a whole for disclosure of
its identity. In painting of the late nineteenth century this was to be
found in the Impressionists, Seurat and the Neo-Impressionists, and
Cézanne, all of whom shaped Matisse's thinking and style. It was a
new vision of aesthetic and expressive wholeness that discouraged
sequential reading of perfectly formed details, which in themselves
predicted the descriptiveness of the whole. Isolated, these
components might seem meaningless, capricious, even inept. Only
by breaking with a more defined or literal imitative art could Matisse
succeed in imposing his temperament and vision upon his subjects.
It was a daring accomplishment, to constitute a solid, familiar form
out of its antithesis in terms of surfaces. We can see another example
of its early history in Matisse's sculpture as well in the one presently
known possible sculptural study related to *The Serf*.

THE BUST OF BEVILAQUA (?), 1900–1901 (?)

From photographs, Mme Duthuit and Pierre Matisse have discounted
as a work by their father (but perhaps by one of his pupils) a small
plaster bust of Bevilaqua in the collection of an eminent San
Francisco physician, Dr. Maurice Galanté (plates 33–37). In actual
appearance the sculpture possesses a sophisticated, even
paradoxical, means of achieving resemblance and an expressive
execution that to my mind separates Matisse from his students, not to
mention other sculptors of the time. The bust's remoteness from the
treatment of the head of *The Serf* would seem damaging to the case
for its authenticity were it not for Matisse's refusal to model two

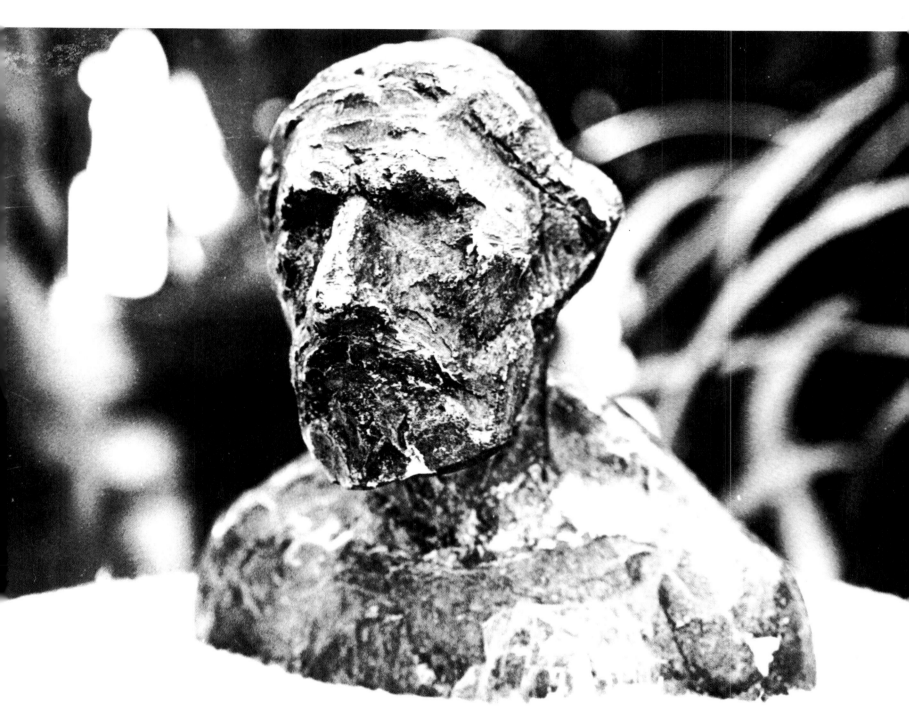

33 *Bust of Bevilaqua (?)* (front view).
1900–1901.
Painted plaster,
7 × 7 ¼ × 4″.
Collection Dr. Maurice Galanté, San Francisco

heads of the same person so that the modes and characterization were the same. Further, *The Serf* was reworked over a protracted period. The underlying angularity and surface faceting in the bust's realization, coupled with its rich nonimitative textures, relates it to the 1901 portrait painting of Bevilaqua in the collection of Mme Marquet, which was shown in the great centennial exhibition in Paris. The bust's left profile shows a strong similarity, particularly with respect to the neck muscle, to a painting of Bevilaqua also owned by Dr. Galanté, but likewise rejected as Matisse's work by two members of his family. According to Dr. Galanté, who was given both bust and painting by Sarah Stein when she was his patient in the 1940s, she obtained the works from Matisse. Until Dr. Galanté can retrieve his correspondence with Matisse in which his authorship of these works was reportedly acknowledged, they will have to be judged on the basis of style and what we can believe Matisse was capable of doing in sculpture at this early date from which there were so few modeled pieces.

Unlike the head of *The Serf,* that of the small bust is tilted upward and when seen against the almost hunched back seems to thrust forward. There is no attempt to shape or etch the eyes, and the most expressive passages of the head result from the angularity imposed on the silhouette and certain sections of the face by the knife. To isolate part by part the surface treatments of this head is to be reminded of their nonmimetic character. Except for the nose it requires the viewer to make a considerable adjustment by means of taking in the whole context of the work to see it as a human head and to see the identity of its components. On the man's left shoulder is a

34 *Bust of Bevilaqua* (right side view)

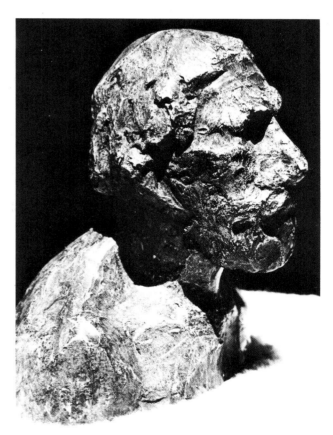

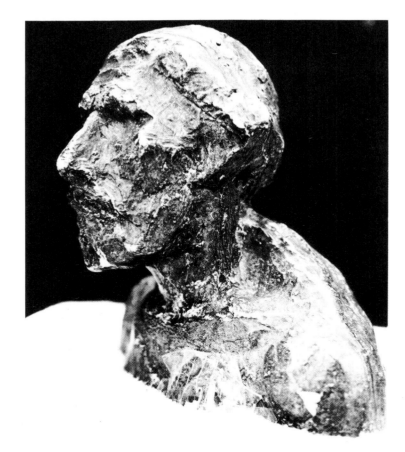

35 *Bust of Bevilaqua* (left side view)

33

36 *Academic Study: Bevilaqua (?).*
c. 1900.
Oil on canvas,
19 × 13″.
Collection Dr. Maurice Galanté, San Francisco

37 *Academic Study* (detail of head)

34

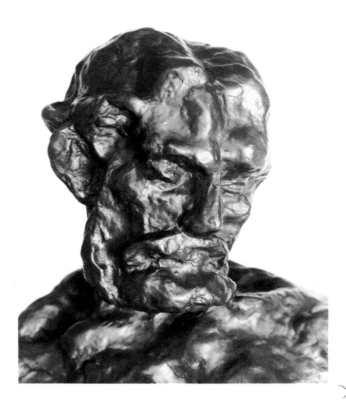

38 *The Serf* (detail of head).
1900–1903.
Bronze,
37 3/8″ high.
The Baltimore Museum of Art. Cone Collection

partial thumbprint, reminding us of one of the many paradoxes of sculpture—the mark made by a finger to suggest another part of the body. Just as paradoxical is the sense of a full and firm body residing beneath its elusive, nondescriptive covering, which along with its less than life-size scale presupposes on the artist's part (and it is a sign of his compliment to the viewer) that his audience shares his inheritance of Western culture and its presuppositions about art.

The early date of this work and its radical reworking from this aged visionary to the pensive laborer in *The Serf,* if indeed the model was the same, may account for Matisse having forgotten its existence, although it was cast from a two-piece mold, suggesting that he wanted to preserve the latter for future casts.

The Serf is not an expressive sculpture, primarily because of the pose of the still impressive body of the middle-aged model. Contrast the faces of *John the Baptist* (probably Bevilaqua twenty years younger) and *The Serf* (plates 38–39). Rodin's prophet is in the act of speaking, his face mobilized for the passionate efforts of communication. *The Serf*'s eyes are downcast and the face immobile, but there is still the potential for expression. In his great and well-known statement, *Notes of a Painter,* Matisse explained in 1908 his views on expression, views encompassing sculpture, as shown by the fact that an illustration of what he opposed is clearly based on Rodin's work.

What I am after, above all, is expression I am unable to distinguish between the feeling I have for life and my way of expressing it.

Expression to my way of thinking does not consist of the passion mirrored upon a human face or betrayed by a violent gesture. The whole arrangement of my picture is expressive. The place occupied by figures or objects, the empty spaces around them, the proportions, everything plays a part. Composition is the art of arranging in a decorative manner the various elements at the painter's disposal for the expression of his feelings I could mention the name of a great sculptor who produces some admirable pieces but for him a composition is nothing but the grouping of fragments and the result is a confusion of expression.[24]

While the plaster version of *The Serf* intact does not betray a violent gesture in Rodin's terms, the closed, if not clenched, fists may have seemed distractive to Matisse. They could have seemed compositionally expendable and thematically redundant. Matisse may have been demonstrating that he would compromise what was dramatic in theme for a more effective decorative arrangement. He told his sculpture students in 1909, "Put in no holes that hurt the ensemble, as between thumb and fingers lying at the side."[25]

In *The Serf,* even more than in the *Jaguar,* Matisse was affirming that expressiveness in sculpture should result from how the artist worked rather than from what he said by the interpretation of the model's action. He was cutting himself off from that great tradition

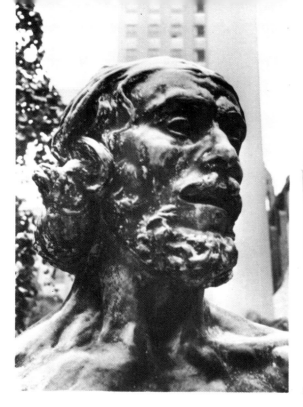

39 RODIN. *St. John the Baptist Preaching* (detail of head).
1878.
Bronze.
6′ 6 ¾″ high.
The Museum of Modern Art, New York City.
Mrs. Simon Guggenheim Fund

of Western rhetorical sculpture, unbroken since the end of the Middle Ages, which Rodin was so avid to continue. But Rodin also realized twenty years earlier than Matisse that the partial figure forced the viewer to focus upon how a sculpture was made, and it is an error to totally polarize the views of these two artists. Such work as Rodin's *The Great Head of Iris* fulfills the general aims of expression found in Matisse's statement.

Critics sympathetic to conservative art at the turn of the century were complaining that too much sculpture was being made without a show of feeling on the artist's part. What Matisse was opening for sculpture, as well as painting, was a more direct expression of the artist's sentiments and sensations, while retaining stock, passive studio postures and ignoring illustrative art. Comparable to the injunction to play expressively that comes from the musical notation *espressivo,* Matisse was urging the artist to find in his modeling an equivalent for his own feeling and at the same time to preserve decorative unity.

THE SERF AND THE ESSENTIAL IN ART

Crucial to Matisse's views on art are his conceptions of the *essential.* He was not alone in the use of this word, for Rodin, Maillol, Bourdelle, Brancusi, Duchamp-Villon, and many others were similarly concerned, although they differed in their vision of its meaning. Matisse urged that the artist distill out of his experiences what was essential (or durable) in his response to the model; he wanted to preserve only the essential in the form of the work of art; and he wanted to keep the essential character of his subject: "It is very necessary for you to remember that [your model] is a Negro."[26] What makes *The Serf* such an exciting sculpture in the context of Matisse's art is that we can see the patient, early working out of these ideas and the difficulties they imposed.

One might well ask how an artist who worked for three years on the same sculpture could express the feelings inspired by his model. First, Matisse expected a continued openness of attitude toward the encounter, either with each new model, or in successive confrontations with the same model. He felt this would permit strong emotional reactions to arise in the artist. It was then a problem of sifting through these various sensations and finding those that were most enduring. The artist had to train himself to be able to return again and again to his model and sculpture and recapture the feeling he wanted.

The model must not be made to agree with a preconceived theory or effect. It must impress you, awaken in you an emotion, which in turn you seek to express Some years ago . . . I would have put down the passing sensations of a moment; they would not completely define my feelings and the next day I might not recognize what they meant. I want to reach that state of condensation of sensations which

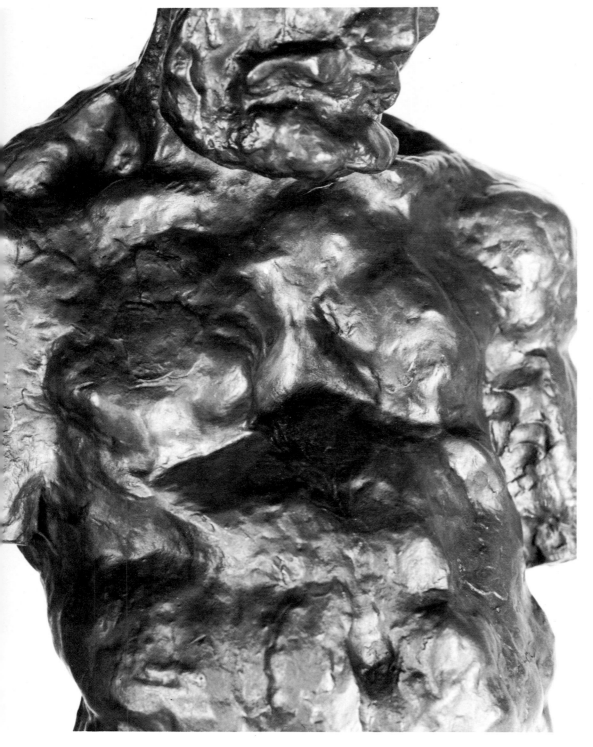

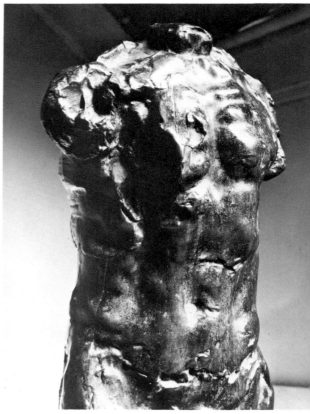

41 RODIN. *The Walking Man* (detail of torso).
1875–78.
Bronze,
33 ½" high.
Collection Henry Moore

constitutes a picture One can judge of the vitality and power of an artist when after having received impressions from nature he is able to organize his sensations to return in the same mood on different days, voluntarily to continue receiving these impressions Underneath this succession of moments which constitutes the superficial existence of things animate and inanimate and which is continually obscuring and transforming them, it is yet possible to search for a truer, more essential character which the artist will seize so that he may give to reality a more lasting interpretation.[27]

Matisse expressed the essentials of form to his students: "Everything must be constructed Exaggeration should be in accordance with the character of the model See from the first your proportions, and do not lose them The mechanics of construction is the establishment of the oppositions which create the equilibrium of the directions In all great periods [the artist was occupied with] the essentials of form, the big masses and their relations Never forget the constructive lines, axes of shoulders and pelvis; nor of legs, arms, neck, and head. This building up of the form gives its essential expression."[28]

THE SURFACES OF *THE SERF*

The surfaces of *The Serf* and *The Walking Man* manifest their artists' avoidance of stylization and a shared love of the body but indicate substantially different approaches to that body's celebration. For Rodin the simulation of flesh in its sensuous continuity and appearance of being stretched over perfectly formed organs was a primary, but not exclusive, aim, as can be seen in his frequently unmodulated surfaces. He often displayed a finesse and smoothness in modeling which Matisse never sought to emulate and often took pains to suppress (plates 40–41). The front surface of *The Walking Man* is a combination of firmly modeled passages and the marks of accidents: accidents caused both by the sculptor, such as digging into previously finished areas, and by the casting. (The work is reparable, as Henry Moore has observed.[29]) Unlike Rodin, Matisse did not seek the appearance of a ruin from antiquity. Consistent with his aims of realizing "the big masses and their relations," Matisse does not carry his definition of areas like the pectorals and abdomen to the limits of Rodin, although there are analogies between the working of the back in the two sculptures (plates 42–43). The back of Rodin's work was less defined than the front because it was not made from a live model; the torso's inspiration could have been found in Michelangelo's art.

Matisse's facture involves a "suggestive synthesis" of things known and observed about the body, subject to aesthetic intuition about when to stop in order to achieve an overall balance of accents. He would understate anatomy but strive for a greater density of aesthetic events than Rodin. Looking at detailed views of *The Serf*

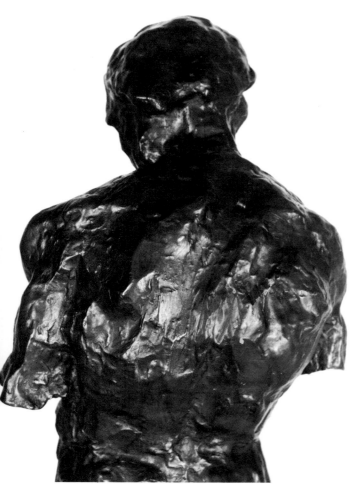

42 *The Serf* (detail of back)

43 RODIN. *Torso* (view of back).
1875 (?).
Bronze,
20 ⅞″ high.
Musée du Petit Palais, Paris

44 *The Serf* (detail of legs)

shows that he did not systematize his touch, but improvised from area to area. The back of the right shoulder is a bulging, faceted mound, larger than in the 1900 painting of a male model. Its seemingly excessive projection from a profile view is explicable as a counterbalance to the sagging, extended stomach, the point where it is possible that the exterior armature, if he used one, entered the body. The deep thorax cavity has been strongly felt and patiently excavated, while the base of the spine has been rudely gouged.

Here, as with the *Jaguar,* Matisse added the editing possibilities of a sculpture knife to the modeling action of his fingers. The resulting facets are analogous to, but not as pervasive as, the broad planes seen in his 1900 paintings of Bevilaqua. The vertical slicing action of the knife on the back of *The Serf*'s right leg, for instance, serves to accentuate the direction of the muscles and general stance of the figure (plates 44–45). Some years later he was to tell his students, "In a man standing erect all the parts must go in a direction to aid that sensation."[30] The sculptor James Rosati pointed out while we were studying this sculpture together, that these large, flat planes influence the reception of light by creating potentially larger luminous zones to contrast with the smaller, more varied accents in the modeled passages. Sidney Geist sees the alternation of "warm modeling and cool editing" with the knife. Matisse did not try to temper the sliced edges, and in this frank exposure of editing there is a similarity to Rodin's earlier development of this technique which can be seen on the back of his *Flying Figure* (plate 46) of the early 1890s. Rodin seems to have edited out passages that he felt did not work because of faulty modeling or because he did not like the results of enlargement by his assistants, such as Lebossé. Matisse used the knife more frequently on an individual sculpture than Rodin and more as a constructive than destructive device. It was a way of establishing the broad planes that allowed the figure to carry from a distance and made its "architecture" more explicit. The conceit of Matisse, shared with Cézanne, was that he could make a body which appeared more solidly put together than in actual life. By not truing his knife-made accents, Matisse called attention to his hand and the feeling behind each decision. What was to dismay him about younger sculptors such as Duchamp-Villon, who moved away from modeling and whose *Horse* Matisse saw in 1914, was the emphasis upon intellect and the avoidance of evidence of emotion and the hand in the execution.[31]

Cézanne and Bourdelle

The influence of two important artists, Cézanne and Bourdelle, intervenes between Matisse and Rodin and helps to account for the difference in motivation and character of their respective styles and factures. Before 1900, Matisse had acquired from Vollard one of

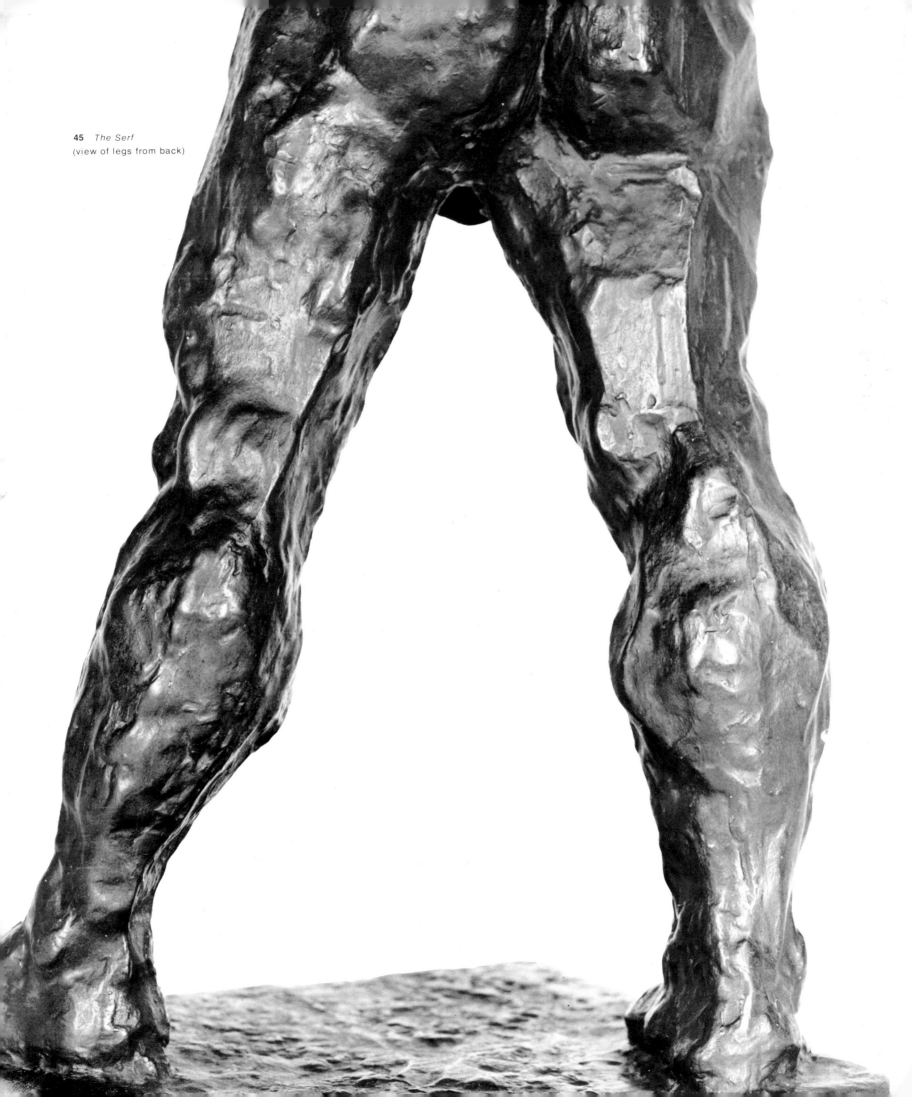

45 *The Serf*
(view of legs from back)

Cézanne's paintings of bathers, along with a Rodin portrait bust of Rochefort. The painting rather than the bust had a positive impact on his own sculpture. What Matisse could have learned from Cézanne's work that was appropriate to sculptures such as *The Serf* were the constructive and expressive rather than descriptive functions of each touch which synthesized anatomical and aesthetic requirements. For both Matisse and Cézanne it was essential that every passage, whether in painting or sculpture, satisfy the needs of the general direction of the anatomy (its projection or recession values; or sculptural "color") and be coordinated with adjacent areas in terms of overall effect. From Cézanne could also have come the example of reforming rather than deforming the body to augment its compactness and solidity. The mutual goal of both artists was an aesthetic carpentry which would make the beholder conscious of an irrevocable joining and interdependence of parts. The older painter's avoidance of preconceptions and facile solutions to achieve charming or ingratiating form in favor of open-ended editing found sympathetic response in Matisse. His search for a "condensation of sensation" echoes Cézanne's distrust of Impressionism.

Matisse studied with Bourdelle for a few months in 1900. Mme Duthuit insists that her father was not really a student of Bourdelle's but only went to him for technical assistance. She remembers him saying, "When I learned to model from Bourdelle " Bourdelle could have informed him of Rodin's methods and views of sculpture and also of his own misgivings and desire to find a new way of

46 · RODIN. *Flying Figure*.
c. 1890.
Bronze,
10 ¼" high.
Collection Mr. and Mrs. Leo Steinberg,
New York City

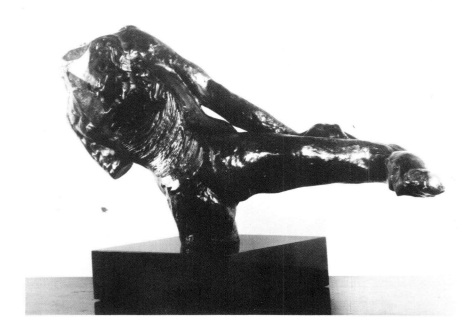

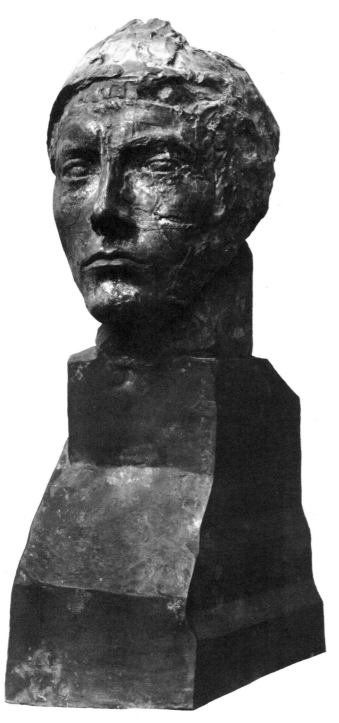

47 BOURDELLE. *Head of Apollo*.
1900–1909.
Bronze,
26 ³⁄₈″ high.
Musée Bourdelle, Paris

48 BOURDELLE. *Torso of Riri*.
1900–1903.
Bronze,
13 ½″ high.
Collection Rhodia Dufet-Bourcelle, Paris

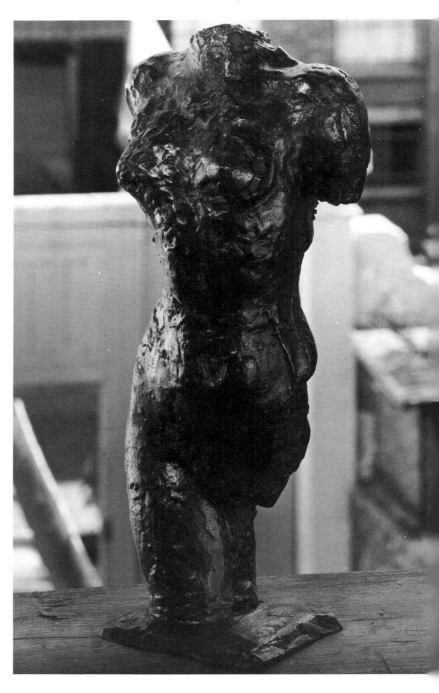

rendering the figure. According to Bourdelle's recollection, his *Head of Apollo* (plate 47), done in 1900, was a turning point and showed him the way to "separate from Rodin." (The side of the head scarred by accidents was the "Rodin" side; the smoother, broader treatment of the other profile was for Bourdelle a new point of departure.) He had come to dislike Rodin's "too easily imitable tragically agitated faces, and holes in the planes of the flesh I escaped from the hole, the accidental plane, in order to find the permanent planes. I researched the essential in structures I searched for universal rhythm"[32]

Bourdelle's words show that he and Matisse spoke the same language and had compatible aims. Ironically, in the late 1890s Rodin felt that with the monument to Balzac he had surpassed his previous efforts in achieving the "essential" in sculpture through the finding of "the great planes" and effects which eliminated considerable detail. But for all his talk to younger artists of "geometry," "architecture," "the great planes," and the "essential," Rodin's sculpture seemed too formless and prone to chance, as well as insufficiently explicit in its aesthetic construction. Bourdelle's sculpture made before 1900 (shown in a beautiful exhibition in 1967 at the Galerie Claude Bernard in Paris) could have provided Matisse with models of the power possible on an intimate scale. It also demonstrates the effects of leaving exposed a vigorous touch, minimizing bodily textures, and reducing focus on the face and extremities. The acceptance of the validity of the partial figure as a complete work of art would have impressed Matisse. Bourdelle's excellent *Torso of Riri* (plate 48), with its imaginatively variegated surface, still manifests the firm presence of the body's internal structure, which also gives the figure its dignified erectness: the torso is made expressive through bearing and facture. By word and act Bourdelle shared Matisse's sensuous love of the human body and its remaking.

As is the case with Cézanne, we cannot look upon Matisse's sculptures as disinterested aesthetic studies of the human form. Both artists wanted to preserve the essential character of the model. Matisse's most impressive statement about the subject of his art, made in 1908, uses as an example an "Italian model," who was probably Bevilaqua. He was almost certainly referring not only to his paintings, but also to *The Serf:* "What interests me most is neither still life nor landscape but the human figure. It is through it that I best succeed in expressing the nearly religious feeling that I have towards life. I do not insist upon the details of the face. I do not care to repeat them with anatomical exactness. Though I happen to have an Italian model whose appearance at first suggests nothing but a purely animal existence, yet I succeed in picking out among the lines of his face those which suggest that deep gravity which persists in every human being. A work of art must carry in itself its complete significance and impose it upon the beholder even before he can identify the subject matter."[33]

Matisse's turning to figure sculpture in *The Serf* in 1900 coincides with a shift in focus that had previously centered on landscapes and still lifes. We can also see that his 1908 statement reflects ideas that go back many years to a pre-Fauve period, and to which the making of sculpture as well as painting so importantly contributed. His isolation of "gravity" as a universal dignifying human quality may help to explain Matisse's antipathy to movement as a subject for sculpture. Matisse worked toward sculptures that had some universal basis in their appeal and that served as the artist's spiritual expression, not as the illustration of religious subjects, which characterized so much that filled the salons. Matisse thus belongs with artists like Rodin, Van Gogh, Gauguin, Minne, and Munch, who at the end of the last century were looking for qualities derived from the means of art and for subjects that permitted personal alternatives to a discredited tradition of religious art.

The Serf stands at the beginning of Matisse's sculpture and the sculpture of this century as a durable and impressive example of the new ways by which this artist believed modern sculpture could express feeling without recourse to drama and pathos. Feeling was to be the motive, not motif, of sculpture. The suggestive synthesis achieved by Matisse in this great work included the preservation of the subject's spirit, while allowing the spirit of the artist more direct expression. With *The Serf,* Matisse emerges as a sculptor of power and vitality, capable of self-mastery by his patient, disciplined reaction to ideas born of impulse. Rather than establishing a fixed style or imitating another man's art, his objectives were to discover personally the nature of modeling and the model, the precedent for which may have been Rodin's most important legacy to Matisse.

Matisse and the Tradition of the *Bozzetto*

The freedom of surface handling which Matisse's figures received is not historically new; it is related to the tradition of the *bozzetto,* the sculptural sketch. This tradition derives from the late fifteenth century and such artists as Verrocchio, Michelangelo, Giambologna, and Bernini.[34] Since the Renaissance *bozzetti,* sometimes large in scale, have been admired for their own special properties, for displaying the artist at his most intimate and complete. (Assistants often helped to execute part or all of the enlarged final works.) Carpeaux's *bozzetti* for his finished portraits and figures are examples of the strength of this tradition in the last century. With Rodin, the distinction between the *bozzetto* and a finished sculpture begins to break down. Rodin did countless works with a liberalized surface treatment, but we find that in many of his life-size sculptures, such as the *Age of Bronze, John the Baptist, The Thinker,* and *The Burghers of Calais,* the facture is not so broad or discernible and not so loosely modeled as in their preliminary studies. His private, small- and

medium-scale works of figures and heads made from anonymous models, particularly the monument to Balzac, display the variety and inventiveness of his touch most dramatically. These works were to have a considerable influence both on public taste with its new awareness of the qualities of the sketch and on younger artists in their redefinition of the nature of sculpture. As with the partial figure, Rodin may have come slowly to recognize and prize the validity and self-sufficiency of his sketches. The emancipation of touch from the convention of the *bozzetto,* or project for a larger or finished sculpture, and its elevation to the fabric of a final work, owes much to Medardo Rosso as well. What separates Matisse from the *bozzetto* tradition, beginning with *The Serf,* is that he did not make sculptures for commissions or as a prelude to larger, more finished forms; and unlike Rosso, he was not matching his modeling to observed effects of light on moving figures. He wanted the quality of arbitrary aesthetic construction comparable to Cézanne's reworking of motifs from nature. He stands in the same relation to Rodin and Rosso as did Cézanne to the Impressionists. The exposed touch, the preservation of all vestiges of spontaneity and decision, early became for Matisse essential to finished sculpture on any scale.

The Purposes of Matisse's Sculpture

Matisse's friends observed that sculpture served the artist by "enriching" his resources and providing another outlet for his vast energies.[35] In 1913 the artist told a reporter from the *New York Times,* "I like to model as much as to paint—I have no preference. If the search is the same when I tire of some medium, then I turn to the other—and I often make, 'pour me nourrir,' a copy of an anatomical figure in clay."[36] Having established his parity of painting and sculpture, Matisse went on to give an example of what he sought and what he did not want in art in terms of sculpture: "We of today are trying to address ourselves today—now—to the twentieth century—and not to copy what the Greeks saw and felt in art over two thousand years ago. The Greek sculptors always followed a set, closed form, and never showed any sentiment. The very early Greeks and the primitives only worked from the basis of emotions, but this grew cold and disappeared in the following centuries. It makes no difference what are the proportions, if there is feeling Above all the great thing is to express one's self."

On another occasion Matisse spoke of the mutual aims of his painting and sculpture: "I practiced sculpture, or rather modeling, as a complementary study to put my ideas in order."[37] Less tersely put and giving us better understanding of what he meant is another statement by the artist: "I took up sculpture because what interested me in painting was a clarification of my ideas. I changed my method and worked in clay in order to have a rest from painting where I had

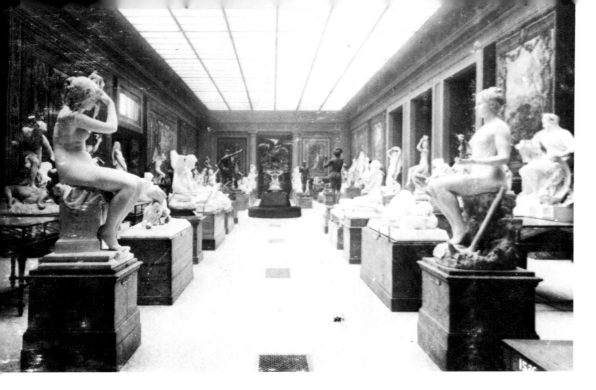

49 The sculpture gallery in the old
Musée de Luxembourg in Paris about 1900.
Gérôme's *Tenagra* is in the right
foreground. Rodin's *Age of Bronze*
and *John the Baptist* are in the right
background

done all I could for the time being. That is to say it was done for the
purpose of organization, to put order into my feelings, and find a
style to suit me. When I found it in sculpture, it helped me in painting.
It was always in view of a complete possession of my mind, a sort of
hierarchy of all my sensations, that I kept working in the hope of
finding an ultimate method."[38]

The ideas to which he referred, as discussed previously and
traceable to the *Notes of a Painter* of 1908, included the search for
finding ways of expressing his feeling for life, the nature of
expression and how it was to be achieved in composition, and what
constituted the essential in nature and form. It is not paradoxical that
an artist who relied so greatly on instinct and sensibility should write
about "ideas." Matisse, whose intellect early impressed the Steins
and Bernard Berenson, among others, was a thoughtful, complex
artist, who favored varied and empirical confrontations of artistic
problems as well as of nature.

The purposes of sculpture were no different for Matisse than those
of painting. He was not interested in historical or literary subjects
(except in book illustration), or in large public commissions that
celebrated civic heroes or that in a chauvinistic way educated and
elevated the populace. We need only to compare his sculptures to
those in a photograph of the old Musée de Luxembourg in Paris at
the turn of the century (plate 49) to appreciate how alien his art
would have appeared in a public collection. "What I dream of is an
art of balance, of purity and serenity devoid of troubling or
depressing subject matter, an art which might be for every mental
worker . . . like an appeasing influence . . . something like a good
armchair. . . ."[39] As much from his paintings as from photographs,
one can see that Matisse's sculptures were intended for studio and
home, works of art made from art, among aesthetic objects, whether
paintings, tasteful furniture, or floral arrangements. The small scale
of most of his sculptures encouraged their location in the home on

sculpture stands, on tables, mantles, and floors. They were always to be accessible not only to the eye, but also to the hand: ". . . a sculpture must invite us to handle it as an object; just so the sculptor must feel, in making it, the particular demands for volume and mass."[40] A photograph permits us to see Matisse enjoying one of his small modeled heads, held in his hand (plate 50).

Small scale was preferable to large in terms of the sculptures' ideal location and the small studios he had before 1909, and also in terms of the limited demand it made upon his time away from painting. Small scale was also a challenge: "The smaller the bit of sculpture, the more the essentials of form must exist."[41]

Although often motivated by commercial rather than aesthetic reasons, at the end of the last century many sculptors were turning to apartment-sized sculptures. Part of the interest in small decorative sculpture was inspired by the French discoveries at Myrina in 1880–83 of Hellenistic terra cottas, many of which came to the Louvre and were to attract artists such as Gérôme, Bourdelle, and Matisse. After 1900, the sculpture salons increasingly made space for vitrines filled with hundreds of figurines. Duchamp-Villon's work between 1902 and 1914 exemplifies a serious young sculptor's concern with indoor sculpture.[42] One historian has argued without qualification that beginning with Canova modern sculpture is "homeless" and no longer part of the "routine of life," as it had been in the past.[43] Matisse, Bourdelle, Maillol, Rodin, and Duchamp-Villon, to name a few, held contrary beliefs. Feeling that the number of successful civic sculptures is restricted, this same historian speculates that "generally, our modern experience of modern sculpture comes to us not in the healthy, natural manner of things which belong to our daily lives, but through visits to museums." Setting aside the implications that museum visits are unnatural and unhealthy, this view of modern sculpture ignores its actual continuation of serious decorative purposes.

50 Matisse examining one of his small bronze sculptures

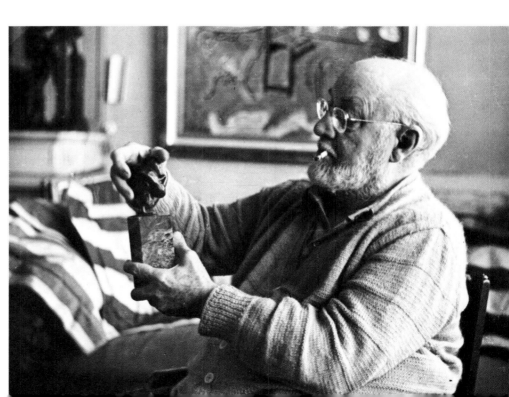

Evidence that Matisse thought of his small sculptures as separate entities, not simply as studies for painted figures, comes from the many paintings in which his sculptures are undisguised. He was far from being disinterested in subject matter, as many have claimed: the sculptures, along with flowers, goldfish, exotic rugs, and beautiful women, were necessary for his hedonistic art and personal surroundings all of his life.

Matisse's Conservatism

In certain respects the sculpture of Matisse is art about art. Unlike Rodin, he was not interested in the heroic, the declamatory gesture, or the natural or fugitive pose unselfconsciously assumed by an inexperienced model. Mme Duthuit remembers her father telling the model to "take a pose you can hold perfectly." Almost all of his small figure sculptures derive from standard studio poses of the time taken from the model or photographs, or from ancient Greek art. To this extent he continued an École des Beaux-Arts ideal which related him not only to conservative salon sculptors, but also to other similarly trained Fauve painters such as Marquet and Rouault. The poses in his small sculptures have their near counterparts in those from antiquity and such turn-of-the-century salon artists as Boucher, Delaplanche, Marqueste, Becquet, Gérôme, and others. Matisse did not share Rodin's avid search for new truths about life expressed by means of new postures and movements. He did not share the older artist's faith that anyone was a possible subject for good sculpture; Matisse, as did his academic colleagues, insisted upon beautiful models.[44] Why this conservatism in Matisse? Was it because he really had no interest in the subject, and by choosing a familiar posture could eliminate the problem of identification, permitting exclusive concentration on form? One answer may lie in his statement of 1908 concerning what he thought would be the charge that he wrote in platitudes: "The rôle of the artist, like that of the scholar, consists in penetrating truths as well known to him as to others but which will take on for him a new aspect and so enable him to master them in their deepest significance."[45] Other answers will become apparent as we explore his sculpture as a whole.

The *Madeleines*, 1901, 1903

Intermittently from 1900 until 1950, Matisse engaged in a long series of figure studies in which he sought two distinct types of harmony in form. One consisted of a personalized synthesis of movement and

H. matsfr

51 *Study for Madeleine I.*
1901.
Pencil,
11 ¾ × 9 ¼".
The Museum of Modern Art, New York City.
Gift of Mr. and Mrs. Pierre Matisse, in honor and memory of
M. Victor Leventritt

stability: movement generated through the body by a strenuous and
at the same time stable pose, which could be comfortably held. The
strong deviation of the flexible axes of the body from an imaginary
central vertical line, and the consequent deviation of the body's
volumes from this axial plumb line, made sufficient drama and

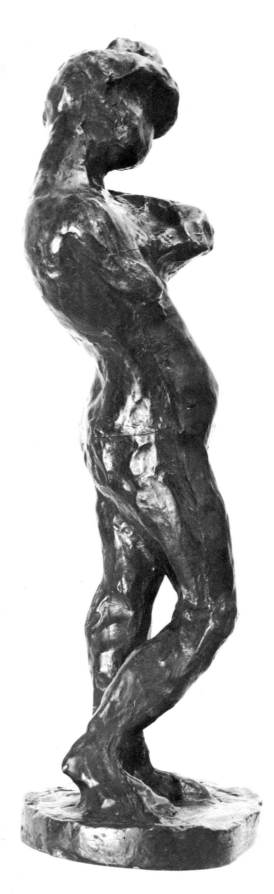

52 *Madeleine I* (right side view).
1901.
Bronze,
23 ⅝" high.
The Baltimore Museum of Art. Cone Collection

aesthetic contrast for the sculptor. Second, throughout his art, whether in painting or sculpture, he was concerned with the figure having no body movement, and was therefore able to achieve harmony with minimal oppositions rather than strong contrasts. He would alternate in sculpture between the serpentine arabesque, which activated the body in depth, and the frontal position. We can understand why he owned plaster casts of both Michelangelo's *Bound Slave* and an archaic Greek sculpture. What he found and enacted in his interpretation of the human body served him in his paintings. With the exception of color, the problems were the same in terms of types of composition achieved through degrees of contrasts. Both sculpture and painting came alive to Matisse by the play of light upon the volumes of his figure or objects. His concern with light in sculpture was apparent at the start, and the changes he was to make in his sculptural surfaces included ideas about sculptural luminosity. If Matisse's aim was to make the "whole arrangement" of his work expressive, it is not hard to understand how having worked from the figure in modeling could be of value even when painting a still life, and the reverse.

While undertaking the long, painstaking construction of the somber *Serf,* Matisse felt compelled to realize his figures more promptly and became involved with different problems. In 1901 he made the first of two sculptures whose title refers not to a goddess or mythological figure, as in salon art, but to the name of his model. *Madeleine I* is shown, her arms folded across her breasts, in a somewhat exaggerated hipshot pose (plates 51–56). Attempts have been made to connect this work with Art Nouveau because of the relative fluidity of the contours and swaying stance. The stance produced a serpentine twist of the body which gave Matisse his arabesque. It was a pose from the studio used by artists who worked in many different styles. Matisse's dislike, however, for affecting a style, and paintings and drawings by the artist of the same pose in the studio, show that this work was a life study.[46] Matisse, like Rodin, used drawings to survey a motif and to coordinate hand, eye, and feeling, but he did not literally make sculpture directly from drawings, as did many turn-of-the-century sculptors and technicians. What gives the small sculpture a contemporaneity foreign to its salon counterparts is Matisse's fidelity to the model's general identity, including her hair style. Conservative sculptors, such as Pradier in his *Psyche* (plate 57), re-created exotic or ancient coiffures to lend credence to the assumed identity of their models. The folded arms of *Madeleine* freed the long contours of her torso and thighs. We can see in the work of Pradier and in Idrac's *Salambo* (plate 58) comparable positionings to get these troublesome limbs out of the way, but the studio pose was disguised by the addition of a butterfly or a serpent. Rodin's *Eve* has a self-hugging gesture which, with the bowed head, transforms the model into a guilt-ridden figure. By foregoing Pradier's butterfly, Idrac's serpent, and Rodin's reference to original sin, Matisse was establishing a position whereby the

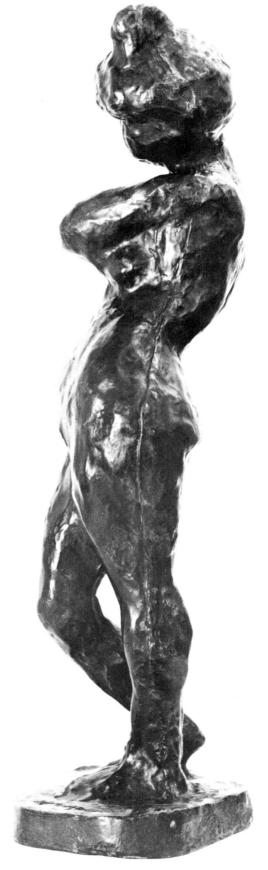

53 *Madeleine I* (front view)

54 *Madeleine I* (left side view)

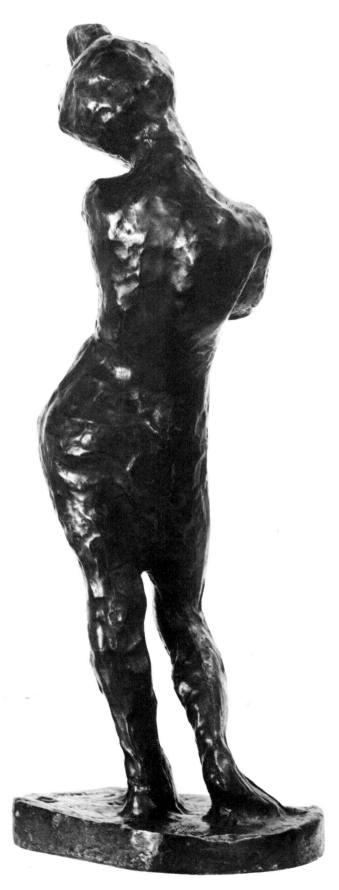

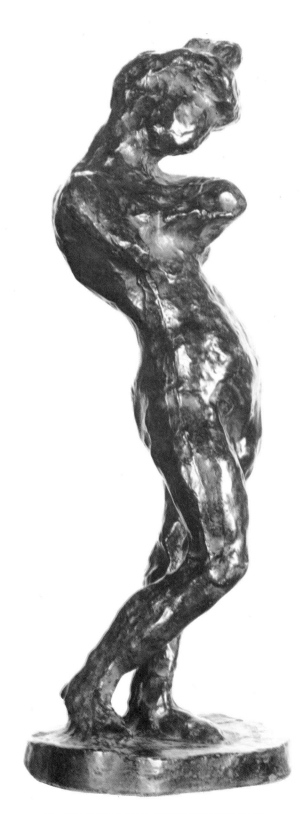

56 *Madeleine I* (three-quarter right front view).
San Francisco Museum of Art.
Harriet Lane Levy Bequest

53

58 IDRAC. *Salambo*.
Formerly Musée de Luxembourg, Paris

57 PRADIER. *Psyche*.
Marble.
The Louvre, Paris

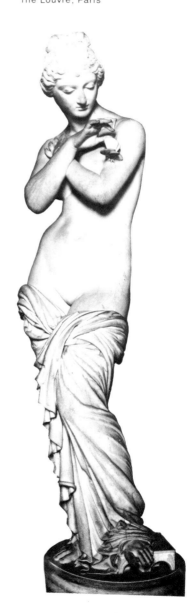

model was stripped and preserved in her nakedness. Matisse must have been aware of the crisis in credibility confronting salon artists at the turn of the century. Legions of Salambos, Psyches, Eves, and Floras numbed the imagination and feelings of critics and salon-goers. Matisse could not abide the formal conventions or the tricks and gimmicks by which the nude was to be realized almost mechanically, by life casts or calipers, in sculpture. He could not settle for a fixed style or impersonal rules, as we can see in *Madeleine II.* "Any of us can repeat a fine sentence but few can also penetrate the meaning."[47]

 Madeleine II is not more closely modeled in form than its predecessor, as one might expect (plates 59–61). The fluency and continuity of contour in the first work might lead one not knowing Matisse to anticipate sharper definition or refinement of surface in its sequel, but the reverse occurred, and the result was more vibrato.

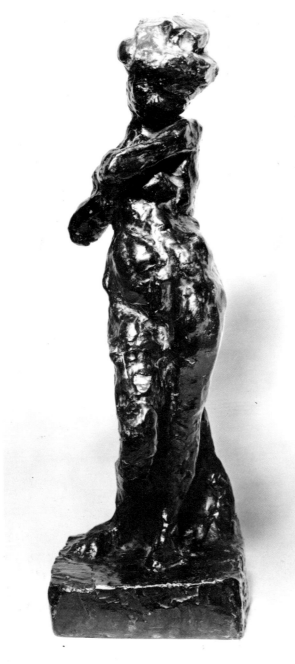

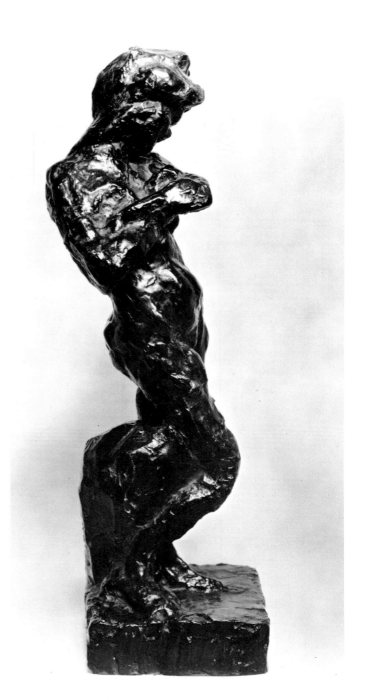

59 *Madeleine II* (front view).
1903.
Bronze,
23 ⅞″ high.
The Jeffrey H. Loria Collection, New York City

60 *Madeleine II* (three-quarter right front view)

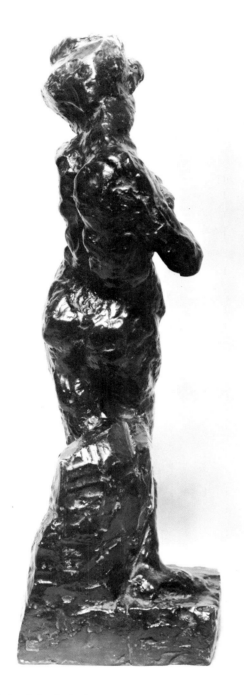

61 *Madeleine II* (back view)

62 *Still Life in Venetian Red.*
1908.
Oil on canvas.
35 × 41 ⅜".
Museum of Modern Western Art, Moscow

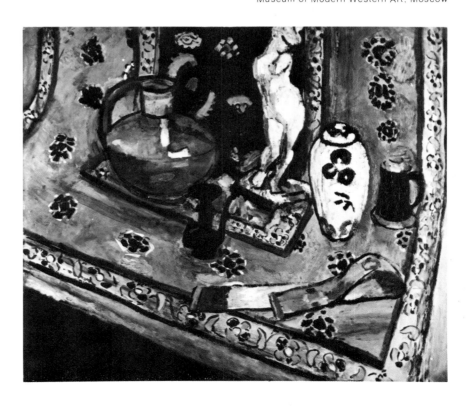

From the beginning, Matisse resisted the attractions of idealization or the systematic simplification so important to both conservatives and younger artists like Brancusi and Duchamp-Villon. Matisse was to say in 1908, as recorded by Sarah Stein, "You must forget all your theories, all your ideas before the subject," and the change in the second version of *Madeleine* could have resulted from a different "condensation of sensation" when he confronted the model or finished first version. Sculpture, like painting, responded to the complexity of Matisse's make-up and his evolution of personal modes for his style.

The plaster cast of *Madeleine II* appears in the *Still Life in Venetian Red* (plate 62), its whiteness not only verifying the material, but contributing to the chromatic orchestration. The sculpture contrasts with its neighboring objects by its more animated silhouette and greater flexibility of axis, a structure of counterpoised volumes that summarizes the painting's dialectic of verticals and diagonals. This is one of the earliest juxtapositions of the sculptural arabesque with the flat arabesques of exotic domestic decoration which persistently intrigued Matisse and culminated in the *Decorative Figure on an Ornamental Background* painting of 1927. The cast, which makes the figure object-like, also serves to evoke human references in terms of stance and gesture in the other objects. In Matisse's still life there is no suggestion or pretext of use, sociability, or symbolizing, as there is in the Dutch still lifes he had copied in the nineties. His objects were chosen and disposed as a display of what he felt was apt for painting, thereby giving us the enjoyment of art on different levels.

The Modes in Matisse's Art

As is true of his drawings, prints, and paintings, the sculptures of Matisse show his ideas about modalities. Alternately, he could draw or paint a model in a hard, angular mode, as in the *Standing Nude* of 1907 (plate 63), or employ a soft, curvilinear sequence of the contours, as in *Le Luxe II* (plate 64). Modalities were not restricted by media, as can be seen in his linoleum print, *Seated Nude,* of 1906 (plate 65), and the transfer lithograph of the same year, *Half-Length Nude, Eyes Cast Down* (plate 66). Meyer Schapiro has referred to these as Matisse's "feminine and masculine modes."[48] One could also describe them as warm and cool or rough and smooth aspects of his style, the former in each pair responding to the natural force of impulse, the latter to deliberation and rectification. In such sculptures as *The Serf* these combine and take the form of alternating passionate modeling and editing with the sculptor's knife. Matisse's paintings show the early modes of a mosaic-induced vibrato, or divisionist application of colors, and the more quiet, fluid effects of large zones of uninterrupted color. Similarly, the

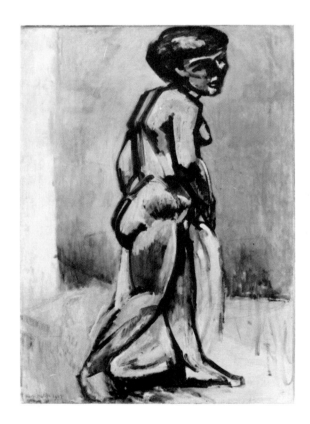

63 *Standing Nude.*
1907.
Oil on canvas,
36 × 25".
The Tate Gallery, London

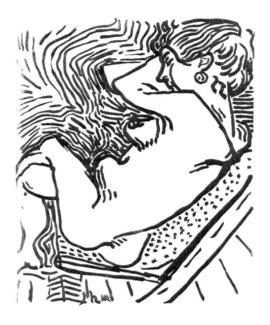

64 *Le Luxe II.*
1907–8.
Casein,
82 ½ × 54 ¾".
The Royal Museum of Fine Arts, Copenhagen.
J. Rump Collection

65 *Seated Nude.*
1906.
Linoleum cut, printed in black,
18 ¾ × 15".
The Museum of Modern Art, New York City.
Gift of Mr. and Mrs. R. Kirk Askew, Jr.

58

66 *Half-Length Nude, Eyes Cast Down.*
1906.
Transfer lithograph, printed in black,
17 ⅝ × 9 ½".
The Museum of Modern Art, New York City.
Given anonymously in memory of Leo and Nina Stein

*Madeleine*s alternate between restful and restless effects. Many times, for more effective contrast, Matisse would mingle the modes in a single sculpture, painting, or drawing. In drawing and sculpture this method can be seen in silhouettes that conjoin angular and curved contours.

Modalities are differences in voice, in the pronunciation of a silhouette. Modalities in art are as old as the Greeks and could have been taught to Matisse by Moreau. Before Matisse they were governed by ideas of decorum with respect to the appropriateness of mode to subject. From the Renaissance through the twentieth century, in rhetoric and music as well as in the visual arts, stylistic modes were recognized as ways by which the artist could achieve a suitability of form to theme no matter what his feelings at the time he worked. Rodin had a strong sense of modal decorum in his public and private works, and Picasso still maintains it in his art. Matisse adds to tradition in that his modalities are practiced on the same model and pose and derive from taste and his feelings. Put another way, Matisse's modes depend more upon moods than motifs. Toward the end of his life, in the murals of the Chapel of the Rosary at Vence, Matisse was able to fuse personal and traditional ideas about modalities.

New Possibilities for Old Poses

Although generally observing the "platitudes" of salon postures, Matisse gave the women in his sculpture a greater sense of abandon. He would give a stronger accent to the thrust of a hip and the swing of the shoulders and make more voluptuous the act of the model's stretching, as in the *Upright Nude* of 1904 (plates 67–68). Even in the more sedentary *Seated Woman* of the same year (plates 69–70), the model's gesture shows that thousands of similar interpretations have not deprived it of instinct and energy. The traditional posture of raising the arms thrust the chest forward and not only liberated the silhouettes of the torso, but extended the figure's height and the vertical movement initiated at the ankles. Matisse never tired of the use of this arrangement of the arms. In the full figure it gave him another set of axes to enrich the body's structure. Even after he had employed the raised arms position sculpturally for the last time in 1950, he would continue to use it in his paper cutouts. Perhaps for the artist it was an emblem of femininity, no matter how unseductive.

The motif of the *Seated Woman* is shared with paintings, such as that in the Gallatin Collection in the National Gallery in Washington, D.C., of seated women arranging their hair. In the sculpture Matisse shows a simple, aesthetic act, which is remote from Jules Franceschi's virtuoso performance of transforming Fortune's hair into a cornucopia of coins and suspending the goddess and her attributes on a marble cloud (plate 71). Matisse,

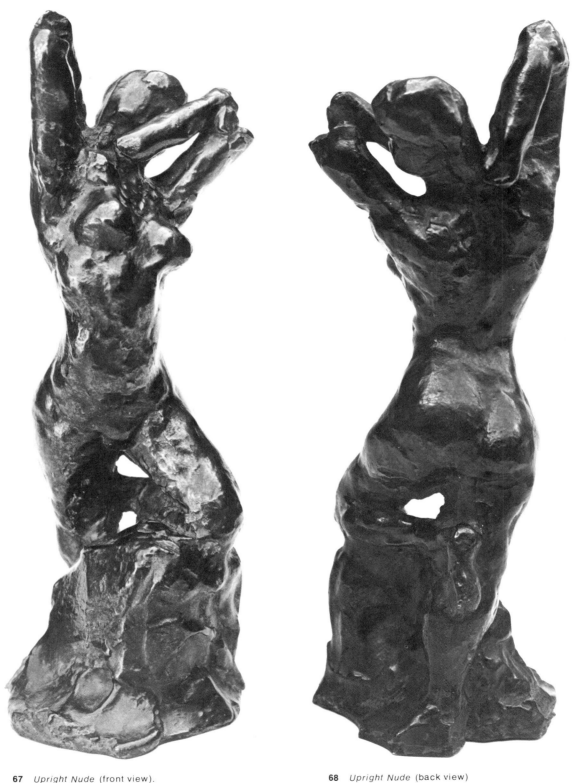

67 *Upright Nude* (front view).
1904.
Bronze,
7 ⅛″ high.
Collection Mr. and Mrs. Norton S. Walbridge, La Jolla, Calif.

68 *Upright Nude* (back view)

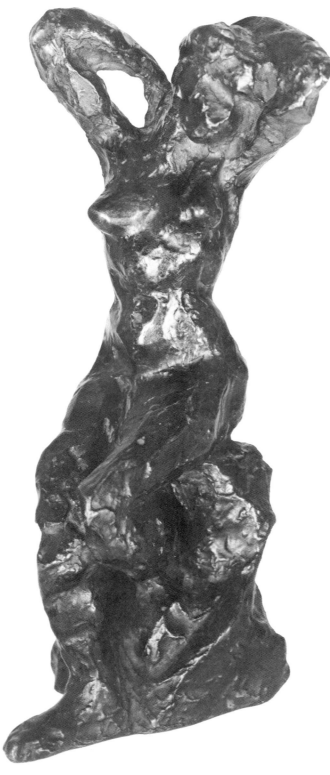

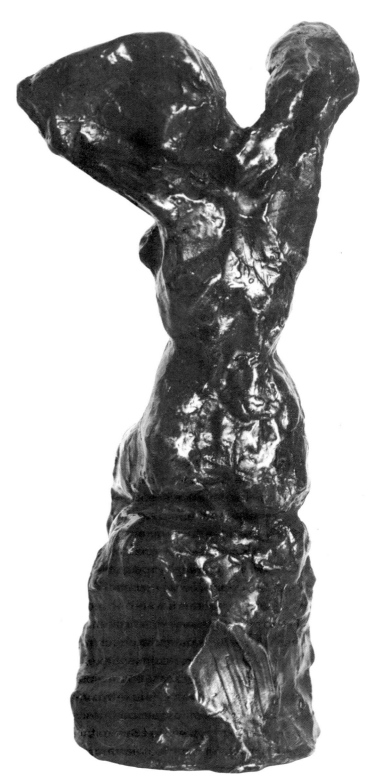

69 *Seated Woman* (front view).
1904.
Bronze,
13 ¾" high.
The Baltimore Museum of Art. Cone Collection

70 *Seated Woman* (back view)

61

71 FRANCESCHI. *Fortune*.
Marble.
Formerly Musée de Luxembourg, Paris

unlike Franceschi, Rodin, and many others, showed no interest in
seeming to liberate the human form from gravity and reality. He
favored the model's solid foundation on the ground and in the atelier.

In 1905 Matisse made the first of several reclining figures,
Woman Leaning on Her Hands (plates 72–74). The model is wearing
a loose-fitting shift pulled up above her waist to expose the lower
portion of her body, which sprawls in a direction opposite to her
extended hands. The pose gave Matisse strong diverging directions
which pull the viewer around the sculpture or encourage turning it in
the hands. The movement is powerful yet stabilized by the double
bracing action of the arms. Jean Matisse owns a beautiful contour
drawing of the model in this pose which, as a reconnaissance, may
have convinced Matisse of its rich possibilities for sculpture in terms
of its many expressive silhouettes. The back view is as interesting as
the front. Consistent with Matisse's candor in reminding us of the
semi-nakedness of the model and her position on the studio floor
was his omission of a modeled base. Photographs show that often he
simply made a figure on a box. A base was not needed for structural
support, and its omission is paralleled frequently throughout
Matisse's life by his decision not to frame paintings—a declaration
of the self-sufficiency of his art when he so wished. Similarly,
Maillol had shown several small figures without bases in 1903.
Matisse could have seen that Rodin left many of his small fragments

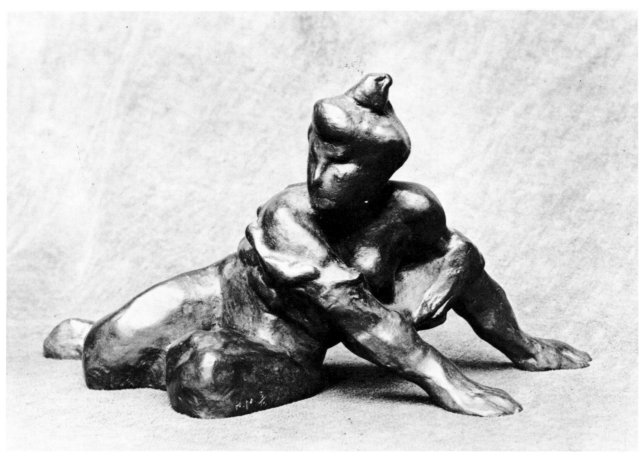

72 *Woman Leaning on Her Hands* (front view).
1905.
Bronze (?),
5″ high.
Whereabouts unknown

73 *Woman Leaning on Her Hands* (front view).
1905.
Bronze,
5″ high.
The Baltimore Museum of Art. Cone Collection

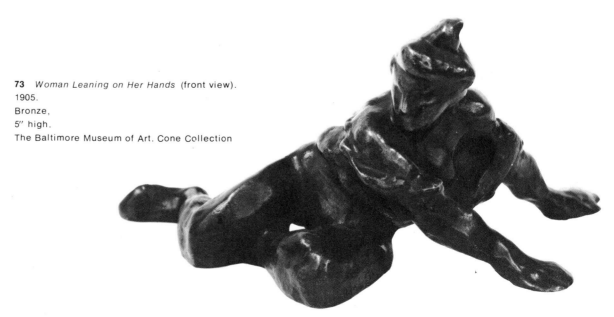

unattached to supports on his visit to the older artist's studio in 1898. Matisse's decision was a logical step from his nonillusionistic bases of the *Madeleine*s and his refusal to model a flat plane beneath the supports of the 1904 sculptures, and yet he did not see this as an irreversible decision. The absence of the base was another gesture by Matisse against salon and traditional sculptural practice: to bring sculpture literally down to earth. The viewer is always reminded of the sculpture's actual size in whatever context it is seen, when no base has been added. When Matisse included the *Woman Leaning on Her Hands* in his *Still Life with Geranium Plant and Fruit* (plate 75) in 1906, he made no attempt to enlarge its scale. In the context of the still life it remains a small object. With his brush Matisse underscored the supporting action of the arms and may have savored the character of its silhouette in comparison with those of the fruit and ceramic objects nearby. The outlined sculptural figure to the left in the painting is his *Thorn Extractor,* also of 1906.

Although he was making radical discoveries in painting at this time, Matisse felt the need to rework an ancient sculpture that interested him. In 1906 he did a free interpretation of the Roman bronze, *The Spinario* (plate 76), probably from memory and during the summer when he was without a model. This was his *Thorn Extractor* (plates 77–78), in which he reversed the ancient posture of the legs and made a standing rather than seated figure, giving more energy and a more precarious balance to the motif. The foreshortening of the head is further exaggerated and gives no

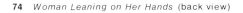

74 *Woman Leaning on Her Hands* (back view)

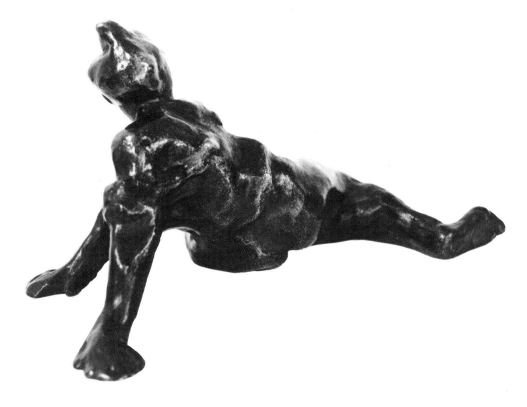

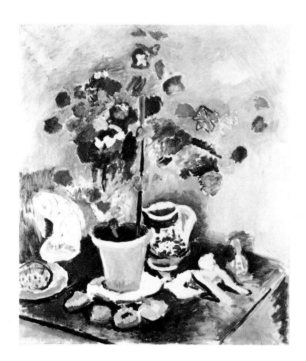

75 *Still Life with Geranium Plant and Fruit.*
1906.
Oil on canvas.
38 ½ × 31 ½".
The Art Institute of Chicago.
Joseph Winterbotham Collection

profile view of a face. The rock has been altered so that it both
supports the leg structurally and is made to fuse with the silhouette
of the back. The arms and raised leg of the youth are so pressed
together as to eliminate the spaces between them. The reversal of
the posture of the legs may have been influenced by the memory of
his drawing of the back of Lysippus' sculpture of *Hermes Adjusting
His Sandal.* Matisse's figure is of a young man like Hermes and not
the figure of a boy as in the original.

The possibilities sculpture afforded him as his painting changed in
the crucial years to 1906 are apparent in his statuette of a *Standing
Nude* (plates 79–80) and the paintings titled *Le Luxe I* and *II.* Matisse
may have posed this sculpture problem for himself: how can one
make an interesting sculpture of a perfectly immobile model who
stands erect with weight equally supported by the legs? All
conservative sculptors resorted to counterpoise by shifting more
weight to one leg, to activate the body's structure, and would not
have allowed the stomach to sag: this was the arrangement Matisse
used in figure paintings. The answer to the sculptural problem he
found in the variety and expressiveness of the sculpture's interior
modeling contrasted with the continuity of the silhouettes. Unlike
Rodin, Matisse, who wanted to envisage the general architecture of
his work from the start, did not build his figures by observing
successive profiles from *all* sides. Modeling was done within a few
observed contours, such as the front, back, and certain sides.
Matisse's painting style had arrived by 1906 at the new option of
simply silhouetting figures, their interior areas painted
monochromatically or undifferentiated with respect to modeling. Not
until the late twenties did he find a sculptural equivalent. Before that
time Matisse continued in sculpture to realize actual volumes and
enjoy their surface variety and responsiveness to light and its
accidents. Not by anecdote or action but by touch was the sculpture
brought to life—a dialogue of fingers and clay.

The 1906 painting *Still Life with Plaster Figure* [the *Standing
Nude*] demonstrates the commonalty of painting and sculpture in
terms of volumes animated by light (plate 81). The conjunction of
sculpture and fruit also recalls Cézanne's *Still Life with Cupid.* To
both paintings, sculpture gives scale and a dominant direction
against which the rest of the painting is adjusted. The fruit and
vessels in the Matisse evoke not only the artist's taste, and perhaps
his sexual associations with the motifs, but also his frequent
analogizing between their form and the human body in his art
classes two years later. The nonfrontal view of the sculpture accords
with Matisse's predilection for eccentric disposition or angular
confrontations of the field to be painted, a predilection shared with
Cézanne. This mode of seeing may help us to understand why many
of his sculptures are most effectively viewed midway between their
front and side.

What Matisse's figurines may lose in terms of the illusionistic
sensuousness of the subject, as seen in Marqueste's *Galatea* (plate 83),

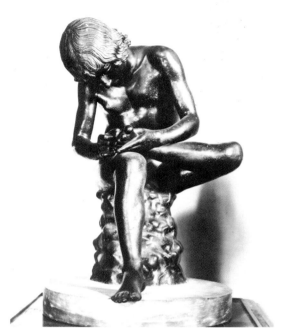

76 Roman. *The Spinario*.
c. second century B.C.
Bronze.
Palazzo dei Conservatori, Rome

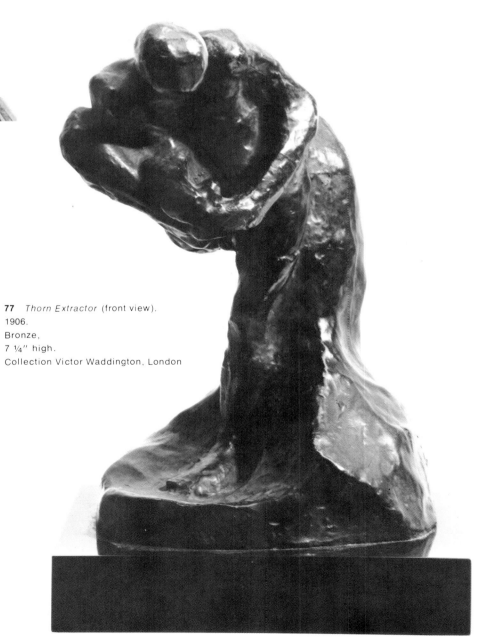

77 *Thorn Extractor* (front view).
1906.
Bronze,
7 ¼″ high.
Collection Victor Waddington, London

78 *Thorn Extractor* (back view)

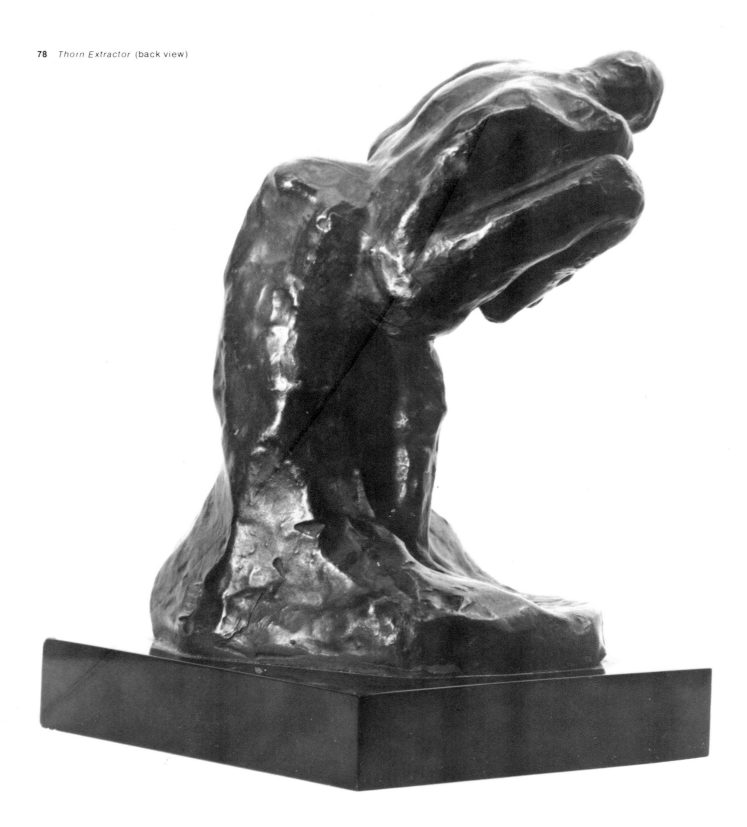

79 *Standing Nude* (front view).
1906.
Bronze,
19″ high.
Whereabouts unknown

80 *Standing Nude* (three-quarter left back view)

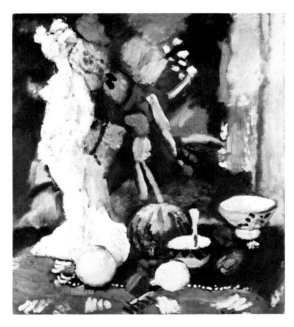

81 *Still Life with Plaster Figure.*
1906.
Oil on canvas,
21 ¼ × 17 ¾".
Yale University Art Gallery, New Haven.
Bequest of Mrs. Kate Lancaster Brewster

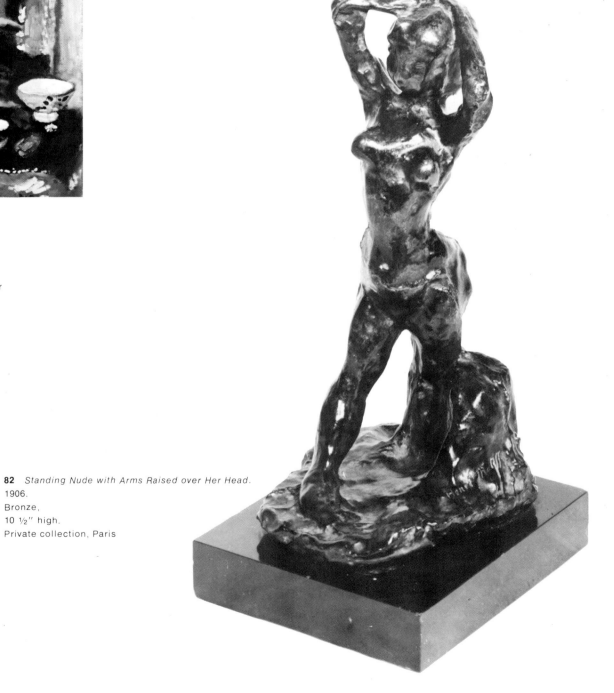

82 *Standing Nude with Arms Raised over Her Head.*
1906.
Bronze,
10 ½" high.
Private collection, Paris

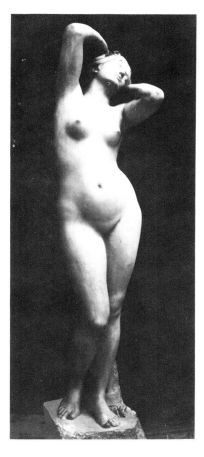

83 MARQUESTE. *Galatea*.
1898.
Marble.
Formerly Musée de Luxembourg, Paris

they gain in the sensuousness of the sculpture as an object.
They address themselves both to the hand and to the eye. In the
Standing Nude with Arms Raised over Her Head of 1906 (plate 82)
Matisse employed the classic standing beauty pose. Even more than
in his paintings, his modeled women acquire a coarseness or
animality because of their ruggedly sketched faces, enlarged
buttocks, short legs, and assertive breasts. If there is a comparable
treatment in painting, it is his *The Gypsy* of 1906 (plate 84). It was an
academic maxim to correct the physical deficiencies of the model.
Assuming Matisse's models were sometimes short of shank, he
made no concession to cosmetic perfection. It is more likely, in view
of his preference for beautiful models, that Matisse's own increasing
ruthlessness as an artist and his passionate feelings acted upon the
proportions as well as the shapes of the parts. Sculpture was not
simply an outlet for his artistic energies; it served his sexual feelings
in ways not possible through painting.

Fauve Sculpture

For those who feel compelled to corset art with labels, Matisse's
small feminine statuettes of 1901–9 are the strongest candidates for
a Fauve sculpture.[49] When we look at the Fauve figure paintings of
Kees van Dongen, Manguin, Marquet, Derain, Vlaminck, Puy, and
Rouault, it is apparent that these artists, in Matisse's terms, have
dispensed with "acquired means," and that they have returned to
what Robert Goldwater calls "a naked simplicity."[50]
Foreshortening, informality and angularity of pose, absence of
tasteful decorative accessories, and the blatant immediacy with
which the effects of the figure are propelled toward the viewer are
Fauve characteristics.

 The Fauvist assault on popular notions of the graceful is
exemplified in Matisse's first essays into the problems and
possibilities of the odalisque in sculpture. This motif had been
preceded by its appearance in such paintings as *Luxe Calme et
Volupté* of 1905 and possibly in the *Joie de Vivre*. In 1906, perhaps
working from the same model who had posed for *Woman Leaning on
Her Hands,* Matisse did violence to the tradition of studied
refinements in the odalisque in his *Reclining Figure with Chemise*
(plate 85).[51] The model's shift falls casually off her shoulder, and the
garment obscures the supporting arm. In keeping with his taste for
strenuous postures in passive situations, the model's left leg is
pulled across the right leg, thrusting the hip into severely prominent
relief, and her left elbow juts into space. As in his paintings of the
time with their somewhat additive figural disposition and tangential
coordination, each section of the body, divisible at its flexible joints,
is made clear, and only the chemise effects flow across some areas.
The equivalent of the divided touch in the *Luxe Calme et Volupté,*

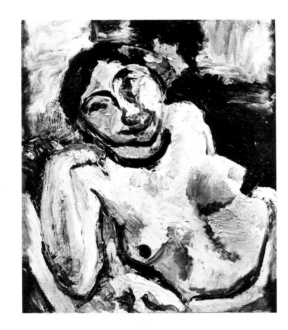

84 *The Gypsy.*
1906.
Oil on canvas,
21 ⅝ × 18 ⅛".
Musée de l'Annonciade, St. Tropez

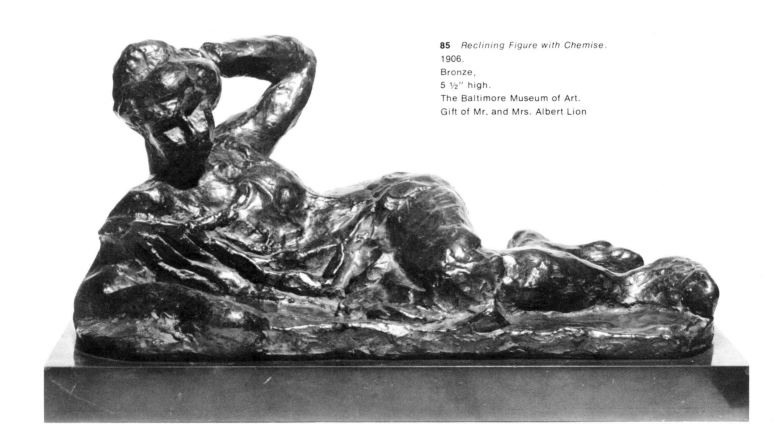

85 *Reclining Figure with Chemise.*
1906.
Bronze,
5 ½" high.
The Baltimore Museum of Art.
Gift of Mr. and Mrs. Albert Lion

71

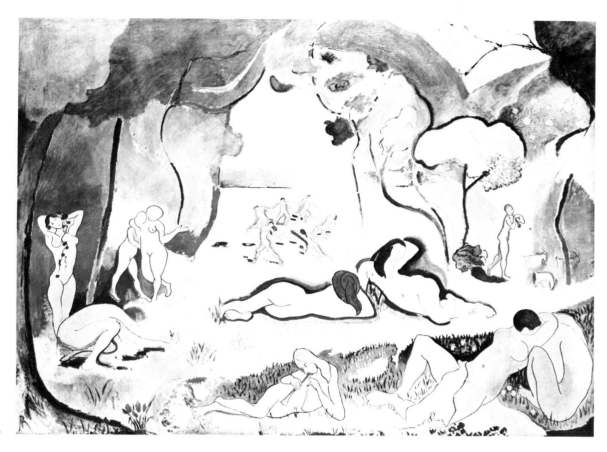

86 *Joie de Vivre.*
1905–6.
Oil on canvas, 68 ½ × 93 ¾″.
Copyright 1971 by The Barnes Foundation

which holds the work together overall, is the coarse modeling that plays counterpoint to the disjunctive silhouette.

In a drawing, perhaps later than the foregoing sculpture, Matisse studies the reclining model from a view above and slightly behind her. The perspective is very different from the head on, perhaps self-consciously primitive, viewpoints of the figures in the *Joie de Vivre* (plate 86). He is particularly concerned with areas of overlapping limbs, which in recollection of academic training receive vigorous accents to clarify where the silhouettes separate and to which limb they belong. The drawing itself is interesting because it is not done on a single sheet (plate 87): as Matisse extended the form, he added additional paper. Perhaps he had started with the idea of making a study of the legs only.

When Matisse returned from a trip to Morocco in 1907, he painted *The Blue Nude* (plate 88). While this painting may have incarnated his sensual souvenirs of the exotic visit, it was also inspired by the first, and subsequently lost, version of the *Reclining Nude* sculpture of 1907 (plates 89–91).[52] Judging from both the painting and sculpture, his memories also included those of odalisques in the *Joie de Vivre* and the *Reclining Figure with Chemise.* It was perhaps his experience with the irregular silhouettes of the sculptures that caused him to change his silhouettes from the mellifluous contours of the *Joie de Vivre* to more accented movement in *The Blue Nude.* At some point in either the first version of the sculpture or the painting, Matisse elevated the left elbow, creating more vertical

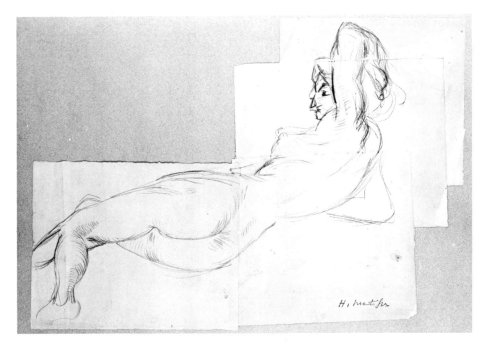

87 *Reclining Nude.*
1907 (?).
Pencil,
16 ¼ × 23″.
Musée Matisse, Nice-Cimiez

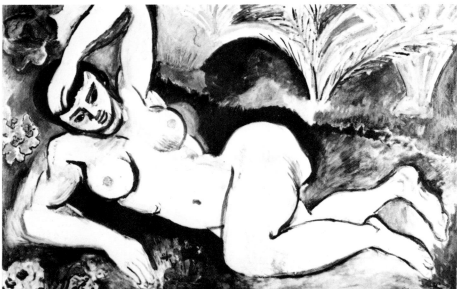

88 *The Blue Nude.*
1907.
Oil on canvas,
36 ¼ × 55 ⅛″.
The Baltimore Museum of Art.
Cone Collection

contrast with the extended body and a more interesting counterpart to the rounded hip. The shocking proportion of the figure to the field of the canvas may have caused cutting off the raised elbow, a type of Fauvist fragmentation. Matisse seemed less willing to undertake the foreshortening of a painted head than a sculpted one.

A comparison of Matisse's *Reclining Nude* with Albert Boucher's *Repose* (plate 92), which won the grand prize for sculpture in the Salon of 1900, shows the disparity of approach within the unity of their admiration for the odalisque. Boucher continues the nineteenth-century taste for period props as the physical and historical support for his model. Her svelte proportions and lithe coordination were indispensable to his sculpture from its inception. As with Ingres' classical treatment of the theme, Boucher carefully arranged the limbs so that there was a continuous graceful contour from head to toe, which avoided drawing attention to the subject's bone structure. Boucher's tact in averting the head and closing the eyes of the model allows us to inspect the woman's nudity without

89 *Reclining Nude I* (three-quarter front view)
1907.
Bronze,
13 7/8" high.
The Baltimore Museum of Art. Cone Collection

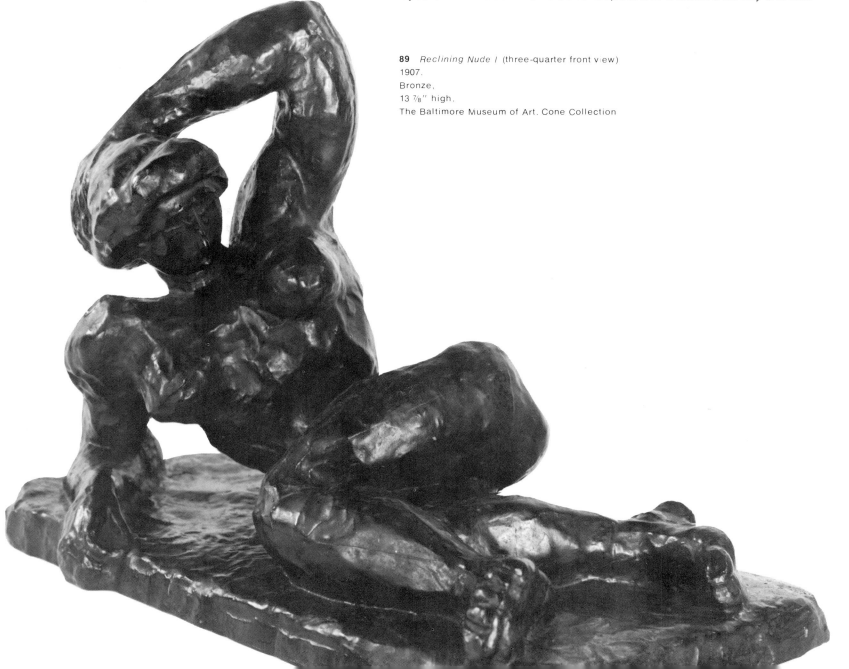

90 *Reclining Nude I* (three-quarter back view).
Collection Mr. and Mrs. Philip N. Lilienthal, Atherton, Calif.

uneasiness. Matisse set his model on a rough slab, gave her almost masculine proportions (the thickness of the upper torso is amazing), and made her seem all elbows, knees, and shoulders. Neither in the painting nor in the sculpture did Matisse opt for ingratiating finish. He was as subversive toward norms of correct modeling as he had been to drawing and painting. There was no compromise in his insistence upon the load and support functions of the limbs. A year after he made this sculpture he told his students, "The joints, like wrists, ankles, knees, and elbows must show that they can support the limbs—especially when the limbs are supporting the body. And in cases of poses resting upon a special limb, arm or leg, the joint is better when exaggerated than when underexpressed."[53] Similar sentiments were tacitly shared by Fauves in their figure paintings, such as those by Derain, and Vlaminck's *The Dancer from the Dead Rat*. The Fauve figure style was antagonistic to conventional taste, but presupposed an academic understanding of body structure and movement and the need for their manifestation to some degree.

Matisse thought in three dimensions as a sculptor. There are several prospects from which he directs us to view the *Reclining Nude* and to see how its particular proportions and foreshortenings are made to work visually. Matisse had Druet photograph the work not only from the front, but looking directly at the feet. A three-quarter frontal view shows most of the figure, but Matisse obviously considered his sculpture from the back and a three-quarter back view, for these views give us the essentials of the masses in relation to each other, which he sought. Always, as in his painting, one must view the part against the whole to gain the context that encouraged distortion. No other sculpture by him was so often repeated in his paintings, where it is usually seen in an interior as part of a still life.[54] In the 1917 *Music Lesson* (plate 96) it is seen in a garden, posed above a small waterfall. Depending upon its location, the compositional needs of the painting, and the mode in which the drawing was done, he altered the sculpture in different ways. In *Sculpture and Persian Vase* of 1908 (plate 93), he used a pot of flowers with a long curving spout as both a contrast and a complement to the shapes and curvature of the form. To avoid possible monotony of equal altitudes of objects in his *Goldfish* of 1909–10 (plate 94), he drastically elongated the raised arm. In the 1911 *Goldfish and Sculpture* (plate 95) at the Museum of Modern Art, New York, he poised the raised elbow just below a wall bracket to give added vertical continuity or an additional stabilizing axis for the composition. None of these changes caused him to rework the sculpture.

Why did Matisse so frequently put his sculpture into his paintings? Was it because of his training with Moreau, which introduced him to the practice of including sculptures in painting? His own plasters and bronzes populated his studio and home and were a natural part of the personal environment that dominated the paintings. Jacques Lassaigne suggests that "in several instances, he places in his

91 *Reclining Nude I* (view from feet)

92 BOUCHER. *Repose.*
1900.
Marble.
Formerly Musée de Luxembourg, Paris

compositions statuettes he has just finished; he seems to feel that, better than living models, they suggest rotundity and volume. It is as if he were seeking to integrate another dimension into the surface by means of artifacts which, having already been transposed from nature, had acquired a plasticity and substantiality of a superior order."[55]

In the paintings in which the *Reclining Nude* is to be found, Matisse employed objects having simple shapes, such as pots, vases, and fish bowls. Small sculpture gave a human presence within the scale of a still life. Through sculpture he had transposed the human form into an object that in itself had been reduced to elementary forms. Its components could be remade in painting so that they at once harmonized and contrasted with those of the vessels. The sculpture had given him a purified, yet interesting and memorable, arabesque. This reductive process appealed to Matisse's life view, which sought the durable and elemental in nature's forms and their hidden continuities. When he treats the goldfish, flowers, and reclining nude in the same painting, they have in common on one level the fact that they are three different orders of nature removed from their natural context. They are remade into art by the artist and installed, in order to serve his pleasure, in a common environment over which he has complete control. On another level he is able to show formal analogies between geometrical, floral, and human forms, such as he gave to his students in their critiques to strengthen their awareness of forms, and that he was later to employ in the making of *Tiaré* in 1930. Despite the absence of living models, family, or friends in the still life paintings, they are forceful expressions of the artist's humanity, best illustrated by his comment in 1947 in defense of artists who did not use the figure in art: "It is always when I am in direct accord with my sensations of nature that I feel I have the right to depart from

93 *Sculpture and Persian Vase.*
1908.
Oil on canvas, 23 ⅝ × 29″
Nasjonalgalleriet, Oslo

94 *Goldfish.*
1909–10.
Oil,
32 ¼ × 36 ¾″.
The Royal Museum of Fine Arts, Copenhagen.
J. Rump Collection

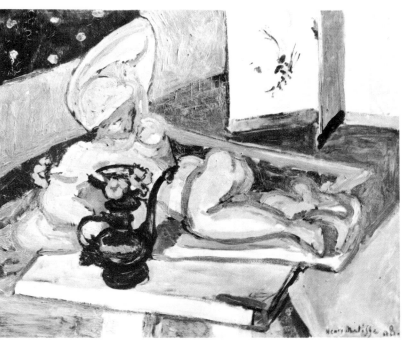

95 *Goldfish and Sculpture.*
1911.
Oil on canvas,
46 × 39 ⅝″.
The Museum of Modern Art, New York City.
Gift of Mr. and Mrs. John Hay Whitney

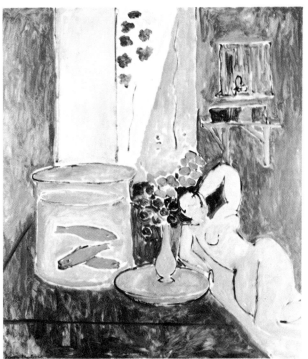

96 *Music Lesson.*
1917.
Oil,
96 × 82 ½".
Copyright 1971 by The Barnes Foundation

them, the better to render what I feel. . . . For me, nature is always present. As in love, all depends on what the artist unconsciously projects on everything he sees. It is the quality of that projection, rather than the presence of a living person, that gives an artist's vision its life."[56]

Matisse and Primitivism

The evolution and character of Matisse's sculpture depended upon his exposure to Western sculpture from classical antiquity to the salon artists of his day. It has often been suggested, however, that in at least a few sculptures made between 1905 and 1908, Matisse showed a susceptibility to African art in terms of postures, proportions, and "angular" modeling. We know that Matisse was interested in and collected African art as early as 1905 and shared his enthusiasm for it with Picasso as well as Derain. Some of his collection of African and South Pacific sculpture remained in his studio to the end of his life and can be seen today in the museum at Cimiez. There is only one sculpture to my knowledge that Matisse himself carved directly in wood. It is a rarely reproduced low relief of three naked dancers circling a log less than eighteen inches high (plates 97–99). Matisse, like the academicians, could countenance physical motion in relief sculpture. The alternation of three dancers seen from the back and the front coincides with Derain's painting *Dancers,* which was shown in the Salon des Indépendants of 1907,[57] but its ancestry within Matisse's art undoubtedly goes back to the rondel group in the *Joie de Vivre* he had shown in 1906. Thematically, both the painting and sculpture were primitive in their atavistic views of an ideal life. The motif of uninhibited exuberance displayed in the dance is related to what Robert Goldwater has written concerning the primitivism of the Fauves, who "attempt to grasp reality by means of a return to something fundamental in the human being, to do away with a developed superstructure, with, as Matisse has said, 'the acquired means,' in favor of something native and simple."[58]

Matisse's decision to try carving, if not influenced by what Picasso and Derain were doing in 1907, was coincident with their efforts. Whether or not Gauguin's reliefs encouraged this abortive essay in a new material with new means is not clear. Unlike Picasso and Derain, Matisse did not adapt a single figure to the circular block with which he was working, and in this regard, as well as in the dissimilarity of technique and lack of color, Matisse's work is unlike Gauguin's. His modeling and subtle perspectives and anatomical inflections direct his relief away from African art. Unlike the dancers of the *Joie de Vivre,* for the relief his subjects were heavyset and muscular, the bodies more sexual and movements more emphatic than their painted sisters'. The nuanced modeling of the wooden

97 *The Dance* (first view).
1907.
Wood,
17 ⅜'' high.
Musée Matisse, Nice-Cimiez

98 *The Dance* (second view)

99 *The Dance* (third view)

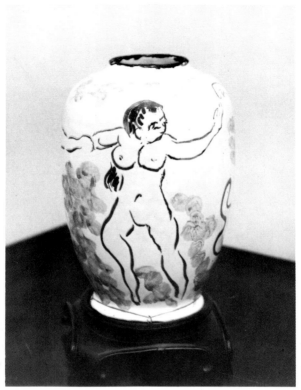

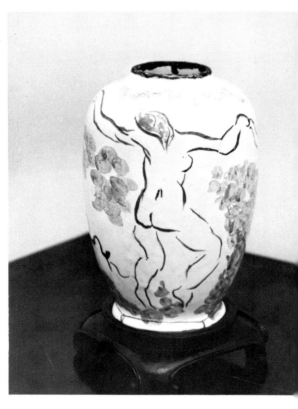

100 *Vase with Dancing Figures* (first view).
1907.
Ceramic,
9 ¼" high.
Collection Mr. and Mrs. Lionel Steinberg

101 *Vase with Dancing Figures* (second view)

102 *Vase with Dancing Figures* (third view)

bodies comes not from African carving but from his own prior fingering of clay. It is hard to believe that Matisse, who had lived in Paris, could have been unaware of the strong contrast between his interpretation of the dance (plates 100–102) and that of Carpeaux in front of the Paris Opera, the installation of which brought outraged protests that Paris had been given a drunken bacchanalia, an homage to primitive rather than classical terpsichore.

The different perspective views of the carved dancers included that of a woman's back, whose spine is accentuated by long hair. It is conceivable that his work on this figure remained in his consciousness until he modeled the large relief of the *Back,* and one of the dancers in the center of the Barnes murals in 1932. Her character and proportions were not inspired by the problems of carving wood, for in 1907 Matisse painted a ceramic tile called *Dancer* (plate 103) with the same figure type in an exaggerated Venusian pose. The heavyset legs of the ceramic figure also delighted Matisse in painting and his modeled sculptures. Both the relief and the ceramic helped Matisse visualize the dance as a formally self-sufficient theme, which was to be important for the large paintings he began two years later.

103 *Dancer.*
1907.
Ceramic,
15 ½ × 22 ⅞".
Musée Matisse, Nice-Cimiez

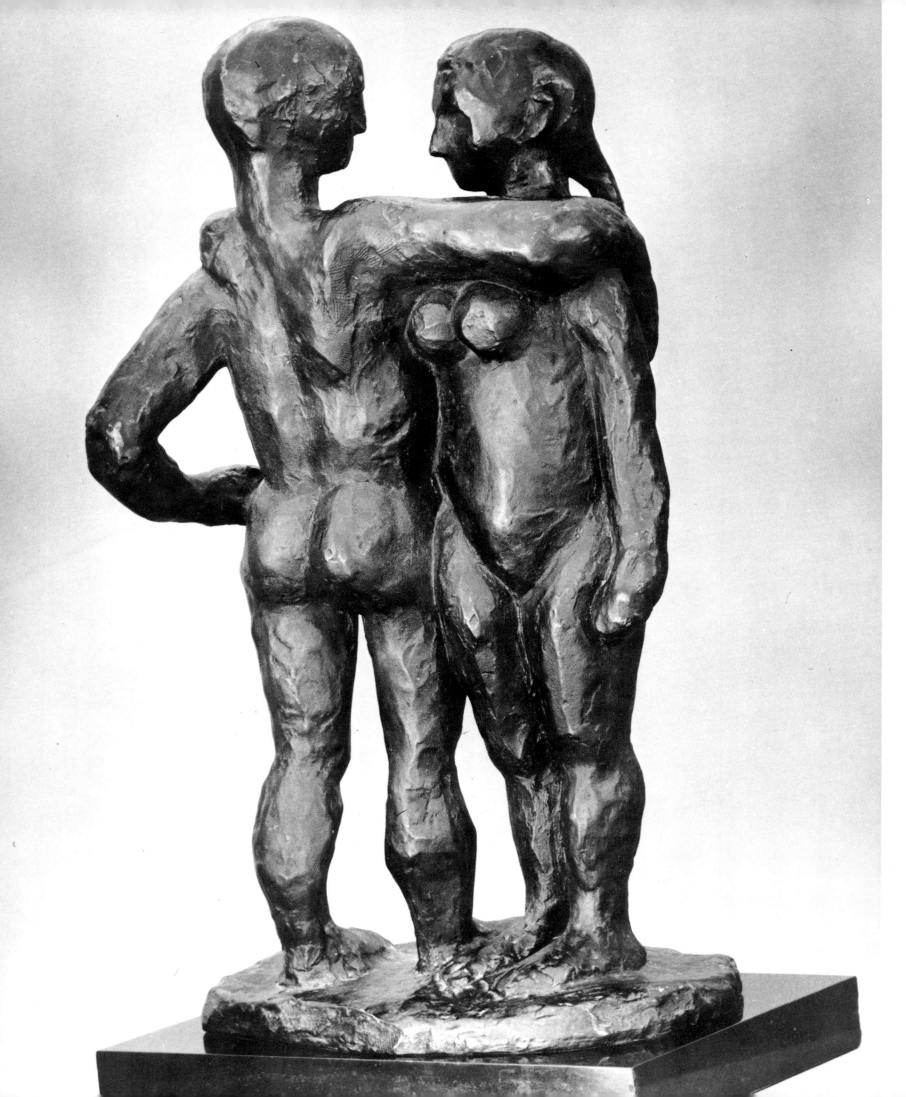

THE *TWO NEGRESSES*, 1908

The one sculpture by Matisse about which there is general agreement that there is Africanizing is that of *Two Negresses* (plates 104–5), first exhibited in the Salon d'Automne of 1908 as *A Group of Two Young Girls* and then as *Two Sisters*. Seen within the context of his previous sculptures and what we know of his teaching, it is possible to account for the erect postures, proportions, and modeling of his sculpture apart from direct primitive influence. Matisse's admiration of African sculpture was not indispensable, essential, or demonstrably influential in his actual sculpture. The title of the sculpture of the *Two Negresses* or *Two Sisters* is true to its source, a photograph from a French ethnographic periodical (plate 106) showing "Jeunes filles targui."[59] In the three instances where it is known that Matisse worked directly from a photograph, it is remarkable how faithful he remained to the poses of the models. In the sculpture of the *Two Negresses* of 1908 he has given more weight and generally thicker proportions to their bodies, and particularly the legs. He has closed the interval between the legs of the girl on the left and broadened that of her partner. Details of the hair, the spread fingers, the hands, and the faces were not carried out, as is consistent with Matisse's resistance to the prospect of the viewer fastening his attention on particulars. The modeled bodies seem more firmly locked together, more stable in stance, as if enacting an architectural or rectilinear coordinate system. His changes from the source were a personalized sort of academic rectification in order to exaggerate stability and achieve monumentality. What, however, caused him to select this particular photograph for a sculpture beyond the reasons listed above? Was it his interest in the primitive, and did these African girls seem related to the Arcadian world he had been recreating in painting? Was it because it offered a personal challenge to work from sources similar to those that had inspired African carvers whose work he admired?

It has been conjectured that the situation in which the models are posed, as well as the body proportions, may have been influenced by Picasso's 1906 painting of *Two Nudes* (plate 107).[60] It might still be argued that Matisse's choice of the photograph may have been similarly inspired. Picasso's women, who are one and the same, do not touch each other and are seen from the sides with mirror-like non-African gestures of self-address. There are, in fact, sufficient differences in the proportions of the two pairs of figures to remind us that there was no need for Matisse to imitate what Picasso had done, any more than he was inclined to imitate another artist's touch, whether that of Rodin, Bourdelle, or Daumier. Further, when the painting is matched with the sculpture, one might ask if it was not possible and more plausible, as Alfred Barr sensibly observed, that as a sculptor Matisse desired "to create a work in the round which will hold its interest from any point of view."[61]

The presence of two figures in one sculpture was unique for

104 *Two Negresses* (back view). 1908.
Bronze,
18 ½" high.
Joseph H. Hirshhorn Collection

84

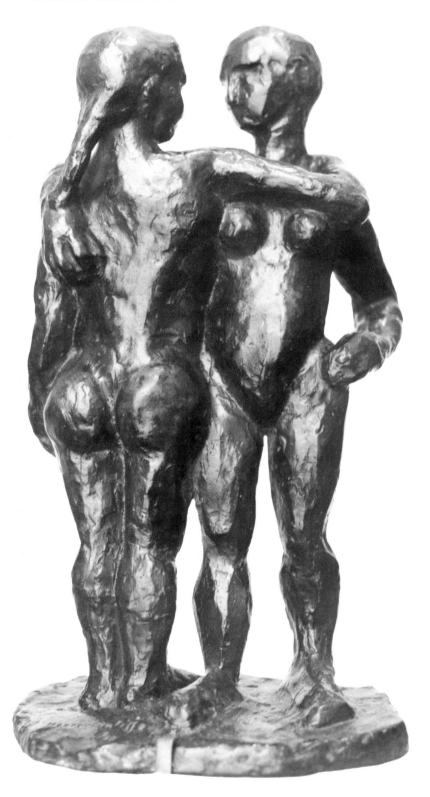

105 *Two Negresses* (front view).
The Baltimore Museum of Art. Cone Collection

106 Photograph taken from a magazine and used by
Matisse as the basis for *Two Negresses* in 1908

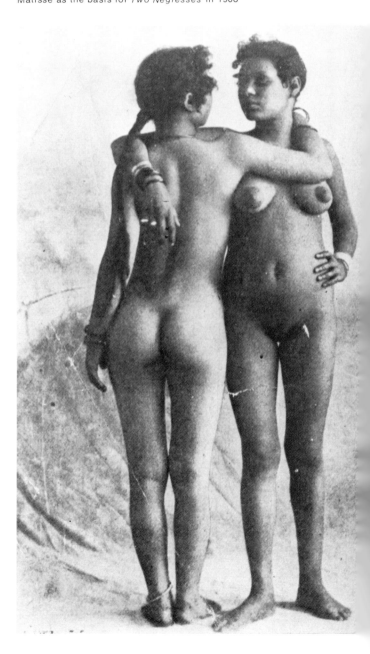

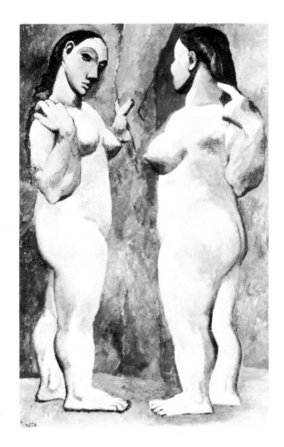

107 PICASSO. *Two Nudes*.
1906.
Oil on canvas,
59 ⅝ × 36 ⅝".
The Museum of Modern Art, New York City.
Gift of G. David Thompson

Matisse, but not the mirrored pose, as we know from the *Joie de Vivre*. In his paintings he had often worked on the problem that went back to the Three Graces of antiquity: uniting three or more nudes, aided not only by color but by the means of body movement, gestures, or postural variation. His preference for the absence of movement in sculpture, confirmed but not inspired by African sculpture, led him to favor two immobilized models. To his academically trained eye the pose of the embracing girls in the photograph was ideal for the reason Matisse praised Cézanne's figure compositions: "Limbs may cross, may mingle but still in the eyes of the beholder, they will remain attached to the right body."[62]

Comparable pairing of women in salon art produced nymphs entwining limbs, bodies swaying, with rapturous expressions and gestures. Rodin employed repetition of the same figure and all manner of acrobatics by which to bring together angels, lesbians, sirens, and cancan dancers, who had separate origins prior to their assemblage, and Matisse may have rejected the ambiguity of ownership of their entangled limbs. African Dogon ancestor couples, sometimes suggested as an influence on the *Two Negresses,* are often shown *seated* and facing in the same direction, and sometimes an arm of one is placed around the shoulders of the other, but they offered no model for imitation.

The sculpture itself seems to tell us what Matisse sought to show: the harmony and analogies of shapes possible in the simultaneous confrontation of the front and back of two similarly proportioned women. The embracing gestures locked and squared off the

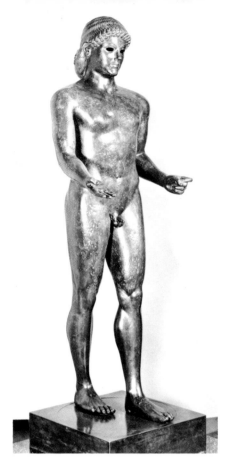

108 Greek. *Apollo Piombino.*
500 B.C.
Bronze,
3′ 9¼″ high.
The Louvre, Paris

composition and added to the horizontal rhythms set up by the alignment of the feet, knee joints, buttocks and pelvis, and the breasts. What undoubtedly attracted Matisse to African art was that he thought he understood the ways by which this sculpture was made, ways which were sympathetic with his own views. He wrote, "All plastic writing, the hieratic Egyptians, the refined Greeks, the voluptuous Cambodians, the productions of the ancient Persians, the statuettes of the African Negroes proportioned according to the passions they inspired, can interest an artist and aid in the development of his personality."[63] Before we settle upon sensuality inspired by African art as the source for the altered proportions of the *Two Negresses,* consider other views expressed by Matisse, many in 1908: "The antique, above all, will help you to realize the fullness of form. . . . The simplification of form to its fundamental geometrical shapes as interpreted by Seurat [when he was a student in the 1890s] was the great innovation of that day. . . . You may consider this Negro model as a cathedral, built up of parts which form a solid, noble, towering construction. . . . A human body is an architecture of forms fitting together and supporting one another, comparable to an edifice of which all the different parts play their role in the whole. If one of the elements is not in its place everything crumbles. . . . Be sure your figure can stand upright and use a plumb line. . . . It is very necessary for you to remember that [your model] is a Negro and not lose . . . yourself in your construction. . . ."[64]

In his admiration for African sculpture Matisse once compared a mask to porphyry heads in the Louvre, and Sarah Stein's notes suggest that he once showed his class a "Negro statue" to illustrate proportions and support. But the *Apollo Piombino* presided over his classroom, not an Ivory Coast figure (plate 108). Matisse's ideas on explicitness of construction derived from European art. His admiration for Cézanne and Seurat precedes in time his discovery of African art, and the use of Negro models seems to have far more bearing on his sculpture than West African figurines. We do not find comparable mutuality in African adult figures, and the larger feet of his women, which fuse with the base, relate to his ideas on revelation of support and exaggeration in accordance with the character of the model. The angular modeling or faceting in the *Two Negresses* is not uniform and commingles with unedited modeled surfaces.[65] Faceting, as seen in *The Serf,* was not an affectation of African carving any more than it was for Renoir in his sculpture.

In terms of his own sculptures, Matisse may have viewed African art not as a source for imitation or inspiration, but rather as a confirmation of personal views regarding figural construction and passionate proportion. "See from the first your proportions, and do not lose them. But proportions according to correct measurement are after all but very little unless confirmed by feeling and expressive of the particular physical character of the model. . . ." Robert Goldwater makes a good case for Matisse's taste for "immediacy of effect" being African-influenced, but early classical Greek

sculpture, such as the *Apollo Piombino,* as well as the art of Gauguin, the Nabis, Maillol, and many other Western sources, were experienced earlier by Matisse and were probably more compelling as models for these characteristics.

Before it was known that Matisse had worked from a photograph, Meyer Schapiro recognized the nonprimitive character of his sculpture:

The archaic appearance of his later sculptures is the consequence of an imposed structure and strong plastic accents. But Matisse has not committed himself to the reproduction of an archaic or naive style. His simpler sculptures retain the complexity of modern vision in their surfaces and often in their spatial composition. In the Two Women . . . each figure appears to be a rigid frontal object, clumsily attached to the other. But despite the individual frontality, we are far from archaic art; the whole of 19th century sculpture is presupposed in this work. For although the profile heads are confronted, the two bodies are turned in opposite directions, one towards the spectator, the other away from him, so that the whole cannot be assimilated to a relief conception, but to a composition of two adjacent and interlocked buildings, turned in opposite directions in depth. By the contrast of the dissimilar articulation of the two facades—one a back, the other a front—the group acquires a remarkable plastic intensity, which is sustained throughout the figures by the vivifying, minute contrasts of an irregular surface.[66]

The *Decorative Figure,* 1908

The voluptuous instincts of Matisse manifest themselves strongly in the great *Decorative Figure* of 1908 (plates 109–10). There is no coy evasion of the viewer by averting the model's gaze: like Manet's *Olympia*, the woman confidently displays her body for inspection. The swollen fullness of her buttocks takes on an arrogance. Her sensuousness comes from the serpentine pose and promising proportions. The box on which she sits recalls the studio; the prudent gesture of the left hand echoes that of a hundred paintings and statues of Venus. From antiquity to the present time, who can count the number of seated women in sculpture? But how many were shown naked, in the round, with their legs crossed at the knees? According to custom, Albert Jouanneault's *Cleopatra* (plate 111) shown in the Salon of 1909 crosses her legs at the ankles. In the early 1870s Dalou modeled a naked young girl, seated in a chair, legs crossed and still wearing shoes (plate 112), but this was a study for the clothed final version of *The Reader*. In 1907 Matisse had used the pose in his painting *The Hairdresser*.

Gérôme's *Tenagra* was a Salon sensation of the early 1890s (plate 113) when Matisse was a student and went to the old Luxembourg

88

109 *Decorative Figure* (front view).
1908.
Bronze.
28 ³⁄₈ × 19 ⁷⁄₈ × 11 ⁷⁄₈".
Joseph H. Hirshhorn Collection

110 *Decorative Figure* (back view).
City Art Museum of St. Louis.
Gift of Mr. and Mrs. Richard K. Weil

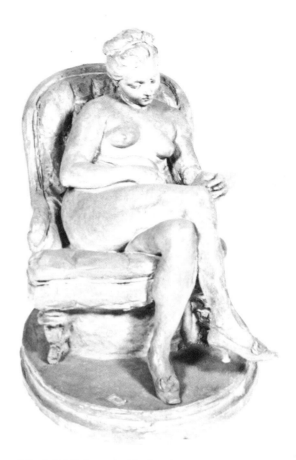

112 DALOU. *Study for The Reader*.
1878.
Terra cotta,
13 ¾ × 13 ¾ × 9 ½".
Musée du Petit Palais, Paris

111 JOUANNEAULT. *Cleopatra*.
Marble.
Whereabouts unknown

113 GÉRÔME. *Tenagra*.
1890.
Marble, tinted flesh tone.
Formerly Musée de Luxembourg, Paris

Museum. The figure sits erect, staring straight ahead, with knees firmly together, like the draped or half-nude Tenagra Aphrodites in the Louvre. All were to see that Gérôme had surpassed Hellenistic artists in his mastery of the body. To augment the fleshiness of his marble, Gérôme had tinted it, a daring act at the time. Matisse harbored no Pygmalion dream and until the *Tiaré* of 1930 would not think of employing a *practicien,* who cut marble, to be a surrogate for his hand. He honored the example of ancient artists in reinterpreting classical postures and by respecting the comprehensive meaning of certain gestures, but he fulfilled his own ethical self-demands by evolving a personal equivalent for the external appearance of the body which compromised its identity as flesh. Perhaps even more than in his great painting of *Carmelina* (plate 114), five years earlier, Matisse brought to the *Decorative Figure* a celebration of qualities rather than measurements, of re-creation rather than reproduction, while still convincing us of the articulation, firmness, and strength of the body's internal armature. Unlike Gérôme, he gave us also a woman of strong personality. Gérôme could challenge criticism of his craftsmanship with proof from his calipers. Matisse modeled for those who recognized aesthetic intuition and feeling as the arbiters of proportion and contour.

114 *Carmelina*.
1903.
Oil on canvas,
32 × 23 ½".
Museum of Fine Arts, Boston.
Tompkins Collection. Arthur Gordon
Tompkins Residuary Fund.

115 *Piano Lesson.*
1916.
Oil on canvas,
8′ ½″ × 6′ 11 ¾″.
The Museum of Modern Art, New York City.
Mrs. Simon Guggenheim Fund

The *Decorative Figure* presents a strong argument for Matisse's best sculptures successfully rivaling many of his best paintings. The figure of *Carmelina* is beautifully fitted into the painting's composition like the keystone into an arch. Just as admirable is the composition and the psychological and physical self-sufficiency of the *Decorative Figure*. Sophisticated foreshortening of the legs allows both feet to touch the ground, eliminating a potentially troublesome space that would exist below the left foot if it had been kept in the air and securely anchoring the composition. Viewed from the back, however, the foreshortening makes the legs proportionately very small in relation to the torso. Some of the woman's spirit comes from the erectness of her posture, and her formal composure depends upon the parallel axes of the head and crossed left leg. The right arm acts like a cathedral buttress, and the artist played against the potentially stable shape of the box by situating the woman to one side of it. Speaking in academic terms, it places the void made by the right arm above a solid form. So strong are the contours from front and back that the sculpture's relocation in such paintings as the *Piano Lesson* (plate 115) does not improve, but rather diminishes its power.[67] More than the *Carmelina*, the *Decorative Figure* reveals Matisse's gift of imparting spirit to his women.

The *Serpentine,* 1909

Matisse's dream of a passive voluptuousness in his women and feeling-inspired self-expression based on a conservative foundation led to the *Serpentine* (plates 116, 118), a postural sister of the *Decorative Figure*. Its more mundane beginnings came during the summer of 1909 at Collioure, where for lack of a model he again turned to a photographic source, such as École des Beaux-Arts students would supply themselves with (plate 117). Professional models were photographed in art school postures, themselves often paraphrases of ancient sculptures. Matisse's use of a photograph showing a model in an *académie* pose based on ancient sculpture was first pointed out as the basis of the *Serpentine,* though not illustrated, by Alfred Barr, and more recently by the English sculptor William Tucker, who wrote:

The model in the original is a solid, even portly, young woman, depicted fully frontally leaning with her left elbow on a pillar, and her left leg crossed over her right. The transformation in the sculpture is amazing; from the stodgy and unconvincing posture of the original Matisse has constructed a new human anatomy, a body made of line—in the sense both of a drawn line and of rope—rather than of implied flesh and bone. In order to preserve a uniform emphasis throughout the figure the proportions of the original are reversed.

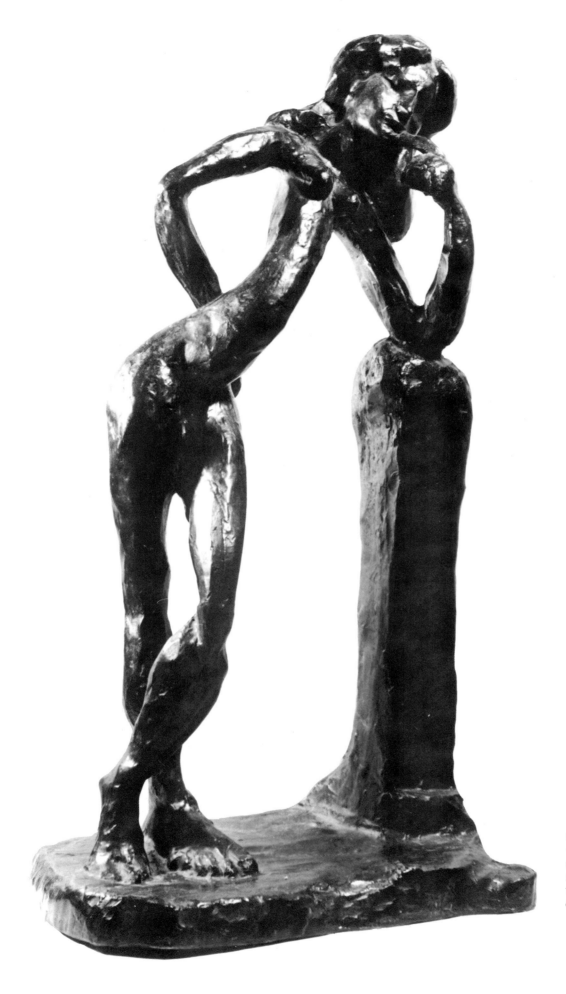

116 *Serpentine* (front view).
1909.
Bronze,
22 ¼" high.
The Baltimore Museum of Art.
Gift of a Group of Friends of the Museum

. . . There seems to be a kind of reverse perspective operating from the tiny waist up to the large neck and normally proportioned head, and downwards to the huge calves and huger feet, and inside the arms. The implied "sculptural" quality of the original lies in its massive bulk: in the sculpture this has been transformed into the articulation of space by the marvelously taut and sure three-dimensional "S" of the sculpture's axis.[68]

Possibly because of his art school background Matisse did not find the posture "stodgy and unconvincing," retaining in the final sculpture even the coy finger in the mouth.

Tucker also argues that "the kinds of distortion that Matisse evolved in painting, the unrolling and stretching of figure volumes up to the picture plane, the use of foreshortening and changes in proportion derived from perspective, were fed back into the sculpture." But we have seen in the *Reclining Nude* and *Decorative Figure* foreshortenings without parallel in his paintings, due perhaps to the multiple perspectives afforded by sculpture. Tucker also believes that the sculptural vocabulary Matisse created "could have been arrived at by no other means." This may well be true, but what Matisse had accomplished in painting before the *Serpentine* was not so drastic in reproportioning, nor did his pictorially evolved devices suggest themselves immediately as he worked. Edward Steichen's great photograph taken in 1909 (plate 119), while Matisse was still at work on the *Serpentine,* shows that originally he had probably been close to the model's proportions if not totally true to them, and that as with his paintings, such as *The Dance,* this sculpture went through various states. With the *Serpentine,* unlike the paintings, these states were all carried out on the single sculpture.

Some of Matisse's most daringly proportioned and foreshortened figures resulted unintentionally when he did some contour drawings in 1908 (plate 120), presumably without taking his eyes from the model to look at the paper on which he was drawing. It is possible that he saw Rodin's drawings done in the same manner. Matisse kept some of these drawings all of his life; they went to the Cimiez museum after his death. Perhaps looking at the early drawings with their distortions of proportions, Matisse may have felt that if the contours were true to his feeling and still gave the sense of the body, they were right. The distortions of the drawings did not provide Matisse with a system but with a new insight into what was possible in art.

It is in the design of the spatial intervals made by the body, the arms, and the support that there may be a discernible influence from the first version of *The Dance,* done before the making of the *Serpentine.* Having said this, it should follow that Matisse wanted his figure to be seen directly either from the front or back, as if it were like his paintings, with the figure being referable to an implied picture plane. But such a supposition runs against Matisse's own words, which also tell us of the particular sculptural problem that

117 Photograph of a model used by Matisse in 1909 at Collioure for the *Serpentine*

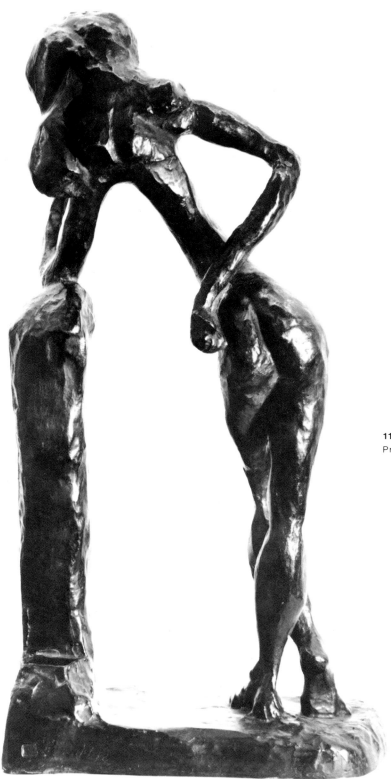

118 *Serpentine* (back view).
Private collection, Paris

119 Matisse modeling the *Serpentine*.
1909

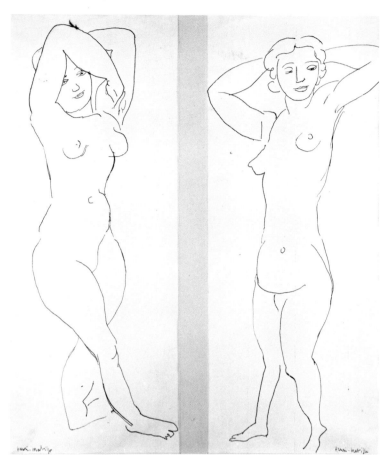

120 *Standing Nudes*.
1908.
India ink, 25 ½ × 9 ¾".
Musée Matisse, Nice-Cimiez

this work had opened up to him. In effect, the artist set himself this challenge: how does one make the model's movement intelligible from any side? His answer: "I thinned and composed the forms so that the movement would be completely comprehensible from all points of view."[69] Neither in the *Serpentine* nor the works before and after it did Matisse lose sight of the differences in possibilities offered to him by sculpture as opposed to painting, nor did he look upon sculpture only as the occasion to try out ideas begun in painting or drawing.

In the *Serpentine* what remains of Matisse's conservative training besides the preservation of the pose is the stabilizing function of paired vertical accents of the weight-supporting leg and arm. The arm is continuous with the post below, especially when seen from the back, and is comparable in structural function or design to the *Decorative Figure* and the 1925 *Large Seated Nude*. The prolongation by the arm of the vertical post has its parallels in paintings, where a figure and a vertical element of the architecture of a room create a common axis. Moreau's injunction to his students to be self-expressive was followed by Matisse in the radical distillation of the figure. Some thirty years later Matisse was to voice the basis for his seeming recklessness in changing his work: "It is always when I am in direct accord with my own sensations of nature that I

feel I have the right to depart from them, the better to render what I feel."[70]

It has also been suggested that Matisse might have been influenced in the reworking of the model's proportions by Bourdelle's earlier figure titled *Fruit* (plate 121). One writer tells us flatly that Bourdelle was "as drastic in his manipulation of proportions as Matisse."[71] Neither in the arms, torso, nor thighs is *Fruit* as contracted in proportion as the *Serpentine*. Bourdelle was frankly modernizing an ancient idea, seen in the Greek sculpture of *Flora* in the Louvre, without the involvement in abstract problems that interested Matisse. Making explicit the strength of construction in the *Serpentine* was essential to Matisse, and while he may have shared this view with Bourdelle, the latter did not make this as apparent in *Fruit*. Matisse was not carried away with abstracting from the figure, and personal ideas of accuracy and plausibility finally arrested the knife as much as intelligibility of contours.

Before 1915 Matisse was to see how Archipenko, Boccioni, Lipchitz, and Brancusi were to solve the problem he, too, had posed, by literally opening up the figure's mass. This solution was impossible for Matisse to emulate because of strong fidelity to anatomy and the figural convention of closed columns. He could never bring himself to substitute concave for convex surfaces, as did Archipenko. Commitment to anatomical credibility and tradition on his own terms separated Matisse from the revolutionaries and explains why he reworked the theme of the birth of Venus more than twenty years after the *Serpentine*.

Matisse, Degas, and Maillol, and *Seated Nude (Olga)*, 1910

Unlike Degas, both Matisse and Maillol had a relatively simple, basic repertory of quiet postures for their models: standing, sitting, and reclining. Matisse's women do not strike us as being engaged in purely hygienic functions of the toilette, or performing as strenuously as Degas' modeled bathers. Degas scorned the decorous pose and would show a model toweling her neck in a foreshortened view so that the top of her head thrusts in our direction (plate 122). Degas was more complete and radical than Matisse in departing from postural conventions such as the beauty pose because of his compulsion to study what he felt was the truth of the body's movements: movements that had become habitual and were acquired outside of art. Even if Matisse had access to Degas' private sculpture studio before 1910, for which there is no evidence, their differences in touch and temperament and contrary ideas about movement in sculpture rule out questions of influence. Today Degas seems closer to Maillol only in the pursuit of firm, clear volumes. He is closer to Matisse in the search for the beauty of the arabesque,

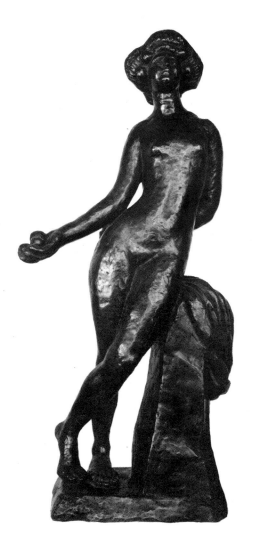

121 BOURDELLE. *Fruit*.
1906.
Bronze,
23 ⅝" high.
Collection Rhodia Dufet-Bourdelle, Paris

such as that given by his dancers, who pivoted in space while maintaining a clear line of balance.

Matisse knew and was friendly with Maillol and in fact helped him with the casting of the enlarged *Méditerranée* in 1905. He resented the rumor that Maillol had led him to sculpture, and Matisse pointed out that he had begun modeling before the two met in 1904: "Maillol's sculpture and my work in that line have nothing in common. We never speak on the subject. For we couldn't understand one another. Maillol, like the ancient masters, proceeded by volume; I am concerned with arabesque like the renaissance artists. Maillol did not like risks and I was drawn to them. He did not like adventure."[72]

A comparison of Matisse's *Seated Nude (Olga)* (plates 123, 130) and Maillol's *Méditerranée* of 1905 (plate 124) indicates a common aim of "purity, serenity and balance," but how inadequate are these words to differentiate the two men. Maillol dreamed of sculptural surfaces that would be like sunlight falling on whitewashed walls, which led him, as James Rosati puts it, to divest forms of texture and reject evidence of the "fingering and thumbing" of modeling.[73] To Matisse, the attainment of Maillol's generalized, placid volumes would have been at the cost of expressiveness and would have produced a series of emotionally neutral silhouettes. The *Méditerranée* has fewer surprises than Matisse's form and is more predictable from successive views and in terms of the intervals

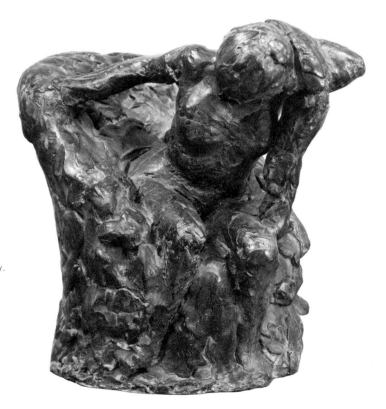

122 DEGAS. *Woman Seated in an Armchair Wiping Her Neck.*
Cast done in 1920.
Bronze statuette,
12 ½" high.
The Metropolitan Museum of Art, New York City.
Bequest of Mrs. H. O. Havemeyer, 1929.
The H. O. Havemeyer Collection

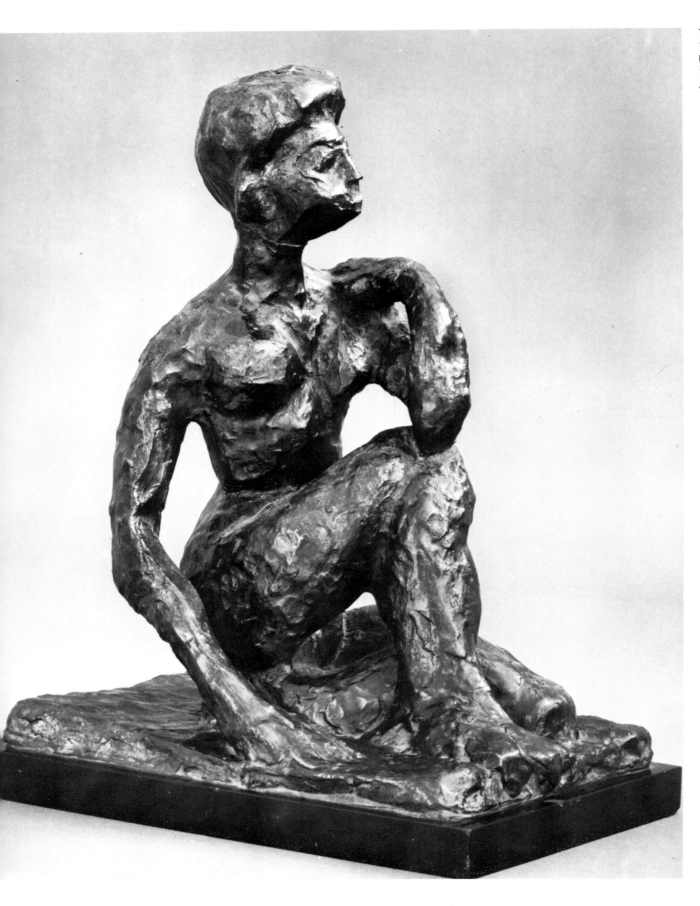

123 *Seated Nude (Olga).*
1910.
Bronze,
16 ½″ high.
Joseph H. Hirshhorn Collection

99

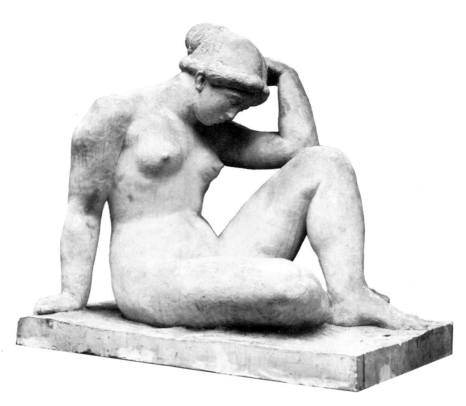

124 MAILLOL. *Mediterranée*.
1905.
Plaster.
Whereabouts unknown

between the limbs, body, and base. *Olga* has contours made complex and vigorous, both by posture, in its dramatic twisting of the spine, and in the ungeneralized contours, which occurred because the sculptor was unwilling to strike an average curve to insure the untroubled swell of a thigh's volume.

The evolution of Matisse's *Seated Nude (Olga)* involved the taking of risks he had referred to. On the basis of its posture it began not as a study from Olga Merson, but from a photograph of an anonymous model worked with at Collioure in the summer of 1908. The essentials of the model's form and pose are there, with the rectification of the position of her right arm, which Matisse felt was too far out from the body. That same year he reworked his sculpture of the *Small Crouching Nude with Arms* (plate 125), this time cutting off the right arm and removing the modeled base, but keeping the enlarged proportions of the legs and feet and the pose with its crossover gesture made by resting the left elbow on the right knee (plates 127–28). Then, perhaps feeling too committed to the photograph (plate 126) or inspired by a different reaction, he impulsively reworked the entire figure, getting more twist in the torso and opening up the pose by lifting the head erect. There are passages of modeling roughed out by the simple expedient of pinching the rolled clay forms used as arms (plate 129). In 1910, perhaps while doing the painted portrait of *Olga Merson* (plate 131), he remembered these sculptures and decided to draw from them for a second portrait. The painting is of a primly posed figure in a shape-concealing dress; the sculpture shows the subject nude and in a more energetic pose. Her whole character has changed, as did

100

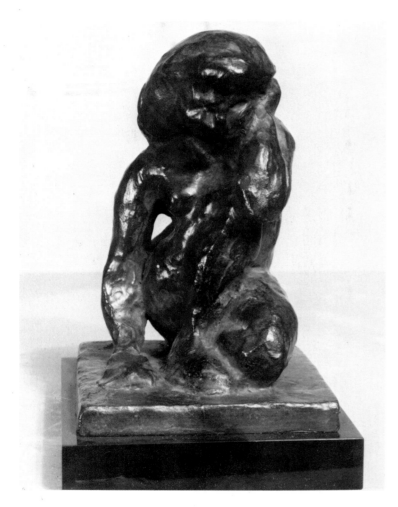

125 *Small Crouching Nude with Arms.*
1908.
Bronze,
5 ¾″ high.
Private collection, Paris

126 A model used by Matisse in 1908 for his
Small Crouching Nude with Arms

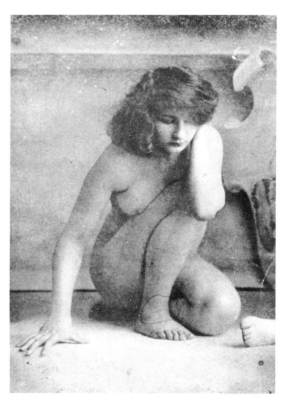

127 *Small Crouching Nude (Without an Arm).*
1908.
Bronze,
5″ high.
The Baltimore Museum of Art. Cone Collection

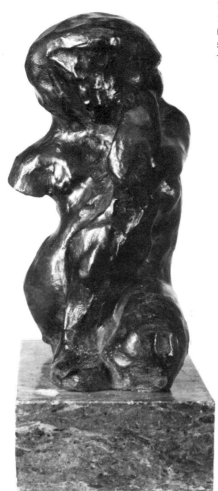

128 *Small Crouching Nude.*
1908.
Bronze or terra cotta,
5″ high.
Whereabouts unknown

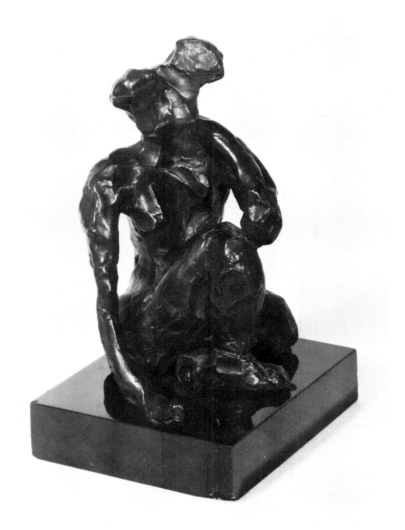

129 *Crouching Nude.*
1908.
Bronze,
7 ½″ high.
Private collection, Paris

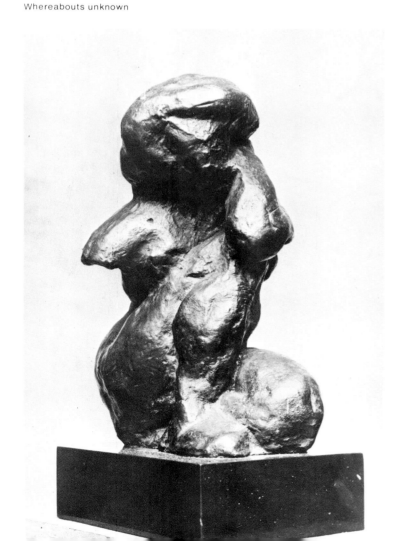

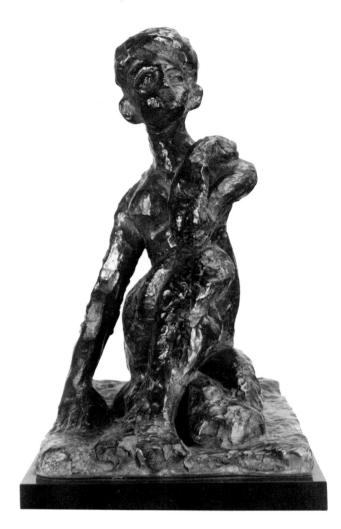

130 *Seated Nude (Olga)*.
1910.
Bronze,
16 ½″ high.
Private collection, Paris

131 *Olga Merson*.
1910.
Oil on canvas,
39 ⅜ × 31 ⅞″.
Collection Mrs. Bernard J. Reis, New York City

that of Jeanne Vaderin in the portraits of that time. Matisse's own intention to rework the painting at some future time is shown in the two big lines he painted across the figure, changing the axis of her posture. In the sculpture, she is given greater sophistication, alertness, and vitality, qualities unforeseeable in the portrait and alien to the phlegmatic type and the ideal of equanimity of Maillol's women.

For reasons of taste and perhaps because of technical difficulty with anatomy, Maillol avoided complicating the poses of his models. Matisse probably found the distinct separation of the woman's left and right sides into open and closed combinations uninteresting compositionally, and he easily handled the anatomical consequences of crossing Olga's left elbow to her right knee. What brings the two artists closer together is comparison of their sculptures with appropriate examples of salon and museum art, such as Delaplanche's *Eve Before the Fall* (plate 132). (A small Maillol study of about 1902 seems like a deliberate rephrasing of Eve's pose.) While Maillol and Matisse may have felt the by-play between Eve and the serpent was trivial or too literary, both continued the general postural type used by Delaplanche, with the stipulation that the woman's right arm play a more important structural role by bracing the figure against the base.

Unlike Matisse, Maillol chose models to fit his style, and even his preliminary studies for large works show a characteristic generosity

of proportion. Matisse could adjust his way of working to different women, and part of his risk-taking, seen in *Olga*, was in unexpectedly arresting the stage of the model's reformation when her arms were still ropelike, her proportions seemingly too meager at the shoulder or swollen in the enormous calves. It was at this point that the form was adequate to his sensations. A proportion was no longer measured against the model, but rather the rest of the sculpture itself and the overall effect. In 1939, Matisse commented on his drawings and paintings in a way which makes us think of sculptures like *Olga:* "Their forms are not always perfect, but they are always expressive. The emotive interest they inspire in me is not especially visible in the representation of their bodies, but often in the lines, or the specific volumes that . . . form its orchestration, its architecture It is perhaps sublimated voluptuousness, that which is perhaps not perceived by everyone."[74]

The Dance, 1911

A statement such as this last can influence our seeing and understanding of the sculpture known as *The Dance* of 1911 (plate 133), which was the last free-standing figure sculpture Matisse was to make before 1918. In terms of its pose, with the weight carried solidly on a straightened right leg which is tilted slightly forward, the title seems incongruous, and the stance suggests a variant on the beauty pose so often used by the artist. The counterpart to this sculpture is not in the big paintings of *The Dance* nor in their sketches on paper, but rather the painted ceramic *Dancer* of 1907. Having finished his commissions for this theme and perhaps tired of its enactment in painting, Matisse may still have felt the need to extend once more his ideas into sculpture. The figural distortions he had created in the big pictures could have enforced the peremptory treatment of the limbs, but it should be remembered that for his sculpture students Matisse had employed the analogy, "Arms are like rolls of clay." Rudimentary as they are, the legs show the swinging action of the hip and the flexing of the knees, and the proportions of the knees are still sufficient to house the joints. The figure at first creates a deceptive impression of the artist having capitulated to impulse and technical insouciance. He has countered the impression of complete malleability or bonelessness by the vertical slicing of the inside of the right leg, giving the necessary contrast and stiffening to make the figure carry; and the central line around which the body's self-balance is conceived is clear and strong. The provocative exaggeration of the legs suggests his delight and fascination with the potential pliability of the body's solid form when transposed into clay. Matisse's own work with the partial figure may have been more influential for the distortions in this sculpture than the paintings of 1910 and 1911.

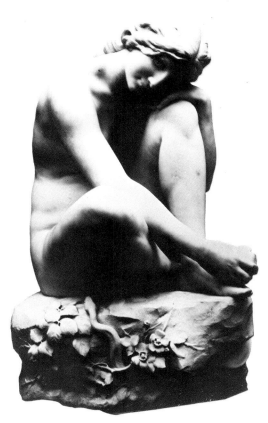

132 DELAPLANCHE. *Eve Before the Fall.*
1870.
Marble.
Formerly Musée de Luxembourg, Paris

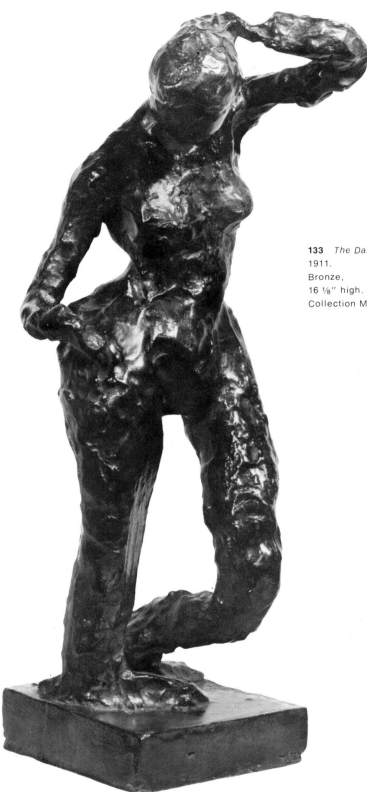

133 *The Dance*.
1911.
Bronze,
16 ⅛" high.
Collection Mr. and Mrs. Nathan R. Cummings, New York City

134 *Girl with the Green Eyes*.
1908.
Oil on canvas,
26 × 20".
San Francisco Museum of Art. Harriet Lane Levy Bequest

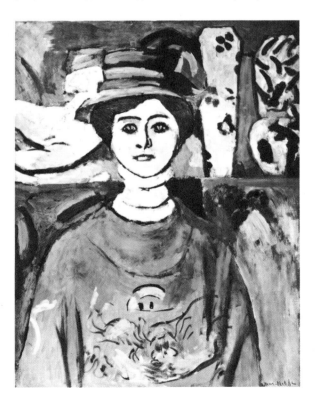

The Partial Figure, 1900–1910

As an artist with academic training who loved ancient sculptures in the museums, who resisted gesture as a basis for expression, and who had liberal notions of what was essential to finished sculpture and painting, Matisse was, not surprisingly, involved in the partial figure from the beginning of his art. At the Académie Julian and the studio of Gustave Moreau he had made drawings from plaster casts of broken ancient statuary. The charcoal drawing made in 1892 of the Capitoline *Niobid* was part of his traditional training, but it was done with the understanding that this was an exercise and not the model for finished paintings or sculptures. In 1908 he included as the central motif in his *Still Life with a Greek Torso* the plaster cast of the fragmented Parthenon pedimental figure known as the Ilissus. His own sculpture of the *Reclining Nude* of 1907, in which he struggled with the rendering of the odalisque, may have kindled his appreciation for this academic talisman, and in the painting he adds to the ruin's partialness both through its segmentation by the vase and through his own schematizing of the musculature. The same cast appears in the background of the 1908 portrait of the *Girl with the Green Eyes* (plate 134), where it is cut by the edge of the canvas and the woman's head. This type of segmentation, caused by overlap and the canvas's edge, reminds us of Matisse's exposure to Impressionism and Degas. In this daring portrait by the lion of the Fauves, Matisse may have used the painting of the ancient fragment not only to establish a studio setting, but also as an ironic reference to his academic training, intended for a skeptical public.

While it is possible that the early sculptures of the *Écorché* and *The Serf* were damaged by accident (the *Écorché* appears in a painting intact, and there is the suggestion that at one time the now missing left hand touched the head of the sculpture), there is also to my mind the more probable incentive to unmake both sculptures for aesthetic reasons and to demonstrate his views on expression. To have replaced or repaired the missing limbs would have been a simple matter, but instead Matisse chose to cast both into bronze. The small sculptures of the *Horse* and *Upright Nude* (plates 135–36) are more obvious cases of studio accidents. In the latter, Matisse made no attempt to conceal the break in the upraised left arm, and this taste for preserving the effects of damage reappeared in 1950, when he had his bronze founder, Valsuani, cast in one piece the broken sections of the *Standing Nude (Katia)*. Matisse's recent experiences of academic study from ancient fragments and Rodin's exhibitions of his partial figures in large number, beginning in 1900, were probably influential on these early occasions. Unlike Rodin, Matisse made no attempt through patination to suggest the antiquity of his bronzes. The introduction of color into bronze finishing, other than the customary dark brown and black, was not to Matisse's taste.

In *Madeleine I* Matisse introduced a more personal device of partialness which separated him from Rodin. The modeling of the

crossed arms was arrested before the full volumes of the limbs had been achieved, a method of work which has perhaps an analogy in drawing, where a figure can be brought to varying degrees of definition. The more coarsely modeled *Madeleine II*, on the other hand, does give us the completed gesture and fuller arms.

Sculptors such as Rodin, Maillol, and Matisse, who early in this century worked with the partial figure, soon discovered that with the separation of certain parts from the body, such as the head and limbs, a new proportional basis could be set up which differed from the traditional norm of referring each part to the figure's total height. Rather than measuring by the eye against the figure intact, the artist could thicken or thin the torso and its parts against each other. These possibilities and the recognition of how a torso could convey spirit are found in Matisse's wonderful *Small Torso with Head* of 1906 (plates 137–38), which he also called *La Vie*. This tiny sculpture has all of the exuberance and vitality of his big canvases of the time that extolled the joys of primitive existence. The pinched breasts are the gestures of an artist sure of himself in succinctly giving the essentials of anatomy. Their proportions make sense when read together with the stumps of the arms. The dimpled haunches of the defiantly protruding buttocks show careful study of the model. *La Vie* mingles the subject's ecstasy with the artist's voluptuousness, daring with patiently achieved execution. The postural abandon of the figure, which drives the body's parts in all directions, forms a wonderful pendant to the concentric self-enclosure of the 1908 *Small Crouching Nude* (*Without an Arm*) and the *Small Torso* (plates 139–40) of a crouching figure, dated 1929 by the Matisse family, but

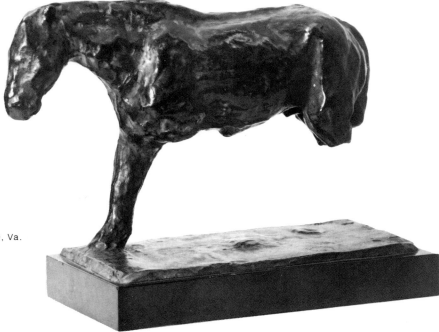

135 *Horse* (left side view).
1901.
Bronze,
16 ¾″ high.
Collection Mr. and Mrs. Paul Mellon, Upperville, Va.

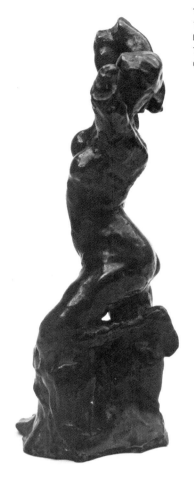

136 *Upright Nude* (left side view)
1904.
Bronze,
7 ⅛" high.
Collection Mr. and Mrs. Norton S. Walbridge, La Jolla, Calif.

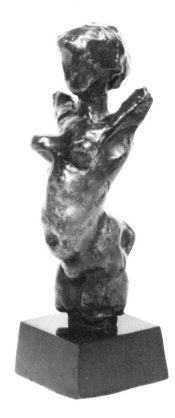

137 *Small Torso with Head (La Vie)*
(three-quarter left front view).
1906.
Bronze,
8 ¾" high.
Private collection, Paris

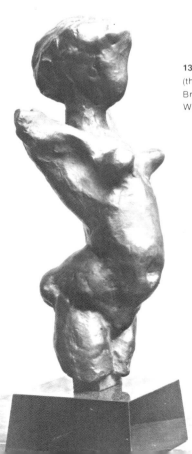

138 *Small Torso with Head (La Vie)*
(three-quarter right front view).
Bronze or terra cotta.
Whereabouts unknown

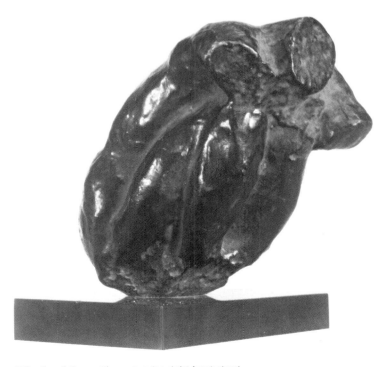

139 *Small Torso* (three-quarter right front view).
1908 (dated 1929 by Matisse family).
Bronze,
3" high.
Private collection, Paris

108

140 *Small Torso* (three-quarter left back view)

whose date on the basis of the paintings I believe to be closer to 1908, as indicated by Alfred Barr. In such paintings as the *Joie de Vivre,* Matisse similarly contrasts open and contracted postures. The *Small Torso* comes out of many paintings having this pose, such as the *Bathers with a Turtle, Le Luxe I,* and *Le Luxe II,* in which a crouching woman extends one arm to perform some function. Perhaps mindful of the academic dictum against making sculptures with extended arms, Matisse chose not to complete the gesture. Nugget-like in its size, weight, and density, it is a piece to fondle. These last three sculptures did not have modeled bases when they were made, allowing them a varied life in the hands.

There are no sculptural studies of hands by Matisse, and neither in painting nor sculpture did he share Rodin's passion for recreating their potential eloquence. He employed a synoptic device to suggest their general shape in his figures. We have an insight into Matisse's aversion to detailing hands in sculpture, beyond his views on expression, from an observation he made about his thoughts on why Delacroix reduced hands to claws, private ciphers, instead of portraying them as did Ingres and Corot: "There are two categories of artists . . . those who on each occasion make a new portrait of the hand each time, Corot for example . . . the others who make of the hand a sign, like Delacroix. With signs one can compose freely and ornamentally."[75]

Matisse did, however, make a foot (plate 141). Mme Duthuit says that it was made in 1909 in connection with his paintings of the *Dance* (plate 142). Alfred Barr quotes an anecdote from Georges

141 *Study of a Foot.*
1909.
Bronze,
11 ¾″ high.
Collection Charles E. Slatkin, New York City

142 *Dance.*
1909.
Oil on canvas,
8′ 6 ⅝ × 12′ 9 ⅝″.
The Museum of Modern Art, New York City.
Gift of Governor Nelson A. Rockefeller
in honor of Alfred H. Barr, Jr.

143 *Torso Without Arms or Head.*
1909.
Bronze.
9 ¾" high.
Private collection, Paris

Duthuit about how Matisse once acted while working on the *Dance,* whose versions are in the Museum of Modern Art in New York and in the Moscow Museum: ". . . he crouched ready to leap as he had done one night some years before on the beach at Collioure in a round of Catalan fishermen. . . ."[76] When we see how concerned the artist was with feeling the sensations of the dance, we can better comprehend his study of a foot pushing off from the ground. This is a rare instance in which we are certain that Matisse used sculpture as a preliminary study for a painting. It shows his concern with authenticity in a painting often looked upon as spontaneously achieved and important for its visual equivalence of figural and spatial arabesques. His instructions to his students at the time, to feel in oneself where the stresses and strains of the model's movement were, came from his own academic experience. Matisse could have seen in the art supply stores and art schools, as well as in paintings such as Géricault's *Portrait of an Artist* in the Louvre, plaster casts of a slightly raised foot from an ancient sculpture, which along with *écorchés* and wooden manikins, were used as an artist's aids in studying movement. Not content with either the exactness of an ancient cast nor the broad contours of his drawing, Matisse rebuilt the foot and then trued it to his own specifications in such a way as to accentuate its upward spring, not only by the firm crease before the toes, but through the direction of the planes. True to the injunctions of such academic theoreticians as Charles Blanc, Matisse did not opt for a svelte foot nor dwell upon the hollows in the heel.[77] But he also eschewed literal classical proportioning and created a silhouette of straightened and curved forms that were in accord with the reductivist mode of his drawing for the *Dance.* Speaking as an anatomist, Dr. Maurice Galanté, who owns the original plaster of the foot, says that the foot belongs to a "masculine woman dancer." The sculpture allowed him to observe the raised foot from several points of view, with benefits to the two dancers to the left of center in the various paintings of this motif.

Perhaps made in the same mood as the *Dance* series is the *Torso Without Arms or Head* of 1909 (plate 143). The upper torso recalls that of *La Vie,* and the ropelike legs have the elongated proportions and free swinging movement seen in the paintings. It is the one partial figure by Matisse that evokes comparison with a work by Maillol, namely, the armless version with truncated legs of *Ile de France* of 1909 or 1910 (plate 144). Matisse characteristically gives more torsion to his figure and greater vitality. His surfaces are less reworked, and he made no effort to true the stumps of the legs. Unlike Maillol, Matisse was willing to sacrifice dignity for energy, human and sculptural. At some point the clay or plaster piece was broken and put back together without erasure of the crack in casting, recalling Rodin's practice in many of his sculptures. It was not mounted on a base when exhibited in 1930 in the Galerie Pierre in Paris, and a photograph shows the sculpture on a sideboard, *lying on its back* (plate 146).

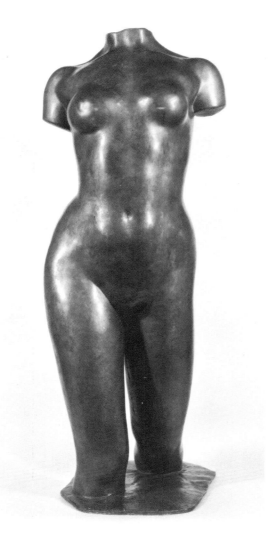

144 MAILLOL. *Ile de France* (torso).
1909 or 1910.
Bronze,
42 3/8'' high, 12 3/4'' wide.
The Metropolitan Museum of Art, New York City, purchase, 1951.
Edith Perry Chapman Fund, from the Museum of
Modern Art. Gift of A. Conger Goodyear

145 Matisse and Maillol in Maillol's studio examining the *Ile de France*

146 View of the installation of
the Matisse exhibition in 1930 at
the Galerie Pierre, Paris

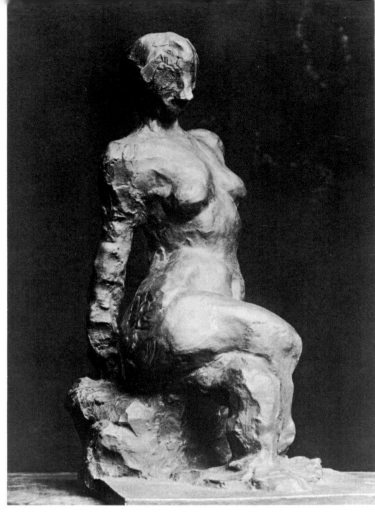

147 *Seated Nude, Arm Behind Her Back*
(three-quarter right front view).
1909.
Bronze or terra cotta,
11 ½″ high.
Whereabouts unknown

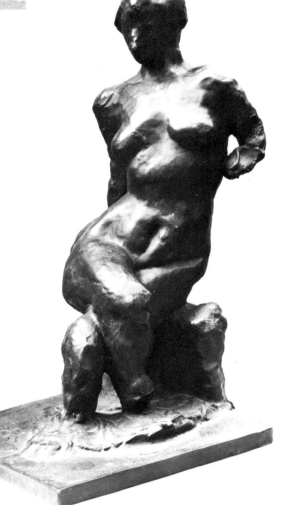

148 *Seated Nude, Arm Behind Her Back* (front view).
Bronze.
Joseph H. Hirshhorn Collection

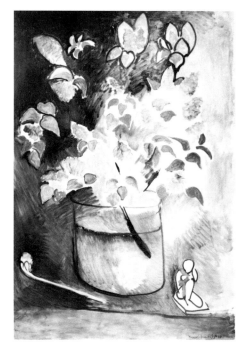

150 *Italian Woman.*
1915.
Oil,
45 ⅝ × 35 ¼".
Private collection, New York City

149 *Lilac Branch.*
1914.
Oil on canvas, 57 ½ × 38 ¼".
Private collection

Seated Nude, Arm Behind Her Back of 1909 (plates 147–48) is reminiscent of the academic idea that in sculpture expression lay in the surface treatment and beauty in the figure's relief. While Matisse's mode of modeling lacked the finish and finesse of conservative artists, his positioning of the figure achieves the utmost from the pose in terms of the body's spiral movement. The woman's left arm was abruptly terminated below the elbow; for, as was the case with Rodin, Matisse preferred not to stop his partial figures at the joints in order to retain a clear statement of the limb's direction. The legs are ended above the ankles, more crudely than they are in the *Venus on a Shell* of 1932 and in the *Back* series. The partialness of the left arm, as that of the 1908 *Small Crouching Nude,* may have stemmed from preservation of the torso's arabesque. From the sculpture's right side one is not aware of the missing limb and can take in the sinuous line that runs through the torso. In all, this figure is less frontally oriented than the *Decorative Figure* of the year before and is another instance of Matisse finding alternative approaches to orienting his figures with respect to the viewer.

One of the possible consequences for painting of Matisse's experience in sculpture with the segmenting of his figures may be seen in the *Italian Woman* of 1915 (plate 150). In this painting, Matisse has brought the background color into the model's right shoulder area. The outline of the lost limb is still apparent beneath the gray, and it connects with the forearm. A year earlier in the painting *Lilac Branch* (plate 149), Matisse did the same thing with the small statuette of the *Small Crouching Nude* of 1908. Conceivably, the action of his brush imitated the amputating action of his sculptor's knife.

151 *Bust of an Old Woman* (front view).
1900.
Bronze,
24 ½″ high.
Joseph H. Hirshhorn Collection

The Portraits, 1900–1915

For a man who said that the expression he wanted in art was not that which was mirrored on the human face and who was not interested in the superficial appearance of things, portraiture in sculpture might at first seem an unlikely activity. His lifelong commitment, however, to portraits in a variety of media (including almost one third of his sculptures) undermines the image of Matisse as an artist disinterested in subject matter. As early as the 1894 medallion profile portrait, Matisse had shown a talent for achieving a likeness worthy of David d'Angers. His purchase of Rodin's portrait bust of Rochefort in 1898, at a time when it was a considerable financial investment, is strong testimony not only of an early admiration for Rodin as a portraitist, but also of a serious interest in learning more about the elements of portrait sculpture. Beginning with the 1900 *Bust of an Old Woman* (plates 151–52), none of Matisse's modeled portraits resemble Rodin's method of work in the Rochefort. Matisse discouraged close, sequential scrutiny of perfectly formed features, and one must often step back and take in the whole to comprehend a distortion or lack of definition. Matisse, who did few portraits before 1900, could have become convinced from the examples of Rodin and Cézanne that capturing not the subject's measurements but his character was essential to portraiture. "One might say that the portrait photograph is sufficient. For anthropometry [in France the branch of the Criminal Investigation Department dealing with the measurement of individuals], yes, but for the artist and his research into the profound character of a face, it is otherwise. . . ."[78]

Matisse fervently believed, as did Rodin, that the artist should be a physiognomist and interpret his subject's true nature by means of the face. Cézanne, as well as Rodin, gave him models of prolonged and thoughtful reflection and reworking of the face in order to discover the emotional and psychological implications of what the features synthesized. As he did not undertake commissioned portraits, Matisse did not have to risk the displeasure of a sitter and consequent financial loss. While members of his family, friends, or models may have occasionally expressed critical views, Matisse had complete freedom to bring total candor and free sensibility to the faces he studied.

In his *Bust of an Old Woman,* Matisse avoided the temptation to treat the picturesque symptoms of age and instead let the woman's nature filter through the total effect of understated modeling and the form's gesture. This was a rare portrait for Matisse in that he used the upper chest and turned the head away from a frontal position. When first seen, the portrait is like a preliminary sketch—with the mouth area apparently shorn off. When we see it in profile, we realize its completeness and recognize such masterly devices as the thin incision for the mouth, which gives a distinctive, individualized set to the whole head. The modeled nuance of the face, particularly

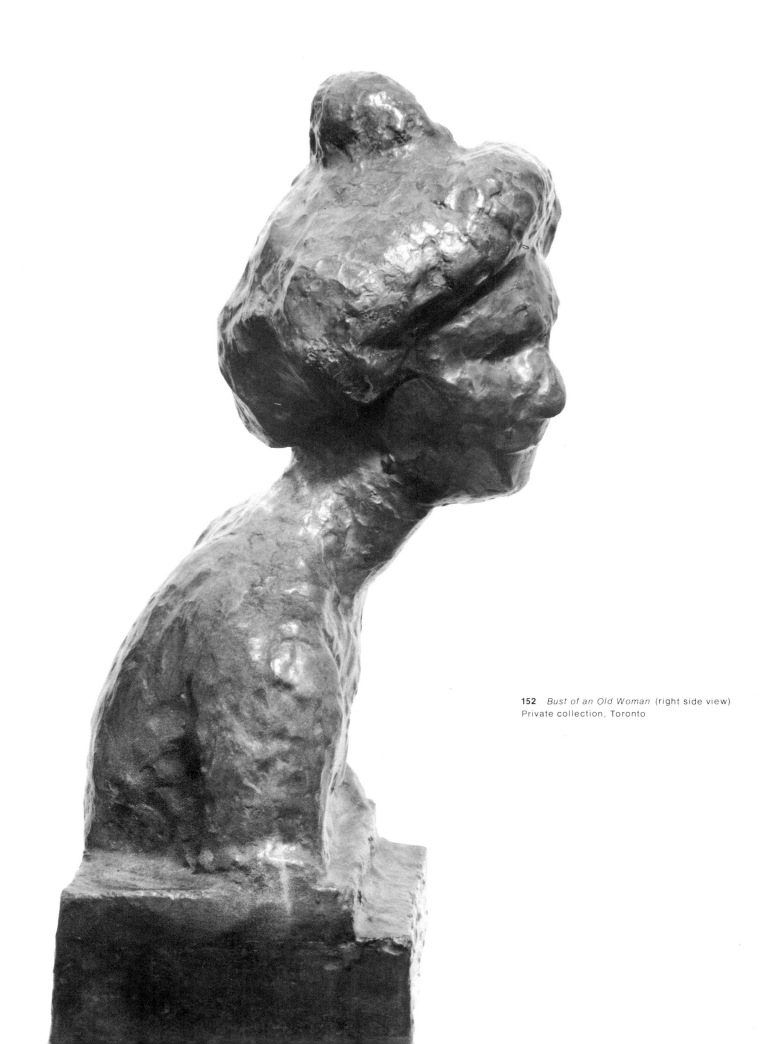

152 *Bust of an Old Woman* (right side view)
Private collection, Toronto

around the eyes, is like the tonal painting Matisse had been doing at the time, in which he let the values establish mood and form.

Between this most "atmospheric" portrait and the later ones of Jeannette, Matisse's portraits are surprisingly small, fitting easily into the hand, which suggests they had been fashioned to some extent in the hand rather than on sculpture stands. The smallest heads, those of his children and of young women, display feeling through a smile, rare in his life-size works (plates 153–60). Faithful to his own instructions as a teacher to exaggerate according to the age and character of the model, Matisse's modeling of his children preserves the large, bulging crania, the malleability of the heads, and the indistinctness of the passages where the features merge with adjacent areas, as at the corners of the mouth and around the eyes. In the tiny heads that smile or verge on speaking, he has grasped how the mood suffuses through the entire face, which gives the sculptures their relaxed and natural appearance.

If we take the smaller busts as a group, we can see the constancy and variety of Matisse's portrait modes. By contrast with the Rochefort portrait, he made it a point to use the hair as a frame or crown for the face, interacting with the shapes and directions of movement below it, thereby facilitating the reading of the entire head. With full confidence in his ability to observe and improvise, he totally avoids mannerism or cliché in the forming of individual features. No pair of eyes are the same; no nose, mouth, or ear is identical with any other in form or means of construction. The strong shape and protuberance of the nose is never disguised or played down, but accepted and accentuated by Matisse as essential to composition and personality. Late nineteenth-century portraits of women, such as Rodin's marble "soul" portraits, tended to minimize this feature. Matisse not only varied the shapes of the noses, but also bent their axes and rethought their attachment to the brow. The asymmetry which helps bring these heads to life owes much to the sculptor's animation of the chin, cheek, and brow areas, which he could not bring himself to neutralize consistently into smooth passages. A modeled face by Matisse is comparable to one of his paintings of figures in a landscape. To achieve unity out of variety, he refused to consider either a hierarchy of features or figures, and the whole arrangement, intervals and brows, had to be expressive.

Besides the portraits Matisse did two imaginative heads, one of a faun and one for a pipe bowl in the shape of a demon (plates 161–63). The *Head of a Faun* dates from the time of the *Joie de Vivre* and may have been inspired by his thinking about this classical theme and perhaps by faun and satyr heads among the Louvre's ancient sculptures. Closer to the toothy leer and facial muscularity of Matisse's *Faun* is Michelangelo's first known marble, which is of this subject. Matisse could have seen this head in the Bargello in 1907, the year of his own *Head of a Faun*. Characteristically, his conception is less demonic, more boyish and lighthearted than that of Michelangelo. The cleft nose, pointed ear, and small horns

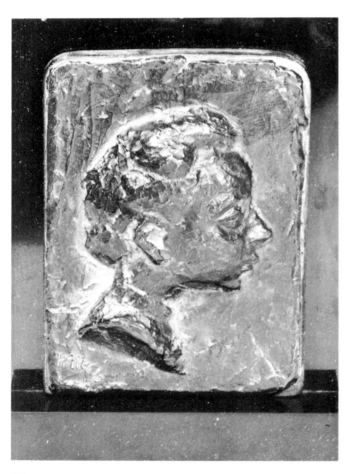

153 *Head of a Child (Pierre Matisse).*
1903.
Bronze,
5″ high.
Private collection, Paris

117

154 *Head of a Child (Pierre Manguin).*
1905.
Bronze,
6 ½" high.
Private collection, Paris

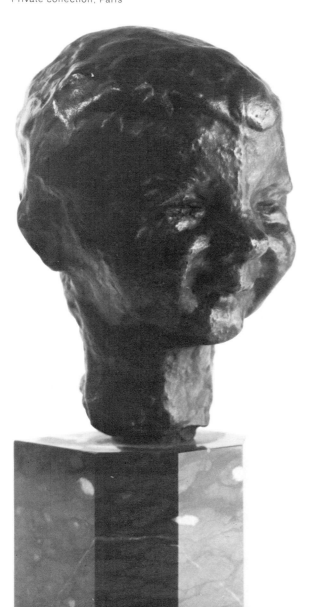

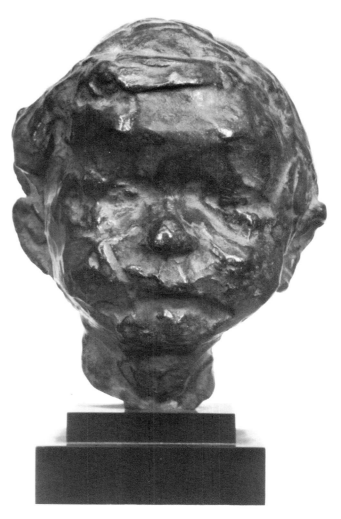

155 *Portrait of Pierre Matisse.*
1905.
Bronze,
6 ⅜" high.
The Baltimore Museum of Art. Cone Collection

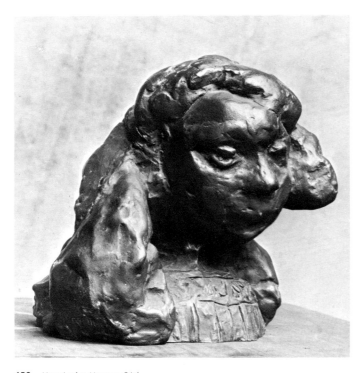

156 *Head of a Young Girl*
(three-quarter right front view).
1906.
Bronze or terra cotta,
6 ¼" high.
Whereabouts unknown

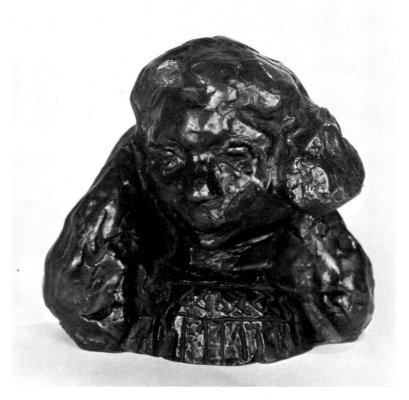

157 *Head of a Young Girl* (front view).
Bronze.
The Baltimore Museum of Art. Cone Collection

158 *Small Head with Pompadour.*
1907.
Bronze,
4 ⅝″ high.
Private collection, Paris

159 *Small Head with Flat Nose (Marguerite).*
1906.
Bronze,
5 ½″ high.
Private collection, Paris

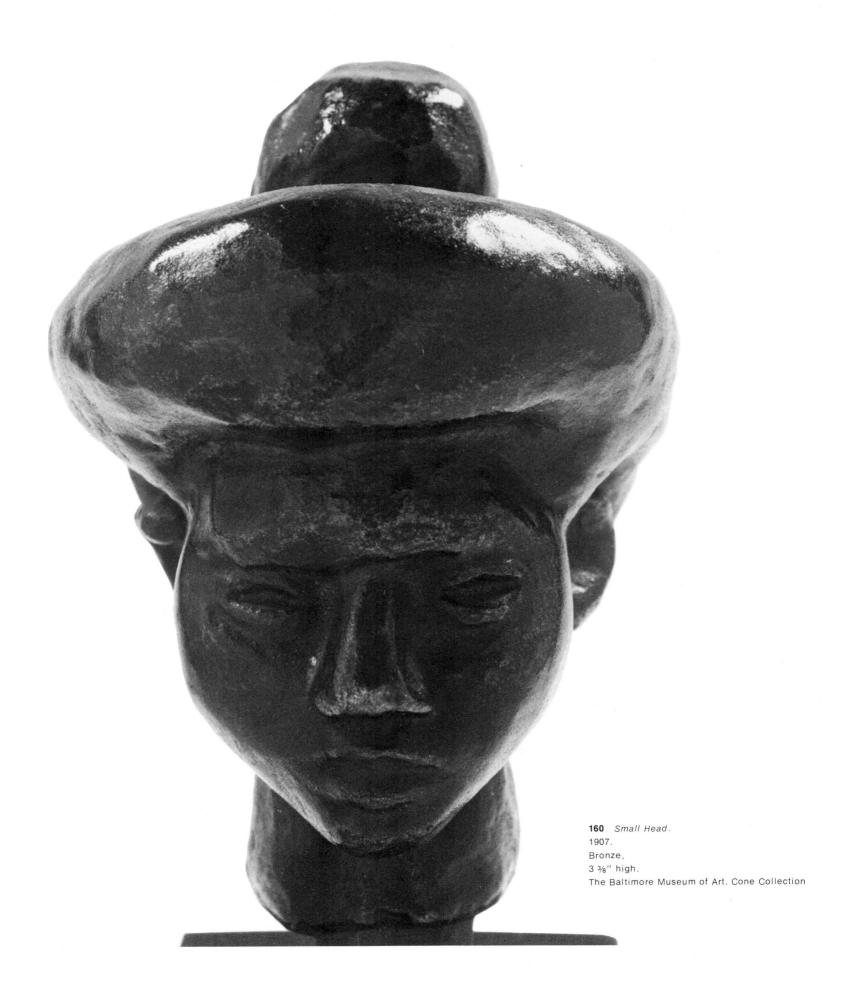

160 *Small Head.*
1907.
Bronze,
3 ⅜" high.
The Baltimore Museum of Art. Cone Collection

121

161 *Head of a Faun* (three-quarter left front view).
1907.
Bronze,
5 ¼″ high.
Collection Victor Waddington, London

162 *Head of a Faun* (right side view)

complete a rich facial characterization not possible in the context of paintings such as the *Joie de Vivre*. Was the piece done for the amusement of his children as well as the artist? Even when playfully making a small head, Matisse shows an amazing touch in mobilizing the substances of his clay and the face itself. Matisse was a smoker, and the demon-headed pipe satisfied his taste for an aesthetic object that could be handled, even if it could not easily be smoked. Both heads give us a rare glimpse of a side of Matisse's imagination that he did not choose to develop.

Thrown into shadow by the light of attention cast on the *Jeannette* series is a superb small bust, the *Head with Necklace* of 1907 (plates 164–66). Recalling the great painted portrait of his wife in 1905, *Woman with a Hat,* the girl's hair is used as a canopy for the head. In the absence of color and its expressive use by complementaries, Matisse fashioned reciprocal shapes, so that the entire conception from shoulder to hairdo consists of rhythm and rhyme; necklace, jaw, and pompadour are conjugates of each other, as are the cheekbones, eyes, and flanking bulges of the hair style. No painted portrait makes us as conscious of the facial bone structure. The thoughtful alignment of the central axis of the face, made up of the triangular pompadour and the strong pendular nose astride the mouth and chin—the latter having its complementary hollow in the throat below—transforms the young girl, so that she resembles an ancient hieratic Palmyrene grave effigy. Matisse enforces continuity by exaggeration, as we see in the upward divergence of the jaw, which rises and expands until it flows into the hair. The forceful nose is crucial to the conception and, as much as the half-closed eyes, gives the image its dignity. The desired character of the girl is now manifest, along with the workings of Matisse's intellect as he meditated on the adolescent visage. At almost the same time, in Paris, Brancusi was contemplating what was dispensable in the head, rationalizing away its features or fusing them with the broad planes of the face. Matisse was fiercely insisting upon the features' individuality, not necessarily their resemblance to the original. For Brancusi, the reformations of the head were to lead to a repression but not elimination of the subject's personality, while reformations by Matisse were essential not only to the credibility of a new formal completeness, but also to a more intense experience of the subject's spirit.

THE PORTRAITS OF *JEANNETTE*

The portraits of Jeanne Vaderin, which Alfred Barr learned from the artist may have been done in one year, 1910, at Issy-les-Moulineaux, probably continued to 1913. In the absence of a photograph of Jeanne, we have only her portrait in Matisse's 1910 drawing and painting, *Young Girl with Tulips* (plate 167), to compare with his great modeled heads.[79] The drawing shows many second thoughts, as the artist wrestled with the location of the eyebrows, chin, and

163 *The Pipe.*
c. 1906.
Bronze,
5 ¾" long.
Private collection, Paris

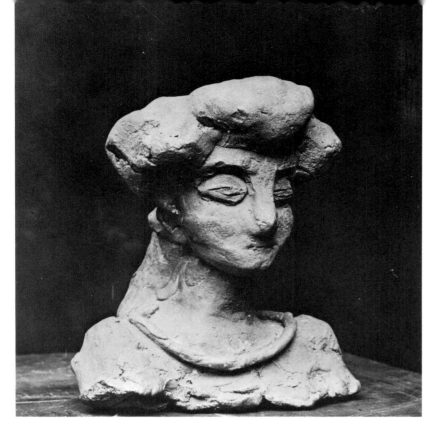

164 *Head with Necklace* (three-quarter left front view).
1907.
Bronze or terra cotta,
6 ⅛" high.
Whereabouts unknown

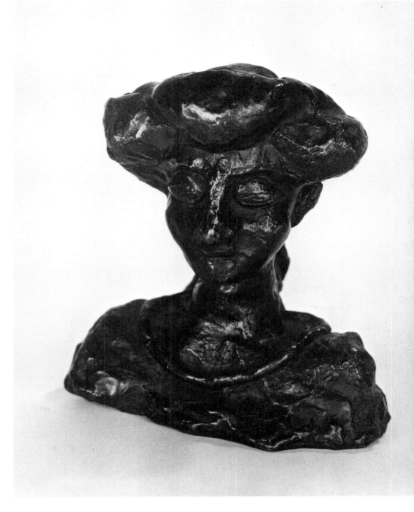

165 *Head with Necklace* (front view).
Bronze.
The Baltimore Museum of Art. Cone Collection

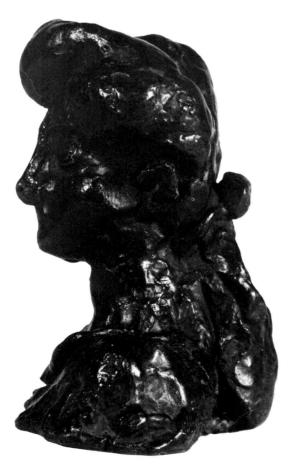

166 *Head with Necklace* (left side view)

124

facial silhouette. The subject's large, strong nose and the marked
asymmetry of the eyes are similar to reformations in the sculptures
and are important to the way Matisse arrived at two different sides of
the face. In such a simplified portrait, the idiosyncratic asymmetries
were crucial for individuality.

The dramatic changes and striking character of the last three
versions of *Jeannette* cause one to hasten past the first two studies,
which by themselves merit sympathetic attention. *Jeannette I* (plates
168–70) was in fact only the second life-size bust Matisse had made,
the first having been done in 1900. Part of his problem may have
been to bring from the intervening smaller heads the same
psychological intensity and richness of decorative effect. By looking
at the second head in the series we can understand the sculptor's
criticism of his first effort. *Jeannette I* lacks the personal animation
and sculptural expressiveness of her twin. The hair style was
rearranged, possibly at the sculptor's suggestion. The eyebrows
were made less obtrusive by being better integrated with the eye
socket, brow, and nose, and the eyes themselves are more
responsive to light changes and evocative of mood. The profile from
the hairline to the tip of the nose becomes less undulating, and so
forth. Frontally, however, *Jeannette II* (plates 171–72) lacks the
vigorous, scaled accents of the *Head with Necklace.* The increased
overall animation did not result in sufficient distinctiveness of design.
The foundations for the final design were there in the large orbits of
the eyes, but the nose was visually, not anatomically, too meager.

167 *Young Girl with Tulips.*
1910.
Charcoal on buff paper,
28 ½ × 23″.
The Museum of Modern Art, New York City.
Lillie P. Bliss Fund

168 *Jeannette I* (Jeanne Vaderin, first state; front view).
1910–13.
Bronze,
13″ high.
The Museum of Modern Art, New York City.
Acquired through the Lillie P. Bliss Bequest

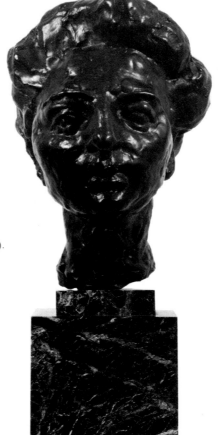

170 *Jeannette I* (three-quarter right front view).
Collection Jean Matisse

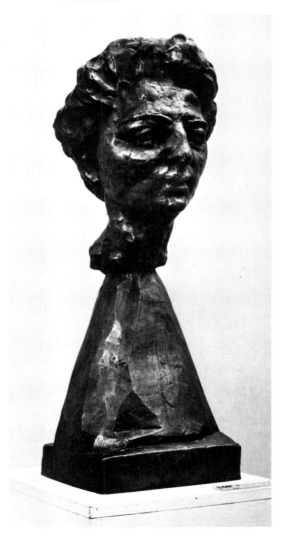

169 *Jeannette I* (right side view)

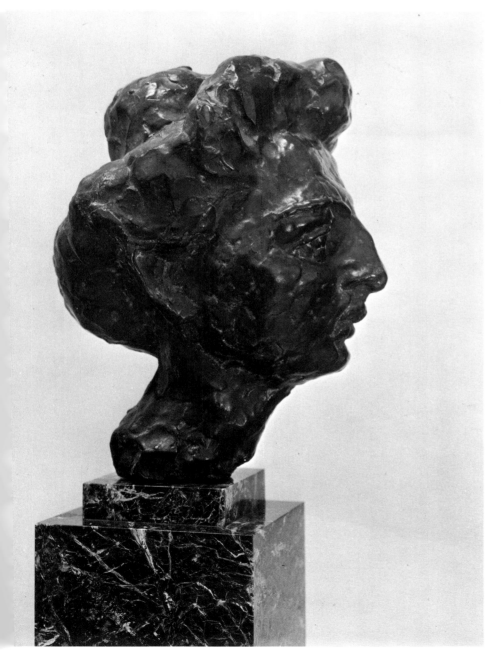

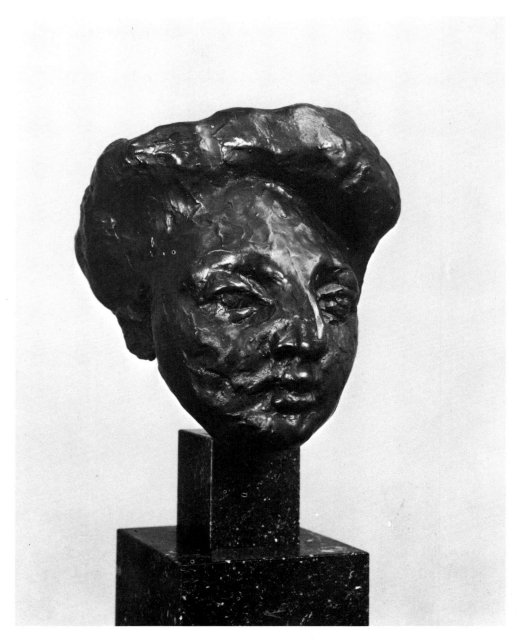

171 *Jeannetie II* (Jeanne Vaderin, second state;
three-quarter right front view).
1910–13.
Bronze,
10 ⅜″ high.
The Museum of Modern Art, New York City.
Gift of Sidney Janis

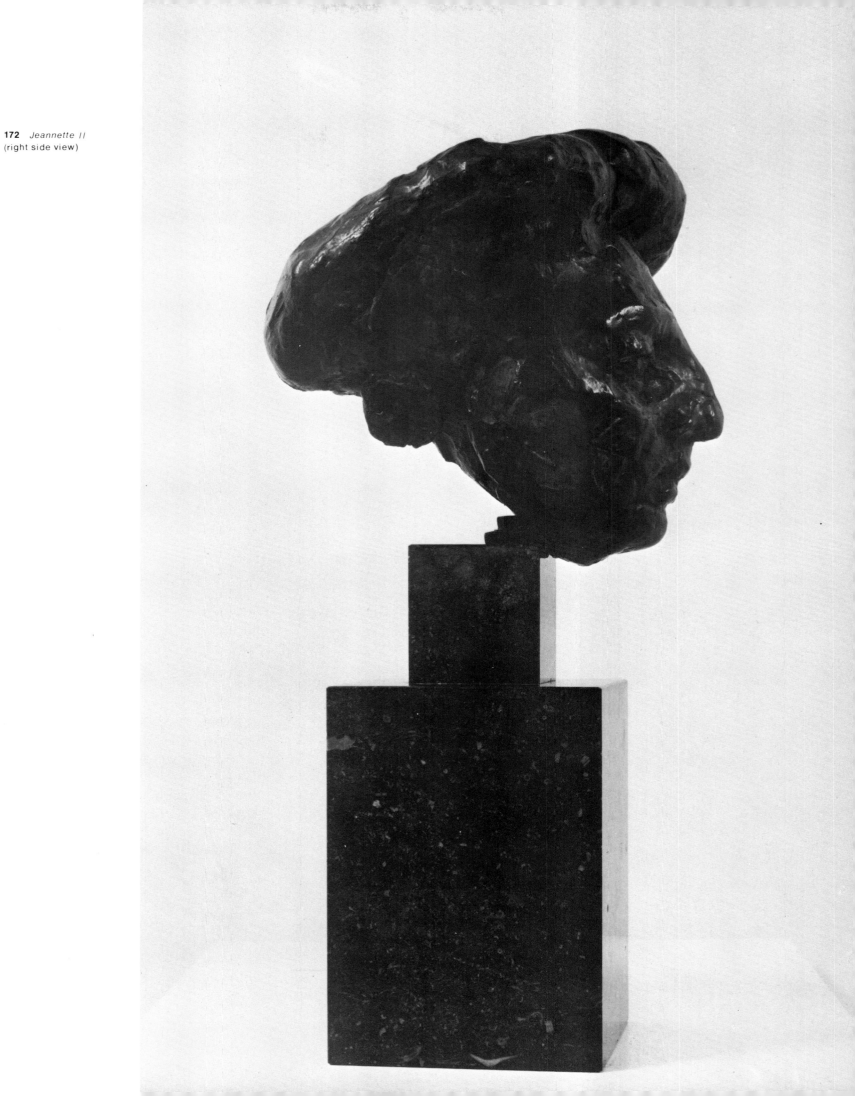

128

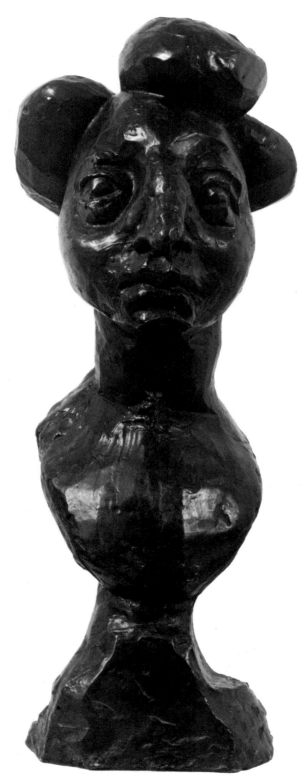

173 *Jeannette III* (Jeanne Vaderin, third state; front view).
1910–13.
Bronze,
23 ¾" high.
The Museum of Modern Art, New York City.
Acquired through the Lillie P. Bliss Bequest

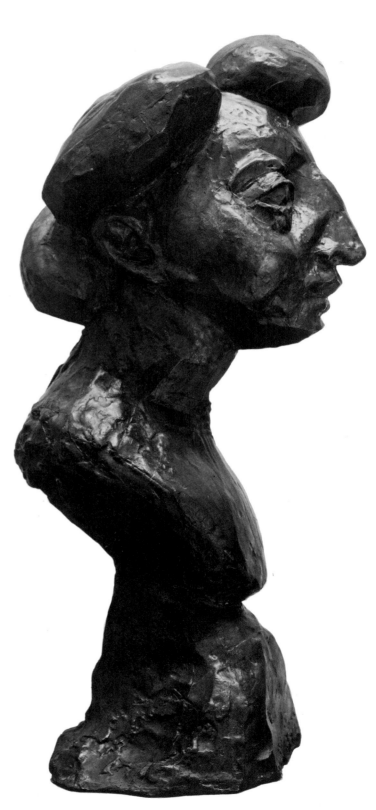

174 *Jeannette III* (right side view)

To begin to understand what was to happen in the next three works, theories about "optic and haptic" sensibilities seem to raise more questions than they answer.[80] We should look at these faces as Matisse did: in terms of modalities and of the artist's problem of treating radically diverse shapes which had to be brought into a forceful and apparent formal unity without loss of character.

Facing the problem of how to get *Jeannette I* up in the air, and perhaps not having a base in the studio that satisfied him, Matisse built up and carved in clay a roughly conical shaft rising from a rectangular base which met the head at the neck. Avoidance of the full bust form and stepped rectangular base of the *Bust of an Old Woman* suggests Matisse's belief in a decorum or aesthetic need unique to each sculpture with regard to its support. The narrower diameter of the cone precluded its being read continually with the neck and gave him an intriguing configuration that was both stable and unstable in appearance. His subsequent rejection of this support, evidenced by his exhibition of the head without it, reflects Matisse's ambivalent attitude toward bases. But part of his audacity lay in modeling and arbitrarily editing his nonillusionistic support rather than relying upon traditional bases with ornate moldings.

According to the records, carefully set down in Alfred Barr's book, *Jeannette III* (plates 173–74), as it has come to be known, should follow. But one suspects that *Jeannette IV* (plates 175–76) might have come next, because it seems more logical as a transition from the second completely modeled head than an abortive excursion away from the so-called third and fifth portraits with their extensive structuring and use of a knife or wire tool for cutting clay. What tends to ground such flights of logic are the examples of *Madeleine I* and *II* and *Henriette II* and *III,* where, broadly speaking, the rough follows the smooth. It is no secret that *Jeannette V* (plates 177–78) is taken from a plaster cast of *Jeannette III*, indicating which predecessor the artist felt was most viable for the final bust. There is really only one sculptural "idea" emerging in *Jeannette IV* that was carried over into the last bust, but it was a crucial one that might have caused Matisse's ideas to coalesce.

Mme Matisse told Alfred Barr that Jeanne did not pose after the second portrait. In *Jeannette III* Matisse was carrying out his admonition to his students: "To one's work one must bring knowledge, much contemplation of the model . . . and the imagination to enrich what one sees. Close your eyes and hold the vision, and then do the work with your own sensibility."[81]

Although it is a good likeness, Matisse may have felt the second head was decoratively deficient because of its many undecided, indefinite shapes and an insufficiently explicit rhythm. He enlarged the bust form and modeled a pedestal of nineteenth-century style, and rearranged the hair—for his own work Matisse was an occasional milliner and hair stylist—thereby enlarging the field for redesigning and giving the sculpture physical self-sufficiency. *Jeannette I* lacks a bust and must be set directly upon a block.

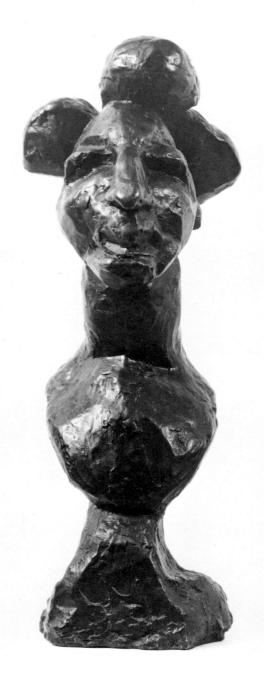

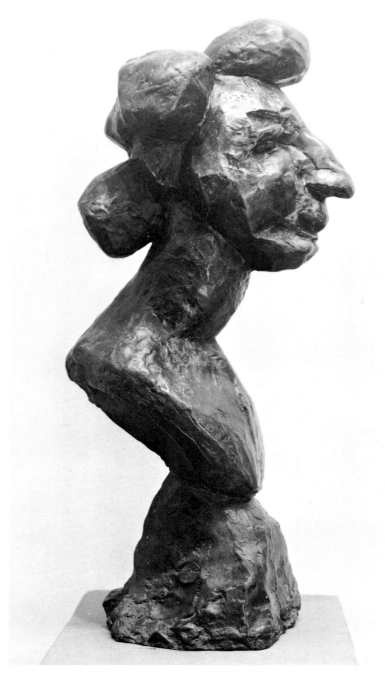

175 *Jeannette IV* (Jeanne Vaderin, fourth state; front view).
1910–13.
Bronze,
24 ⅛″ high.
The Museum of Modern Art, New York City.
Acquired through the Lillie P. Bliss Bequest

176 *Jeannette IV* (right side view)

177 *Jeannette V* (Jeanne Vaderin, fifth state; front view).
1910–13.
Bronze,
22 7/8" high.
The Museum of Modern Art, New York City.
Acquired through the Lillie P. Bliss Bequest

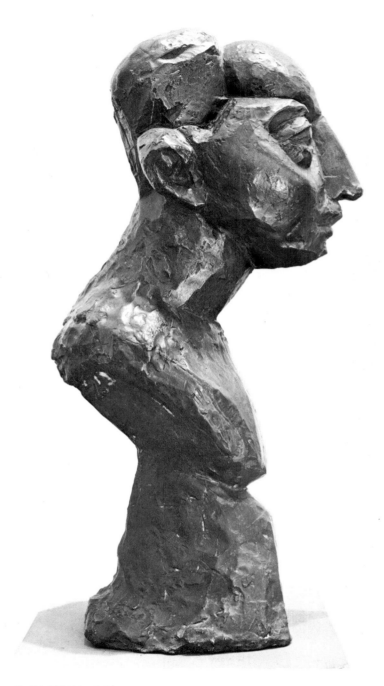

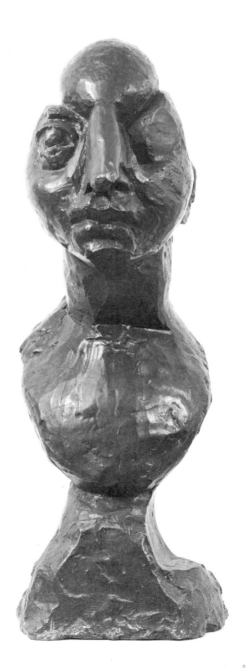

178 *Jeannette V* (right side view)

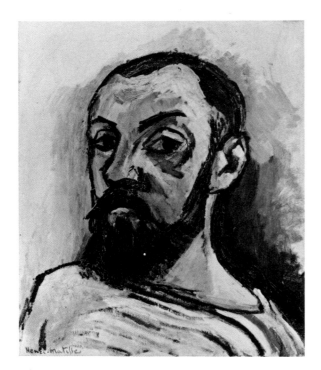

179 *Self-Portrait (Collioure).*
1906.
Oil on canvas,
21 ⅝ × 18 ⅛″.
The Royal Museum of Fine Arts, Copenhagen.
J. Rump Collection

Matisse may have felt that the bust was a more felicitous termination than the abrupt form of the neck. By refashioning the hair, he introduced three strong shapes to replace a single amorphous one, and they could now be sensed by the viewer against the more forceful triad of eyes and nose below them. He rejected the possibility of symmetrical hair styling, perhaps to counter that of the features. The asymmetry of the base, preserved in the last three busts, complements the position of the pompadour and activates the lower section. Rather than account for the dramatic and more decided reshaping of the eyes over the preceding version by haptic theories or by citing the possible influence of Cameroon masks, one can look at the Matisse *Self-Portrait* of 1906 (plate 179), now in Copenhagen, and see his Cézanne-like restructuring of the eyelids and bone structure around his own right eye.[82] "Everything must be constructed. . . ." This would not be the first instance of a sculptor remaking his subject into a semblance of his own image. Coincident with the thickening and strengthening of the nose ("All things have their decided physical character. . . .") the eye orbits are now made to intrude into the skull above, something not found in the painted portraits nor in the drawing of Jeanne. The necessity of strengthening the line of the mouth and increasing it proportionally was inevitable in terms of what transpired above. *Jeannette*'s identity is preserved by clarifying but not eradicating her frontal facial contour, the curvature of the nose, the breadth between the eyes, and their disparity of shape and glance. Transcending physical alterations, the woman comes into psychological focus.

Matisse's greatness as a portraitist was shown in his ultimate dissatisfaction with such a strong portrait as this last work. For some unknown reason he threw aside in the next study all that had been so painstakingly earned. Perhaps it had been too painstaking, for he then proceeded to rework the head rapidly and thereby achieve a tighter integration of his parts—in short, to forget previous details and to work for broader masses and rhythms. The sliced section of the upper jaw is better seen in profile. The general range of accents is still present, but with far less nuance. The smile, perhaps a return to the original shape of the lips, brings the curve of the mouth into concert with that of the grossly enlarged nose, chin, and tapered bust contour. The change in facial expression forced the cheeks to swell upward, making them, rather than the eyes, the obvious shapes to be read against those of the hair. Rough as it is, the modeled facture is more of a piece than that of the third bust. Having broken with the anatomical restraining form of the cranium over the eyes, Matisse continues the invasion of the brow by the eye sockets. This time he increased the swell of the forehead directly above the nose. The small early *Head of a Young Girl* of 1906 augurs this decision. It is this step which next leads to a crucial fusion of nose, brow, and pompadour, perhaps giving him the means and incentive to rework the third version into a more cogent portrait.

Working from a plaster cast of *Jeannette III*, Matisse cut away the

hair, the back of the head, and the woman's left eye. Presumably with clay, he rebuilt the new areas on the segmented plaster. The gourd or hand-mirror shape for the nose-brow-pompadour synthesized three different parts of the face into a single expressive form. The left side of the face was being rebuilt when Matisse slashed much of it away. He then stopped. Why?[83] In the preceding works, starting with *The Serf*, Matisse enforced the direction of a plane or firmed a contour with his knife. This is true of the chins and busts of the two preceding *Jeannette* portraits and of the upper left jaw of the fourth head. The taller of the *Two Negresses* has had her left cheek similarly slashed, and the lower right jaw of *Olga* was cut away. In the 1900 portrait *Bust of an Old Woman,* when he had finished the closely studied modeling of the features he sliced off the mouth and did not disguise the surgery. When looking at *Jeannette V*, it helps not to focus on the left eye alone, but to read the whole left side of the face against the sharply faceted neck and chest in order to appreciate the power of the head's asymmetry. "At the end I had discovered that the resemblance in a portrait comes from the opposition which exists between the model's face and the other faces, in a word, from its particular asymmetry. Each face has its particular rhythm and it is the rhythm that creates the resemblance."[84]

In Rodin's art there are heads that suffered from accidents or contained impressions made from now-departed limbs against which they rested—*The Head of the Crouching Woman*, for example—but there is no comparable audacious cutting of the face as in *Jeannette V*. Rodin sometimes made a daring and unpredictable addition to the final portrait, as in the untempered rolls of clay inserted above *Baudelaire*'s right eye or in the bridge of *Balzac*'s nose. What Matisse accomplished in *Jeannette V* was no accidental or lucky stroke any more than it had been in the *Bust of an Old Woman*. Unlike the act of a diamond cutter, his was an inspired stroke, resulting from instinct or some unknown calculation of what was needed or not needed. Curiously, Matisse did not exhibit his fifth bust until 1950, perhaps because he was apprehensive about how others would look at it, or because like Rodin, who regarded his mutilated *La Terre* with mingled fear and fascination, he preferred to live with it himself. That he did not destroy the bust is more revealing than his failure to exhibit it. What he said about not being content with a painting done in one sitting applies to this series: ". . . I prefer to continue working on it so that later I may recognize it as a work of my mind."[85]

Jeannette V is not only the most strongly designed of the series, but it emanates the most forceful personality. In 1946 Matisse wrote in his essay "Exactitude Is Not Truth": "There is an inherent truth that must be disengaged from the outward appearance of the object to be represented. This is the only truth that matters." That he had not lost himself in the formal problem of the last head is shown by the fact that in spite of all the drastic changes he had made, he retained and reshaped the woman's ears. Had he not told his students, "Ingres said, 'Never in drawing the head omit the ear.' If I

do not insist upon this I do remind you that the ear adds enormously to the character of the head, and that it is very important to express it carefully and fully. . . ."[86]

JEANNETTE V AND PICASSO'S WOMAN'S HEAD, 1909

The extent and manner of Matisse's reaction to Cubism is difficult to define sharply. In 1910 Matisse and Picasso knew each other and each other's work, but the older artist was publicly hostile to Cubism. Some have tried to explain the changes in *Jeannette V* by Matisse's exposure to Picasso's *Woman's Head* (plate 180), which, even if made in 1910, preceded the *Jeannette V*. Assuming that Matisse saw Picasso's sculpture before he had solved his problem, what would he have learned, and what solution did it offer? I suspect nothing and none. In the same way that Matisse used sculpture, Picasso was consolidating his painting ideas in this one modeled portrait and experimenting with Cubism and how it looked in the round. He was moving in the direction crucial to Cubism, that of interpreting the human being by means which denied the possibility of "imitation of

180 PICASSO. *Woman's Head.*
1910.
Bronze,
16 ¼" high.
The Museum of Modern Art, New York City.
Purchase

181 DUCHAMP-VILLON. *Maggy*.
1911.
Plaster,
29 ¼″ high.
Private collection

nature'' and which derived from the artist's imagination. Picasso's
ideals were of conceptual elements employed instinctively, acting to
produce reversible but inconstant inversions: discontinuity where
the face had continuity, concavity for convexity, and so on. The *Head*
is a continuation from drawing and painting of reducing his means to
straight and arced planes, now transposed into modeled ridges.
The individuality of the features was almost assimilated into a
greater homogeneity of shapes and rhythms. The woman's identity,
character, and mood are still present, but have receded behind the
vigorous reworking of the total form. Both Picasso and Matisse were
stressing expressiveness of execution. Matisse, however, was
moving in other directions not so dependent upon devices derived
from painting. He was avoiding systems and was not so
self-restricted in his modes as the younger artist at this particular
time. Matisse was accentuating the features by exaggerating their
individuality and reducing the number of elements and contrasts of
his composition, thereby accelerating its readability. *Jeannette's*
assertive character and elegance thus comes through more strongly
than Picasso's more pensive subject.

Picasso's work belongs to atmospheric Cubism and produces
innumerable shifting shadows through the work, whereas Matisse
places the eyes and nose in such strong relief that they remain
visible and anchor the composition no matter what the lighting.
Matisse was for fusion and countability, not diffusion of innumerable

accents. Picasso's head from hair to neck is completely modeled and has no gesture like that of the left side of *Jeannette*'s face. Picasso's indented or inflected invasions of the woman's bone structure were at that time less drastic than those Matisse achieved by cutting into the cranium of his sculptured head.

JEANNETTE V AND MAGGY

Recently it has been suggested that Matisse's portrait may have been influenced by Duchamp-Villon's *Maggy* of 1911 (plate 181).[87] We are not told specifically what could have influenced Matisse and what the younger sculptor could have taught the older man. *Maggy* is a symmetrical head without ears, lacking the more audacious cranial incursions of Matisse's art. There is nothing demonstrable in terms of shaping, facture, character analysis, or composition that Matisse could have learned from Duchamp-Villon. The large proportions for the nose have an older ancestry in Matisse's art than in that of Duchamp-Villon. *Jeannette V* is a more sophisticated conception and less dated than *Maggy,* despite contrary claims.[88] *Maggy* belongs to a group of pre–World War I sculptures that show reductiveness and hard, firm surfaces. The very conceptions of the bases and necks predict the overall differences in the two heads. *Maggy* has an almost Egyptian facial set, a remoteness and self-enclosed quality that is alien to the more assertive *Jeannette V* and to Matisse's ideas of what constitutes the mystery of the face. In *Maggy,* both subject and artist have assumed an impersonality, a cool, cerebral quality, that undoubtedly chilled Matisse at the time when he was insisting upon the evidence of feeling in art. He also said that he discarded evidences of his own rationalization in portraiture, which polarizes his position in relation to that of Duchamp-Villon.

HEAD OF MARGUERITE, 1915

The next portrait made by Matisse was of his daughter Marguerite, executed in 1915 (plates 182–84). In comparing the sculpture with his two painted portraits of Marguerite done in 1916 and 1917, one is struck by the narrowness of proportion in the head when seen frontally. Viewing the sculpture from both sides suggests that Matisse was making two profile studies of his daughter; one with the right eye closed, the other with the left eye open. The lateral compression of the mouth augurs what he will do in the *Head of Lorette* (plate 185) in 1916, where he seems to have boldly repainted the woman's left cheek and reduced the symmetry of the lips. Asymmetry was a crucial means for individualizing his subjects in portraiture, and in the *Head of Marguerite* it also gives him the opportunity of presenting his subject in two different moods. The wrenching of the nasal axis out of vertical alignment may have been encouraged by a profile viewing of the sitter or may have resulted

182 *Head of Marguerite* (front view).
1915.
Bronze,
12 5/8" high.
Collection Pierre Matisse

137

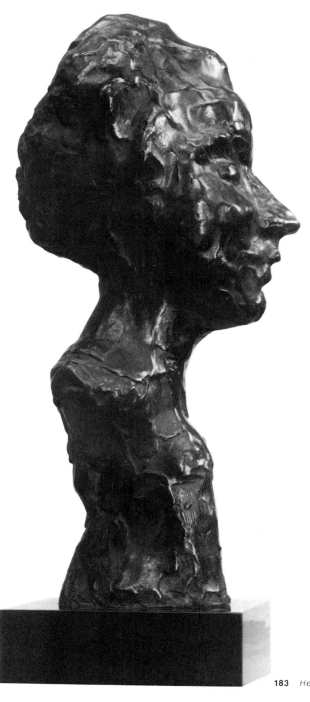

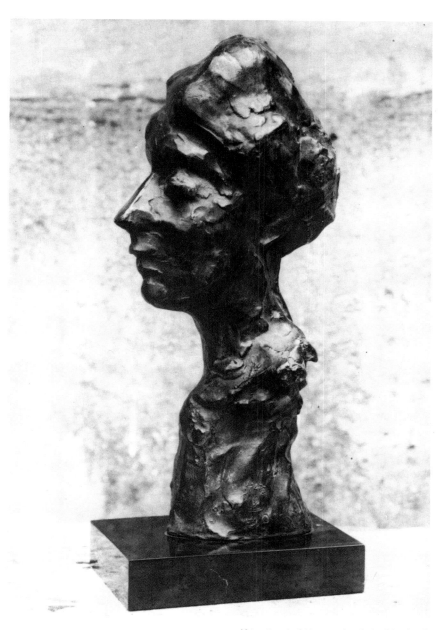

184 *Head of Marguerite* (left side view)

183 *Head of Marguerite* (right side view)

from the haste and impetuousness of the work's making. What is apparent is that the solution to the problem of imaging *Jeannette* did not fit the problems of interpreting his daughter. His painted portraits invited frontal studies, while sculpture gave him the incentive both to examine the profiles and to animate the face by internal modeling to a degree he did not consider appropriate in oil.

The First Sculptures in Nice, 1918

Matisse's biographers make it clear that his permanent move to Nice in December, 1917, was a turning point in his career. Prior to that time, and especially during the war years, there was a sobriety to his mood reflected in the tone and ruthless execution of many of his paintings. In this medium the impact of Cubism was strongest in his severely linear and stiffly graphed *Head, White and Rose*, of 1915 and perhaps in the *Bathers by a River* of 1916–17. He had contracted the bathers to straight and curved lines and consigned each of them to a roughly vertical color compartment. Although the chronology of the three sculptures which date from 1918 is not clear, they suggest, first, the continued flow of ideas, masculine energy, and recklessness from the paintings; then a return to the patience, discipline, and pleasure of studying museum art; and finally a new mood of contentment and détente in his style.

The baseless *Seated Venus* (plates 187–89), whose hands are clasped in front of her right leg, has an angularity achieved by the pointing of the shoulders, chin, knees, and elbow. Her bodily axes make it appear that she had been conceived within an invisible cube, the three-dimensional equivalent of the rectangular zones of the big painting of the *Bathers*. The hard vertical editing is made to tighten the arabesque, and Matisse has defeated suggestions of sensuous volume by slicing off areas of swelling in the body. The featureless, pointed oval head is as blank of expression as are those of the *Bathers*. The figure is a far cry from the 1909 drawing of the same pose in the Art Institute of Chicago (plate 186). The differences may not have been due simply to the models, but possibly also to Matisse's reworking of *Back III* about a year before, in which the figure was restricted by its own main axes, made more coincident with those of the edges of the relief, and its surfaces scored by the shearing effect of his knife. The tough-mindedness of Matisse in achieving a serious but brutal beauty without a single ingratiating gesture transcended any one medium.

Whether the copy (plate 190) after the crouching Rhodian Venus came before or after the *Seated Venus* is not clear. Matisse may have seen the fragmented small Greek torso in the Louvre early in 1918 (plate 191) or worked from a cast of it at the School of Decorative Arts in Nice, run by an old friend, where he modeled in clay during the afternoons. With the addition of the head, he made

185 *Head of Lorette.*
1916.
Oil,
14 ⅛ × 10 ½".
Musée Matisse, Nice–Cimiez

Henri-Matisse août 1909.

186 *Seated Woman Clasping Right Knee.*
1909.
Pen and ink,
11 ⅝ × 9 ¼".
The Art Institute of Chicago.
Gift of Emily Crane Chadbourne

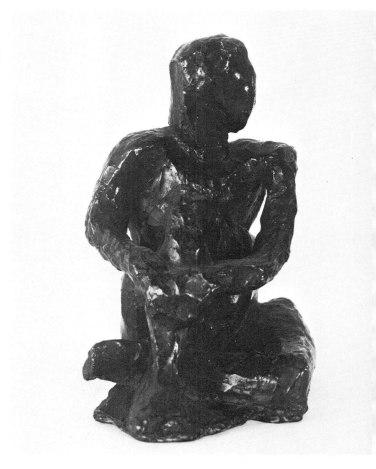

187 *Seated Venus* (front view).
1918.
Bronze,
9" high.
The Baltimore Museum of Art. Cone Collection

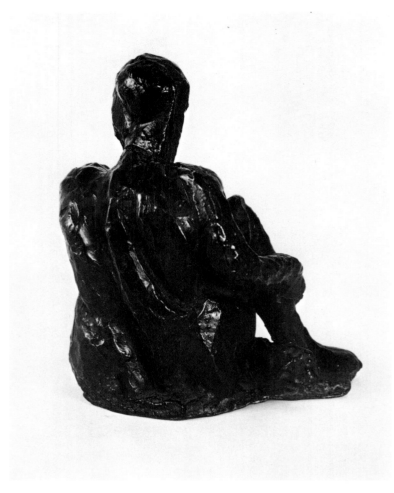

188 *Seated Venus* (back view)

the gesture of the armless body more circular, as if the figure existed within a shallow sphere, and his goddess took on the aspect of a coiled spring. Despite the rude working with the knife, the body has a full sensuousness denied the *Seated Venus.* Was this the expression of his feeling that he felt the Greek classical sculptors had denied to their art? After the flattened forms of his painted figures, was this sculpture a desire to again shape and feel the literal fullness of a woman's body? Unlike the big pictures such as the *Bathers,* the motif was given to him, and the strain of invention was lessened. But living in Nice was to provide him with new ideas.

The third sculpture of 1918, *Figure with a Cushion* (plate 192), probably came after the *Seated Venus* and *Venus.* In its pose and touch there is a lessening of the tension and disciplined reworking of its predecessors. The woman sprawls luxuriously, her form loose and free of any circumscribing geometry. The pose may have been indirectly inspired by memories of odalisques used by salon sculptors such as Becquet, who would pose their models so that the raised torso was supported by the prop of an urn on its side, from which issued water, inspiring the inevitable title, *La Seine et la Source* (plate 193). The girl's left hand was so arranged by Becquet

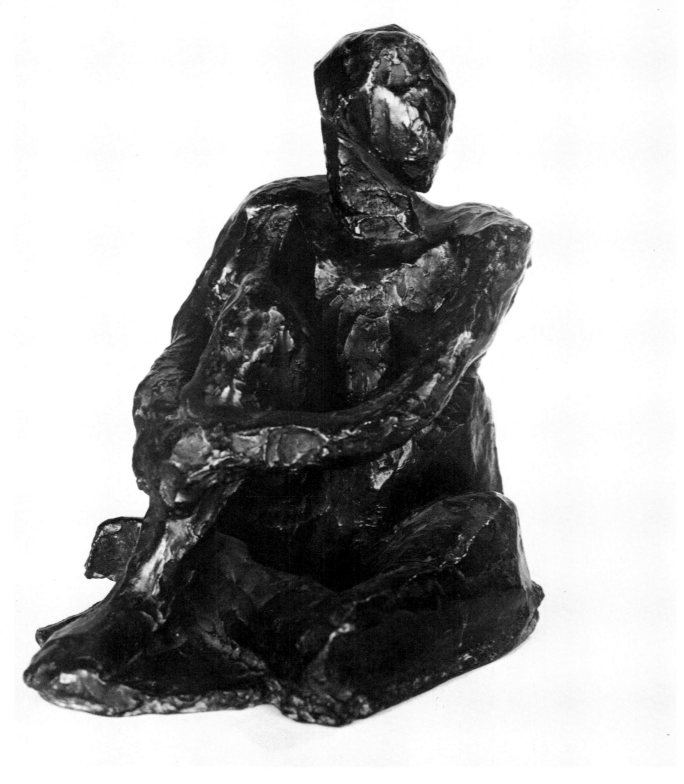

189 *Seated Venus* (three-quarter left front view)

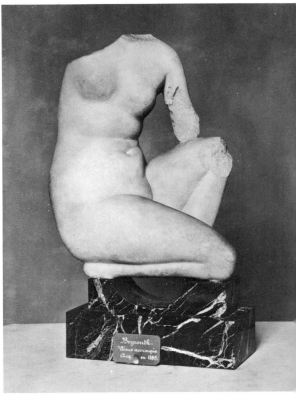

190 *Venus.*
1919.
Bronze,
10 ¾″ high.
The Baltimore Museum of Art. Cone Collection

191 Hellenistic. *Crouching Venus.*
Marble.
The Louvre, Paris

192 *Figure with a Cushion.*
1918.
Bronze,
5 ⅛" high.
The Baltimore Museum of Art. Cone Collection

193 BECQUET. *La Seine et la Source.*
Marble.
Whereabouts unknown

that she seemed hardly to weigh upon the support. Matisse employed a cushion to shore up the elbow and used no sleights of hand to disguise where the weight was taken. The bolster came from Matisse's Nice hotel studio, the frequent setting after 1918 of his painted themes of models in a pseudo-harem environment, inspired by another memory, the trip to Morocco. The feeling of détente in this last sculpture complements what was happening in the paintings, where for many years Matisse was to avoid tautness of drawing and to lighten his touch and palette in order to produce tasteful sunlit interiors, landscapes, and views of Nice. He was embarking on a lengthy new chromatic exploration, during which sculpture was to play no role in consolidating his ideas until the mid-twenties, when this study had run its course. His obsession with the light of the Mediterranean from 1918 until 1922 suggested no equivalent in sculpture.

The *Large Seated Nude,* 1924–25(?)

The *Large Seated Nude,* worked on probably between 1924 and 1925, signals still another return by Matisse to a personal form of classicizing. A photograph of Matisse in his Nice hotel room studio (plate 194), taken presumably after 1924, shows a portion of one wall and a door covered with his own work, as well as a painting by Courbet and reproductions, and possibly a print, by Renaissance artists. On the door panel at the left is a reproduction of Michelangelo's Medici tomb figure of *Night.* To the right, just below the Raimondi print after Raphael, is Matisse's 1924 lithograph of a reclining figure. Its counterpart of the same year is a lithograph of

194 Matisse and a wall of his Nice studio.
c. 1925–26

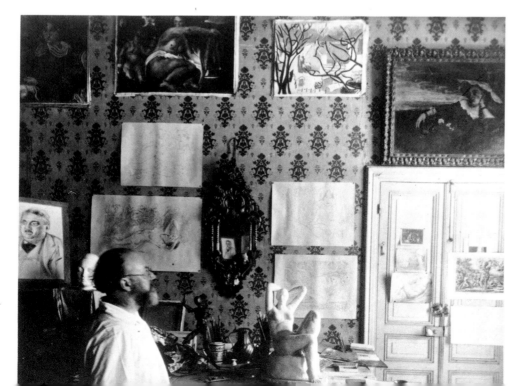

195 *Night.*
1924.
Lithograph,
10 ¼ × 17 ¼" (sight).
The Baltimore Museum of Art. Cone Collection

196 Matisse in Nice, Place Charles-Félix.
c. 1928

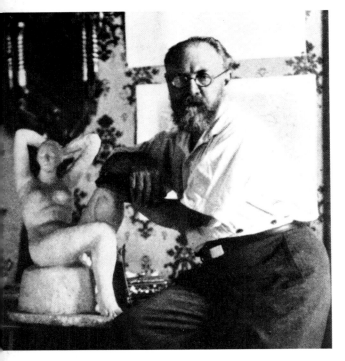

approximately the same pose reversed, which he titled *Night* (plate 195). The Michelangelo reproduction and the lithograph are just to the right of the first version of Matisse's *Large Seated Figure* in plaster, providing good grounds for assuming a relationship among all three. The plaster sculpture coincides in its orientation with the posted lithograph rather than with *Night*. Without such visual evidence—proving the value of photographing artists' studios with the works they pin up—to have suggested Michelangelo as a source for the *Large Seated Nude* would have strained the credulity of many readers, including Matisse's friends who wrote of the artist's distaste for the Renaissance and Michelangelo in particular.

In his splendid catalogue of the Henri Matisse centennial exhibition, Pierre Schneider published a letter from the artist to his friend Camoin, in which he wrote, "I am also working at the École des Arts Décoratifs directed by Andra, a former student of Moreau— I am drawing the *Night* and modeling it. I am also studying the Lorenzo de Medici of Michelangelo. I hope to understand the clear and complex construction of Michelangelo." This letter was dated April 10, 1918, six years before the lithograph titled *Night*, and the modeled form based on Michelangelo's tomb figure may have been the first plaster version of the *Large Seated Figure*.

Michelangelo used his postures and gestures to express strong states of mind or being. His allegorical tomb figure is expressive of torment. How surprising, then, that an artist who made art to soothe "mental workers" should draw his ideas for a sculpture of relaxed voluptuousness from such a source. Just as the reproduction isolated the tomb figure from its morbid environment, so, too, Matisse fixed his focus on the massive body and the arrangement of the legs. The exaggeration of anatomy by Michelangelo to make the pose plausible was not lost upon Matisse, particularly when it came to treating the upper torso and its portion of the twisting arabesque of the figure.

From photographs taken of the artist and his sculpture during these years there appear to have been at least three versions of this sculpture (plate 196), of which the first two were probably destroyed by the artist. What seems to have been the earliest version was cast in plaster and is shown in the artist's Nice hotel room with Matisse leaning on the woman's raised left knee. Was this sculpture the result of the modeling after Michelangelo in 1918? The photograph shows the proportions, facial treatment, and perfectly rounded silhouette of a classical Venusian figure, introduced into coexistence with the houris of the simulated harem paintings, although the latter provided the pose and cushion for the sculpture. This now lost sculpture suggests that, like Picasso at the same period, Matisse experienced a thermidorean reaction to his own radical art, a return to beautiful forms, a museum phase in which the figure was rehabilitated along the idealized lines of ancient prototypes. In this period Matisse felt compelled to move out of himself and the total

197 Photograph of *Large Seated Nude*
(second version?) in clay
in Matisse's hotel room studio,
Nice, 1924 (?)

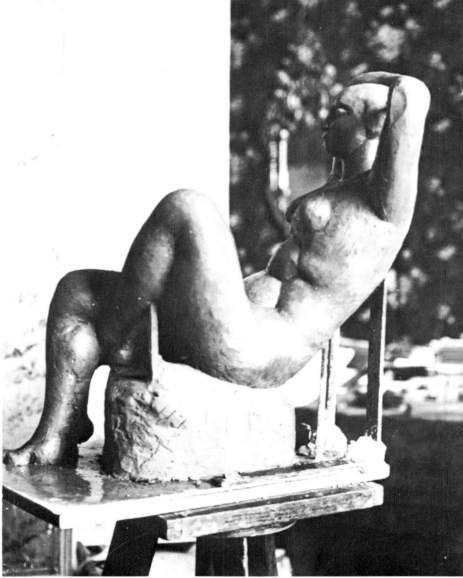

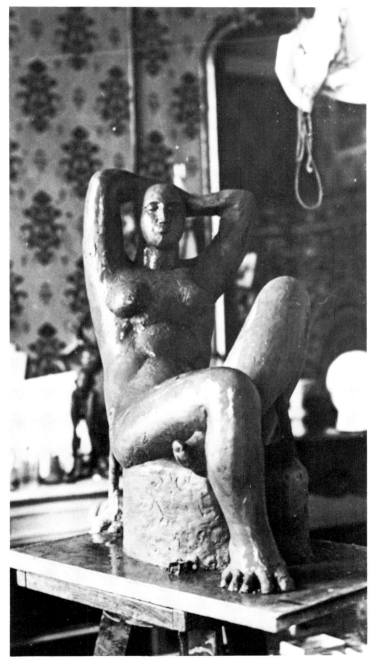

198 *Large Seated Nude* (left side view)

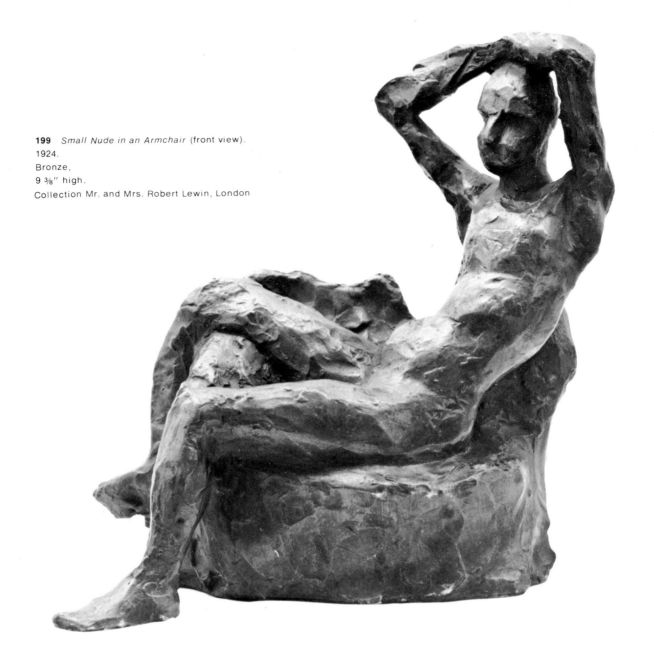

199 *Small Nude in an Armchair* (front view).
1924.
Bronze,
9 ⅜" high.
Collection Mr. and Mrs. Robert Lewin, London

obsession with his own sensations. This need for discipline and external influence was expressed in 1936: "The arts have a development which comes not only from the individual but also from a whole acquired force, the civilization which precedes us. One cannot do just anything. A talented artist cannot do whatever he pleases. If he only used his gifts, he would not exist. We are not the masters of what we produce. It is imposed on us."[89]

A pair of photographs taken of the second version of the *Large Seated Nude* while the clay was still wet (plates 197–98) shows that Matisse had not been satisfied with his reactions to the soft volumes of the body and was making changes in the direction of tightening the composition and altering its expressiveness. He had squared off the framing forms of the arms, changed the head's direction and the facial type to the schematic features and oval found in some of his paintings, and in omitting the hair established a hard cranial shape that set the tone for the reworking of the neck and body. The abdominal region lost its soft folds and creases in favor of a more

angular faceting, and the position of the raised leg was changed so that it met the other at a more severe angle. The cushion was trimmed back to make its edge tangent with the line of the torso, so that there was continuity between figure and support. Neither the lithographs nor paintings of the time show a comparable spartan quality in the figure.

While he was working on the *Large Seated Nude* in 1924 he made a smaller, more informal and slackly posed study of the same basic theme, positioning the model on a backed chair. This was the *Small Nude in an Armchair* (plates 199–200). It suggests that Matisse needed to untrack himself from intense concentration on the problems of the bigger sculpture. The smaller but more elongated torso shows the lower body turned to the side and the upper toward the front, as if the artist were testing the effects of two postures at

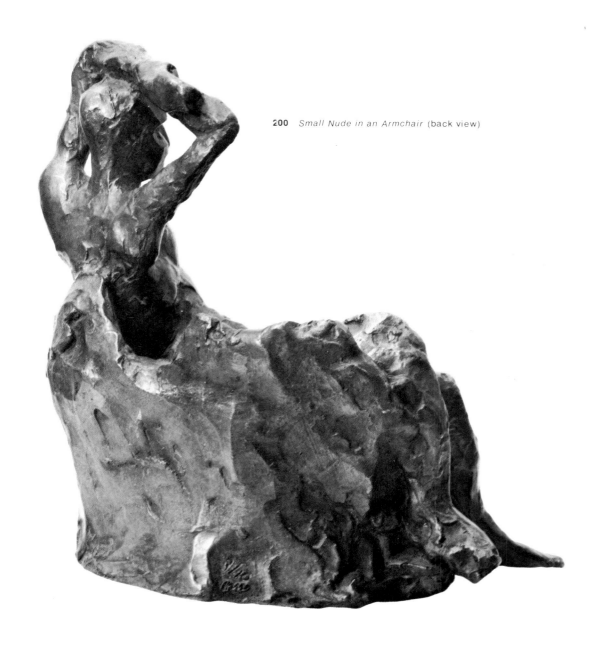

200 *Small Nude in an Armchair* (back view)

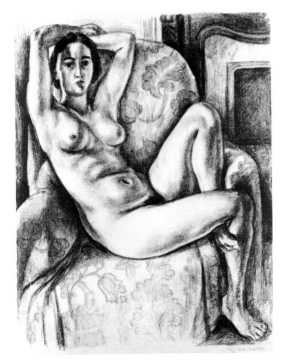

201 *Nude in an Armchair.*
1925.
Lithograph.
25 × 18 ⅞".
The Museum of Modern Art, New York City.
Gift of Abby Aldrich Rockefeller

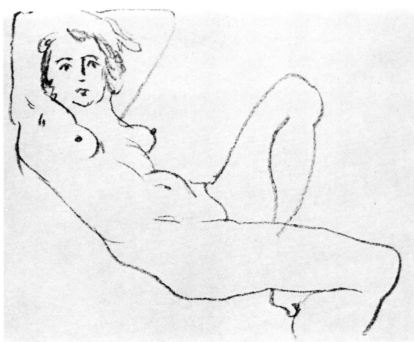

202 *Reclining Figure.*
1924.
Lithograph,
10 ⅝ × 16 ¼".
Stanford University Museum

203 *Odalisque with Raised Arms.*
1923.
Oil on canvas,
25 ½ × 19 ¾".
National Gallery of Art, Washington, D.C.
Chester Dale Collection

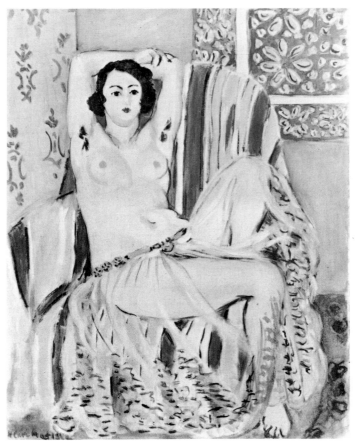

once. The *Large Seated Nude* (second version) differs from its lithographic counterparts in being less frontally oriented in the upper part of the body. The model's pose in the smaller sculpture is midway between upright and reclining, and it may have influenced the making of a semi-reclining figure of *Venus on a Shell,* which was destroyed some time after Matisse was photographed holding it. What we learn from the *Small Nude in an Armchair* is that it was a counterpoint to a larger sculpture, which in turn was an antidote to his painting of the period, all of which were accompanied by similar studies in prints and drawings (plates 201–3). To reinvigorate his art in the mid-twenties, Matisse again called upon all his resources.

In late 1924 or 1925, Matisse either redid the second sculpture of the *Large Seated Nude* or made a completely new version (plates 204–5). Almost the entire front of the figure has been redrawn with the knife, earning Matisse an intensity of emphasis which restored a masculine strength and intonation to his style, badly needed by then. The final figure has a more closely knit, more obviously achieved unification than its prototypes. Instead of muscular tension to convey the strain of the body's support, an equivalent effect is attained by the abdominal crease and angular surface planes which create it. Matisse has resolved in this sculpture his ideas on the silhouette and affirmed the pointedness of the raised left elbow, giving a more expressive contrast between the round and angular in the arabesque. The intervals made by the arms and legs are more obviously calculated, more assuredly worked out than in any to be found in paintings or drawings of the time: his sculptural figure had to be

204 *Seated Nude* (front view).
1924 or 1925.
Bronze.
31 ½″ high.
The Baltimore Museum of Art. Cone Collection

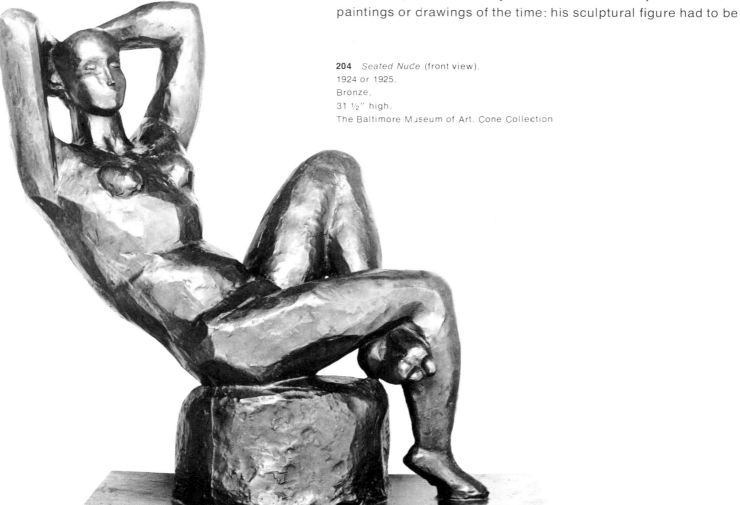

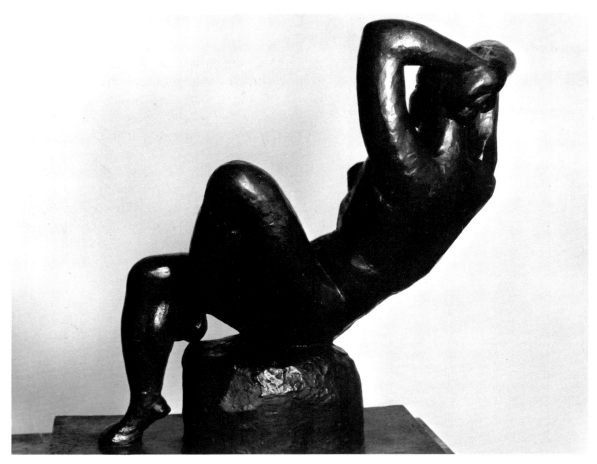

205 *Seated Nude* (back view)

self-sufficient. The artist once commented, "Drawing is like an expressive gesture, but it has the advantage of permanency. A drawing is a sculpture, but it has the advantage that it can be viewed closely enough for one to detect suggestions of form that must be much more definitely expressed in a sculpture which must carry from a distance."[90]

The *Large Seated Nude* may also have satisfied Matisse that he had found in sculpture the means to work with the Mediterranean light. He had insured concreteness of form against the accidental effects of light. Luminosity would not weaken solidity or expressiveness. He had started by recourse to an ancient, external influence, but in the subsequent process of study he had returned to his natural practice of being attentive to his own reactions, a process which Lawrence Gowing has beautifully analyzed: "His method was to watch his reaction, and his reaction to the reaction, and so on, until the cumulative process gathered a momentum of its own that became irresistible. 'I am simply conscious,' he wrote, 'of the forces I am using and I am driven on by an idea that I really only grasp as it grows with the picture.' "[91]

In some ways this was Matisse's most audacious work in sculpture. Taking a casual pose from painting, he had swung the sculpture out into space, divided it into two radically different parts, and complicated the problem of imparting the sense of a single

continuous central axis about which the figure was constructed. From an installation photograph taken in the 1930 Galerie Pierre exhibition it seems that, as in the 1907 *Reclining Nude,* Matisse felt his preferred view was a three-quarter frontal position. This placed the viewer directly opposite the head and raised arms. From the contemporary lithographs of the same pose it is clear he depended upon the erectness of the arms, neck, and head to give a semblance of classical balance. Richard Moore has discussed how Matisse's solution to stabilizing and equalizing the importance of both halves of the figure related to academic ideals of aplomb.[92] When through photographs we see the *Large Seated Nude* in Matisse's wallpapered hotel studio, it is like a premonition of the 1927 painting, the *Decorative Figure on an Ornamental Background* (plate 206), in which the powerful sculpturesque form of the seated woman contrasts with the densely textured interior. The painting vigorously joins the flat, decorative arabesques Matisse had derived from Oriental painting with the three-dimensional sculptural arabesque developed out of Western art, but it was a synthesis he would not sustain.

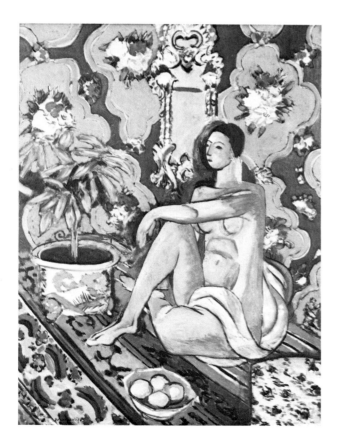

206 *Decorative Figure on an Ornamental Background.*
1927.
Oil on canvas,
51 ½ × 38 ⅜".
Musée National d'Art Moderne, Paris

Upright Nude, Arms over Her Head, c. 1927, and *Study for Raised Arms*

Two of the most intriguing unpublished works by Matisse are these two sculptures on view in the Cimiez museum. Mme Duthuit recalls finding them when she and Jean Matisse were transferring the contents of their father's atelier to the new museum. The half-length *Upright Nude, Arms over Her Head* (plate 207), was in "terre seche," the head slightly damaged, and Mme Duthuit had it cast in plaster. She believes that both sculptures date from about 1927 and were made from the model Henriette, who appears about sixty or seventy times in paintings, drawings, and sculptures of that period. Mme Duthuit particularly recalls the cylindrical neck and ovoid head of the model, which her father stressed in such paintings as the *Decorative Figure on an Ornamental Background,* the *Seated Nude* in the Brody Collection, *Odalisque with a Tambourine,* and drawings and lithographs of the seated nude. In all probability Henriette posed for the sculptures of the *Large Seated Nude.*

Matisse's daughter remembers seeing her father working with the smaller sculpture, reflecting on the possibility of adding it to a torso but then rejecting the idea. That these pieces were stored for so many years may indicate Matisse's feeling that they were incomplete or unresolved. Pierre Schneider suggests that these severed figures may have disturbed the artist as felled trees, particularly raw, upright stumps mutilated by the axe, had always disturbed him. That her father did identify the poses of these sculptures with trees—specifically, *Standing Nude (Katia),* 1950—was confirmed by Mme

207 *Upright Nude, Arms over Her Head.*
1927 (?).
Plaster.
Musée Matisse, Nice-Cimiez

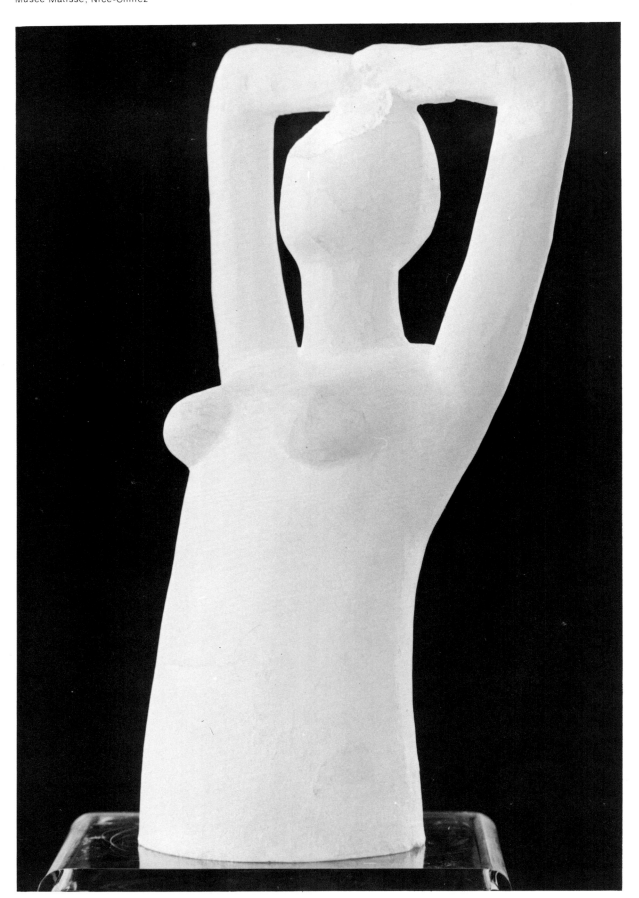

Duthuit. They constitute a different type of partial figure from those earlier discussed because of their horizontal cleavage or evidence of cutting.

Both sculptures are among the most abstract of all Matisse's modeled forms. Until we can see more of the drawings from about 1927, it is hard to say how much their elimination of features and purification of anatomy derived momentum from this source. Paintings such as *The Hindu Pose* of 1923 in the Donald Stralem Collection indicate that Matisse may have originally envisaged a figure seated cross-legged as well as a standing pose. The later *Seated Venus on a Shell* conception probably was rooted in this figure.

The *Upright Nude* shows how in his sculpture Matisse fought off the temptation of prettiness, as he did not in many paintings of the early twenties. There is studied resistance to perfected curves and graceful rounding off of the elbows. The upraised arms give an abruptly angled frame to the space about the head. The sharply defined spatial areas prophesy the paper cutouts after the fifties, in which there is an equivalence of figure and field. (Admittedly, photographing the white plaster against a black background prejudices the argument.) Whether cutting with scissors or truing clay with a knife, Matisse wanted the juxtaposition of the clean, clear big form and the matrix of irregular contours from which it derived. Like the last of the *Backs*, the *Upright Nude* is the congealing into a firm, simple form (notably the arching tubular torso) of countless previous essays with the motif, but unlike the great relief he still had ideas about redoing the concept. The durability of this obsession can be seen not only in subsequent paintings and drawings, but in the last sculpture he was to do more than twenty years later.

The smaller sculpture, while lacking a torso, is of the same pose (plate 208); it was likewise never cast in bronze or exhibited in the artist's lifetime. The almost tubular arms are more elastic, and there is a greater feeling of echoed roundness of shapes and space than in the larger work. The shoulders that have been pulled forward by the movement do not meet in a chest, but instead form a cave or flower-like enclosure for the head. The way that the curvature of the converging arms rhymes with that of the abstracted head was still another new formal invertion for this often repeated section of the body. The visibility of the spaces made by the bent arms and their distance from the head is minimalized. Depending upon the view, the gesture is either open or closed, a duality not possible in a single painting.

208 *Study for Raised Arms.*
Late 1940s (?).
Dried clay (?),
3 7/8" high.
Musée Matisse, Nice-Cimiez

The *Reclining Nude*s, 1927, 1929

When in 1927 Matisse returned to the modeling of an odalisque (plates 209–10), he changed the original direction of the pose. Was it to give himself a fresh start, literally a new perspective on an

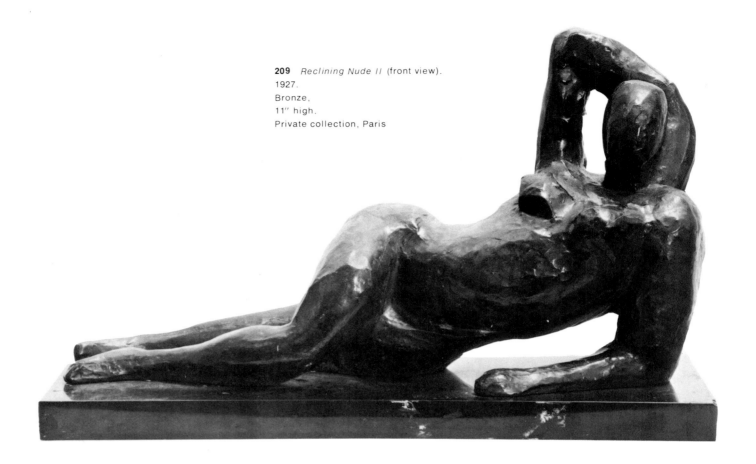

209 *Reclining Nude II* (front view).
1927.
Bronze,
11″ high.
Private collection, Paris

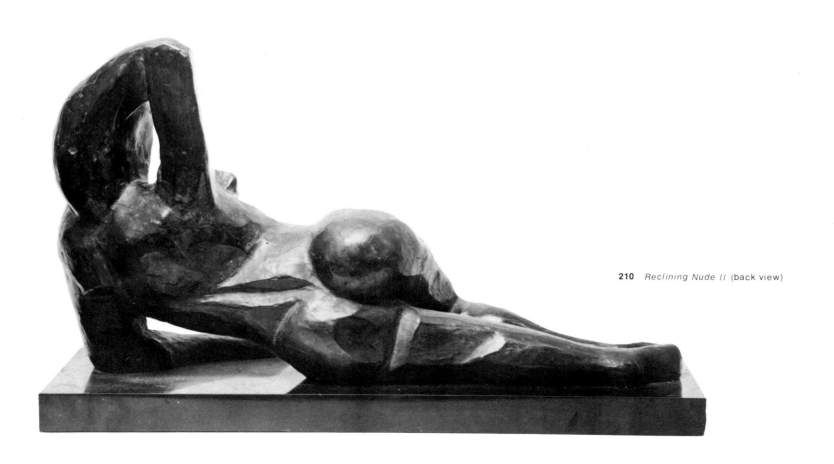

210 *Reclining Nude II* (back view)

old problem? Was it to accommodate the tendency to read laterally from left to right so that the head and raised elbow would form the climactic rather than initial elements? By contrast with the *Reclining Nude* of 1907, that of twenty years later was given a greater frontality with more severe torsion around a less sharply inflected central axis. From the front it is easier to read the phrasing and unity of the breasts, head, and arms. As in the *Large Seated Nude,* the contrast is clearer between the pointed elbow and rounded hip. (Matisse destroyed a large modeled odalisque done about this time, which did not have such a contrast. The repetitious rounded forms made this now lost sculpture seem bland.) The pleasure that Matisse took in strong and surprising contrasts is evident in the figure's back, which has received bold slicings and wedge cuts that achieve the curving spine and crease below the left buttock. His painting of a *Nude, Seen from the Back,* also of 1927, shows no comparable daring.

211 *Reclining Nude.*
1929.
Charcoal,
19 ½ × 24 ½".
Whereabouts unknown

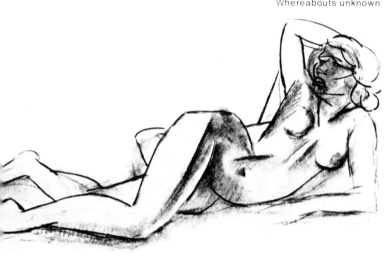

So strong is this redesigning of the back and the overall sculpture that the English sculptor William Tucker is inclined to see an important breakthrough in Matisse's sculpture, and he has given this sensitive analysis: " . . it was in the reclining figure that Matisse found the most satisfying solution: the reclining figure need not support itself by any but the most rudimentary anatomical structure; the problems of implied balance and muscular tension in the figure are avoided; the characteristic twist (Matisse's arabesque) can be the function of the sculpture as a whole, not of the pose (as with the standing figure). The recumbent posture he developed has no dominant front or back. . . . In all, the release from anatomical structural problems allows Matisse to invent, to use shape expressively in a new synthesis of the parts of the body."[93] Matisse could only have agreed with this analysis in part, because after 1929 and *Reclining Nude III* he was again to make sculptures of seated and standing figures, which did not inhibit his inventiveness. Interestingly enough, in 1930 at the Galerie Pierre, Matisse showed his *Figure with a Cushion* (1918) from the back.

In the odalisques of the late twenties it has sometimes been suggested that Matisse had arrived at abstraction with no regard for the subject of the sculpture. In the *Reclining Nude III* of 1929, he added hair to the otherwise almost purely geometric form of the head. Matisse, rather than putting his subject completely at the service of abstract form, put abstract form at the service of expressing his reactions to the essential nature of his feminine subject. His women in the sculpture of the late twenties have become more generalized, or typified, but do not lose the image of their sex. His inventiveness lay partly in finding new syntheses and shapes by which to increase both the feminine sensuality and formal perfection of his sculpture.

In 1929 Matisse did a drawing of an odalisque (plate 211) in which he pointedly and flatly reconstituted the normally undulant silhouette of the body in a mode that was consonant with his use of the knife in

the 1927 *Reclining Nude II*. The hard, straight cuts in the sculpture may in themselves have been descendant from his scaffolding-like drawings of women done during the war. The 1929 drawing shows Matisse moving away from the seduction of abstraction, particularly in the treatment of the face and hair. What he steadfastly wanted to avoid was stylization and the loss of that which inspired feeling. Perhaps he felt that abstraction offered such risks.

The 1929 photograph of Matisse working on the *Reclining Nude III* (plate 212) is remarkable in the clarity with which the intensity of his effort is mirrored in the artist's face. From the unfinished state of the clay under his hands we can see how Matisse did not prefigure all of his changes in his head, but made them only after studying each stage. Up to the time the photograph was taken he had changed the direction of the head, now averted from the viewer, giving the sculpture a new closure and fresh rhythmic pairing with the reshaped, reproportioned, upraised arm. The hardening of the woman's neck into a clean cylinder form, which is visible in the photograph, was probably the first step in moving toward the final form. Once this had been done the sculpture had to be reworked in its entirety in order to be consistent.

Reclining Nude III (plates 213–14) carries within it some of the most abstract design in Matisse's art, and to some it may suggest a disinterest in the motif—"no image" as one writer has recently put it.[94] But what Matisse had achieved was his ultimate expression of an elegant but almost torpid voluptuousness in the odalisque. For all the drastic changes the woman's sexuality is even more insistent. This elegance in sculpture meant inverting the customary

212 Matisse modeling *Reclining Nude III*. Nice. 1929

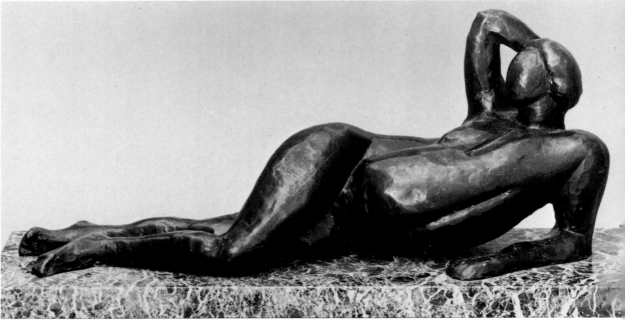

213 *Reclining Nude III* (front view). 1929. Bronze. 7 ½" high. Joseph H. Hirshhorn Collection

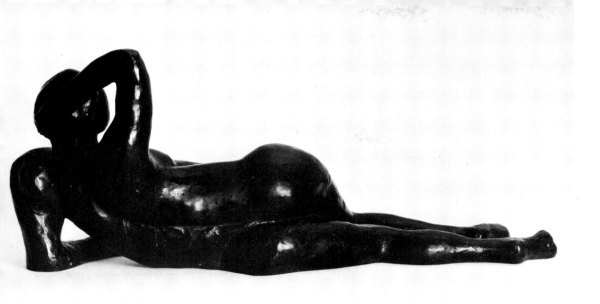

214 *Reclining Nude III* (back view).
The Baltimore Museum of Art. Cone Collection

anatomical association: turning from slimness to a drastic thickening
of the woman's trunk, flattening out the suggestive curve just above
the raised right hip, pressing the breasts flat against the chest, and
incising two vertical creases into the torso to give animation and
direction to the increased bulk and twisting of the upper body. This
ruthlessness resulted not only in a revelation of new sculptural form,
but also in a heightened sense of the woman's languor. Matisse had
stopped painting by 1929, and when he resumed in 1932 with the
Barnes murals, his figures inherited the formal elasticity of the body
found in the *Reclining Nude III.*

The Two *Torso*s, 1929

In the same year that Matisse was stretching and twisting the full
figure into new shapes, he also gave us the most distilled expression
in sculpture of his thought and feeling about women (plates 215–16).
While working on the problem of arranging the full body
longitudinally, Matisse may have decided to take up the challenge of
its most economical latitudinal expression. Two audacious and
little-known sculptures are a pair of small torsos, originally without
bases, which were probably inspired by a Roman copy of a Greek
torso that he had owned since before World War I (plate 217). The
larger of the modeled torsos comes closest in configuration to the
ancient fragment. As was to be expected from past performances,
Matisse had no desire to simulate a ruin and by the rounding off of
the silhouette discouraged imagining the missing parts. The modest
proportions of the Greek girl's bust continued to influence Matisse,
but the sensual, personalized contour of his sculpture evokes the
reaction he had to the subject. The smaller of the two torsos is the

160

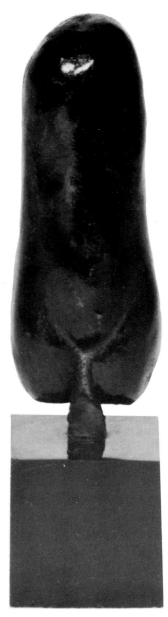

215 *Small Torso.*
1929.
Bronze,
3″ high.
Private collection

216 *Small Torso.*
1929.
Bronze,
3″ high.
Private collection

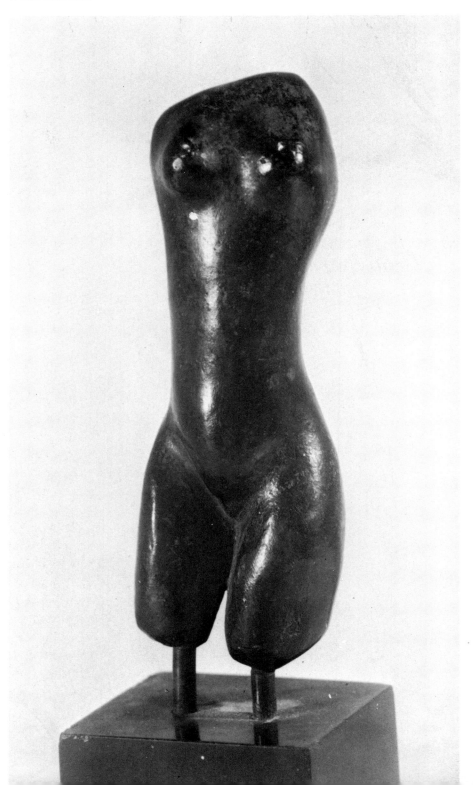

217 Greek. Torso fragment.
Fourth century B.C.
Marble, Roman copy,
24 ¾" high.
Musée Matisse, Nice-Cimiez

most daring contraction of the body in Matisse's art. The form recommends a phallic allusion and defeats the idea of "no image" in his art at this time. Despite its discrete size, this small sculpture seems to sum up, and in a more candid and succinct way, the artist's erotic feelings expressed in the paintings of the decade. Like Brancusi, having arrived at a sculpture which consisted of a single shape and surface, Matisse felt the need to recomplicate his sculpture. The small torso was seminal to the first *Venus on a Shell* of 1930 and may also have contributed to the resolution of Matisse's problem with the last version of the *Back*.

The *Henriette* Portraits, 1925, 1926–27, 1929

The effects of Matisse's classicizing and thoughts about monumentality resulted in the depsychologizing of the human head in the *Henriette* series. The first portrait is a sensitive, nuanced study of the model, which already carries in its proportions and general configuration the essence of the second version. To preserve the idiosyncratic asymmetry of *Henriette I* (plate 219), Matisse individualized the formation of the eyes and the right and left contours of the face. Perhaps to achieve the same effect, his painted portrait of Henriette, *Femme à la Voilette (Woman with a Veil)* of 1927 (plate 220), shows the willful distortion of the proportion of the left side of the woman's face where t is supported by the hand. But this reproportioning and redrawing cf the shapes of the head can also be explained by its context within the painting's emerging design and the artist's apparent desire to coordinate the curve of the face with that made by the woman's right arm.

In the first sculptural portrait the patch of clay on the forehead suggested to me that Matisse was concerned with insuring the concreteness of this area under strong light. Pierre Schneider pointed out in a conversation that the artist's family refers to this lump as a "pastille," which the artist would use at the end of a working session. The pastille had the effect of creating a "breach," flaw, or weakness by which Matisse could then "re-enter" the work when he took it up again. This makes one wonder if the left eye of *Jeannette V* was not a "pastille" made by the artist at the time, but of which he never again availed himself in order to take the last head further. Many are the paintings which he had finished and were then slashed with a stroke of the brush or nub of the brush, intending to rework them, but for various reasons failing to do so.

By 1925, Matisse had not done a modeled portrait since the *Head of Marguerite* ten years before, and one senses the desire of the artist to extend into portraiture the fullness of form he had been working with in the *Large Seated Nude*. *Henriette II* (plates 221–22) is the most symmetrical and detached treatment of the face that he

218 *Torsos* from *Jazz*.
1944–47.
Color stencil,
16 ¼ × 10 ¾".
Stanford University Memorial Library

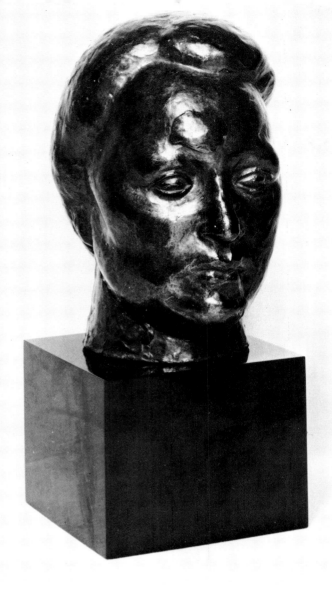

219 *Henriette I (Grosse Tête).*
1925.
Bronze,
11 ½" high.
Collection Mr. and Mrs. Nathan R. Cummings, New York City

220 *Femme à la Voilette (Woman with a Veil).*
1927.
Oil on canvas,
24 ⅛ × 19 ¾".
Collection William S. Paley

221 *Henriette II (Grosse Tête).*
1927.
Bronze,
12 ½ × 8 ½ × 10 ¾″.
San Francisco Museum of Art.
Harriet Lane Levy Bequest

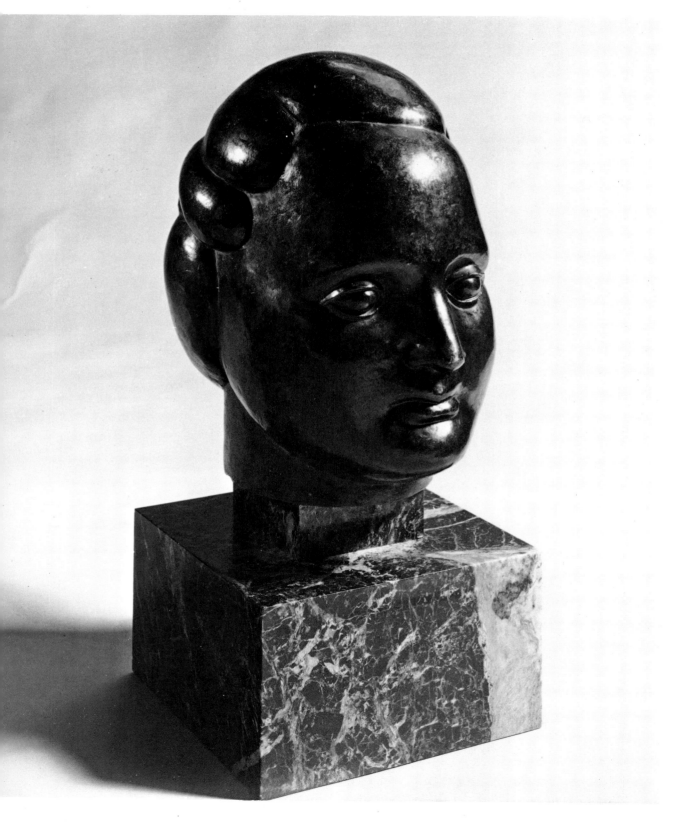

222 *Henriette II (Grosse Tête;* seen under different lighting conditions).
Private collection, Paris

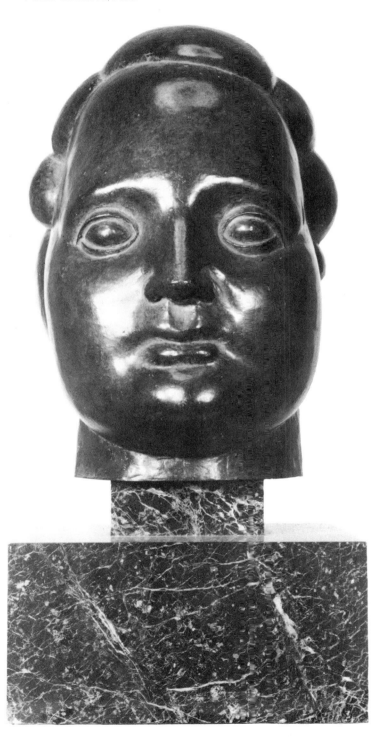

ever displayed in portrait sculpture, and it is the only work that approaches vacuity of facial expression under certain lighting conditions. (Two photographs of this head taken with different lighting and from different viewpoints illustrate almost contradictory effects.) To paraphrase the words of Picasso, the more Matisse elaborated a portrait the less descriptive it was, in order to become a vehicle of his own expression. *Henriette II* was the result of what Gowing has called a "compulsive purism" in the twenties, by which Matisse sought to avoid the complicated and disturbing in order to attain through purification a simplified harmony.

A photograph of Matisse at work on *Henriette II*, reproduced in *Cahiers d'Art* of 1926, shows a Baule type of mask hanging on the door frame to the room in which the artist was modeling the head (plate 224). It is not inconceivable that the masklike countenance of the second *Henriette* was influenced by the sculptor's meditations on this particular African mask, whose serenity and featural refinement seems closer to European taste than African. A similar photograph of Matisse at work on this sculpture shows still another mask hung from the wall just to the upper right of the African mask (plate 225). This was a Nice carnival mask, according to Mme Duthuit. The juxtaposition of these masks with the small painted portrait below them may have been accidental or done out of whim, but as arranged they constituted an interesting demonstration of ways by which the face, detached from any figural reference, has been treated in Western, primitive, and vernacular art. From the title that he gave the *Henriette* series, "Grosse Tête," and the total absence of the supporting bust, it is possible that Matisse was

223 Matisse working on the second head of Henriette in his Nice studio.
c. 1926

224 Matisse working on the second version of Henriette in his Nice studio

225 Matisse working on
the second version of Henriette
in his Nice studio.
In the foreground is a version
still in clay of the *Large Seated Nude*

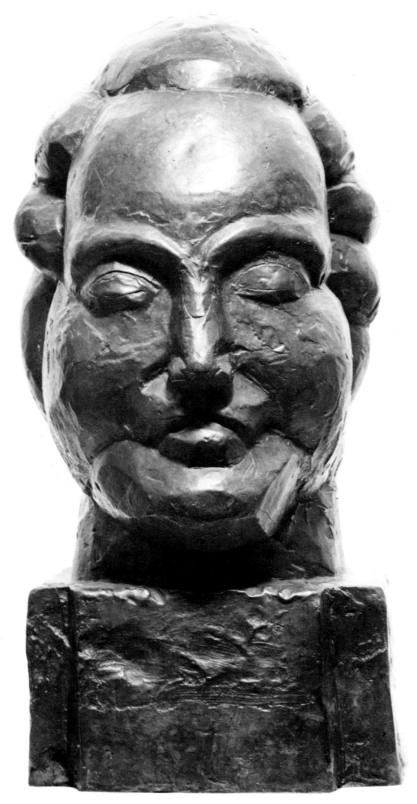

226 *Henriette III* (front view).
1929.
Bronze,
16″ high.
Collection Victor Waddington, London

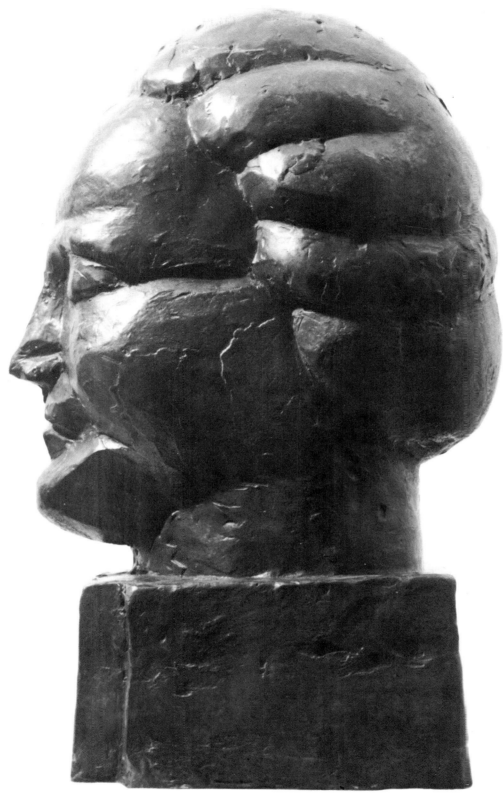

227 *Henriette III* (left side view)

interested not only in monumentality, but also in a type of
self-sufficiency associated with masks when not in use. He may also
have sought to fuse the portrait with the idealized head, the
concentrated expression of calm. But Matisse also had models for
this sort of imagery in the sculpture of his contemporaries.

The cold formality of *Henriette II* reminds one of Lipchitz's 1920
heads of Berthe Lipchitz and Gertrude Stein. Ironically, these heads
constituted a rehabilitation of more human qualities in Lipchitz's
art after his Cubist crystallized forms. When Matisse moved in 1929
to the third version of *Henriette* (plates 226–27), he may have sought
to restore expressiveness to the face, not so much in terms of the
woman's character (which would have created a puzzle of
interpretation), but rather in terms of his own reactions to the second
head. In such strongly reshaped areas as that above the mouth,
Matisse was flexing his artistic muscles. The restoration of ragged
evidences of his touch and the slashing of his knife relieved the
hard symmetry of the features and the severe frontality. The rugged
massiveness of the whole head, as an object, is reinforced by the
new cubicular base. But a change of place, a change of mood, will
again result in a change of mode, a shift in voice from the guttural
back to the lyrical.

The *Tiaré*, 1930

Following a trip to Tahiti in 1930, Matisse is supposed to have
combined the remembrance of a Tahitian flower, a tiaré or white
gardenia worn by the women in their hair (plate 228) with the shape
of a woman's head (plates 229–32). While to some it may suggest
a concession to Surrealism, within his own art it is a late flowering of
the tendency to analogize in an homage to the fertile beauty of
feminine nature. It is a remembrance of the fusion of the central
features of the head, seen in *Jeannette V,* and the format of the
Head with Necklace of 1907. The clean geometry of the heads of the
Reclining Nudes was still fresh in mind and hand. The Baltimore
Museum's *Tiaré* wears an actual gold necklace (plate 230), Matisse's
one concession to mixing his materials in sculpture, which adds to
her regal appearance and circular rhythms. The egglike head is the
fulfillment of Matisse's teaching references many years before, but
it is possible that Brancusi's purified heads encouraged Matisse to
dispense with the eyes and mouth to facilitate the metaphor. What
these late heads lost in terms of vigorous and passionate modeling
and psychological depth they gained in decorative splendor.

Tiaré has a special purity in Matisse's sculpture for having been
purged of traces of the forming process. Of all his sculptures, that
of *Tiaré* in theme and form seemed to him most eligible or worthy of
being transferred to stone. In about 1934 Matisse had his son Jean
carve a beautiful white marble version, which was kept in his Cimiez

228 A Tahitian gardenia—tiaré—from which Matisse was
inspired to do his sculpture *Tiaré*. (From *Hawaiian
Flowers and Flowering Trees*, by Loraine E. Kuck and
Richard C. Tongg, Charles E. Tuttle Co., Inc.,
Rutland, Vt., and Tokyo, Japan)

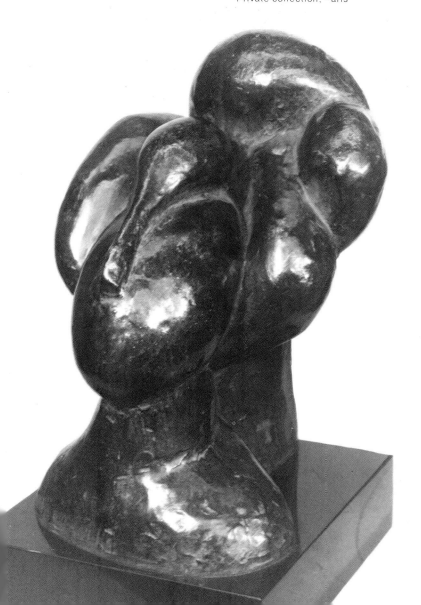

229 *Tiaré.*
1930.
Bronze,
8 ½" high.
Private collection, Paris

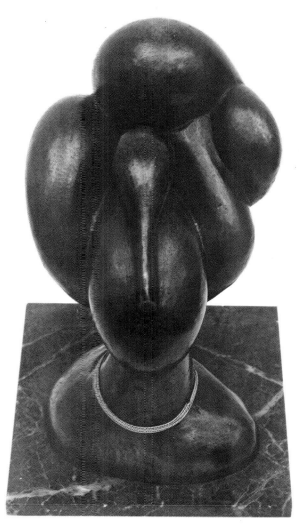

230 *Tiaré (with Necklace).*
1930.
Bronze,
8 ⅛" high.
The Baltimore Museum of Art. Cone Collection

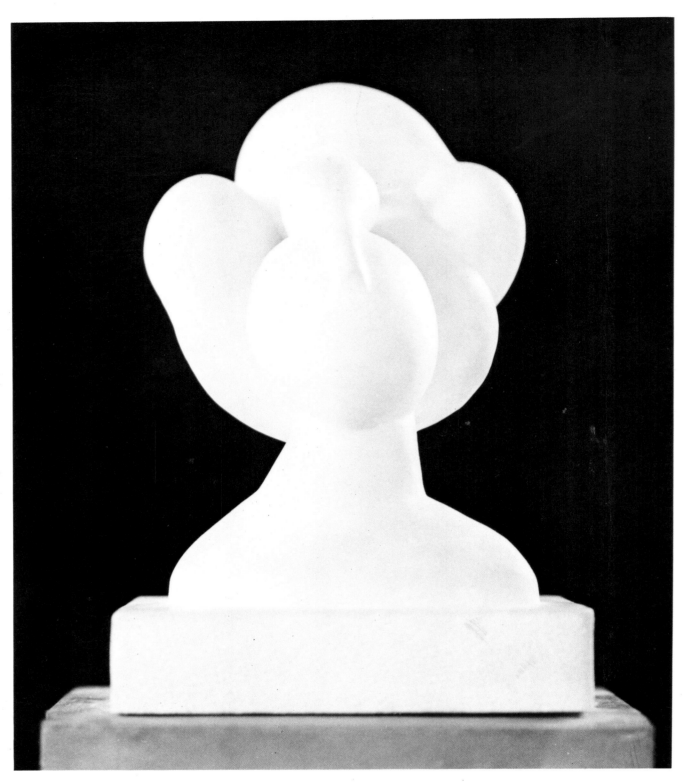

231 *Tiaré.*
1930 (?).
Marble,
7 ⅞″ high.
Musée Matisse, Nice-Cimiez

232 *Tiaré* (side view)

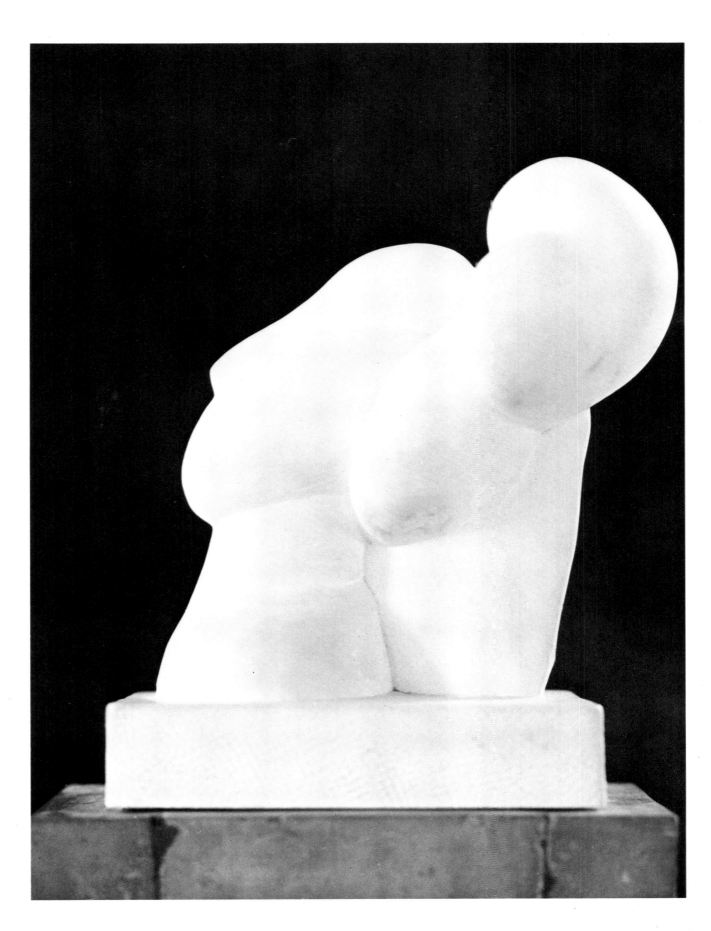

studio until his death. White marble gave the artist the color and light to show off the purity of his shapes and to extend the reference to the Tahitian gardenia. *Tiaré* suggests a symbol of Matisse and his art: its gesture, intended to give us pleasure, is open yet secretive. The form is irrational in its syntheses, calculated in refinement, eccentric and concentric in movement, and somehow always revolving about its fertile center like the artist, who once said, ''I am only interested in myself.''[95]

The *Back*s and Monumental Decorative Sculpture, 1909–30

The dream of monumental sculpture preceded by many years Matisse's making of his first relief of the *Back* in 1909. Far from having a ''distinct aversion''[96] to the scale and grandeur of the ancients (his casts of an archaic *kouros*, the *Apollo Piombino,* and his own Greek torso must be kept in mind), or harboring a complete antipathy to Renaissance sculptors as some writers would have us believe, it is conceivable that Matisse sought in this series to do for modern monumental decorative art what Michelangelo and the Greeks had done for religious sculpture. A photograph of Matisse's studio in 1953 (plate 234) shows the plaster cast of *Back IV* on one side of a large mirror, and the small cast of Michelangelo's *Bound Slave,* with its back turned to the camera, on the other. The problems of time, expense, and lack of studio space before 1909, rather than attitudes toward what sculpture should not be, accounted for the absence of works larger than *The Serf.* Matisse acquired a large studio at Issy-les-Moulineaux in 1909 (plate 233), and Gertrude Stein wrote of it, ''Soon the enormous studio was filled with enormous statues and enormous paintings. This was the period of the enormous for Matisse.''[97] The great demands upon his working time that sculpture of heroic scale would have exacted were the practical, not ideological, deterrents. But why should not an artist who painted large salon-size paintings at least think similarly about sculpture?

In the manner of many salon sculptors, Matisse did not undertake his first *Back* as the result of a commission. There is no published evidence that he had a specific architectural site in mind. Mme Duthuit says that he had to make the relief ''self-sufficient.'' The decision to work in relief may have stemmed from such mundane considerations as the problems of self-support for a life-size work, as well as the experience at that time of working on canvases of comparable size and subject.[98] Matisse may also have shared the interest of artists such as Maillol, Bourdelle, and Duchamp-Villon in countering the illusionistic relief by making sculptures that harmonized with the surface of the wall—more ''architectural'' than ''pictorial'' in character. In the summer of 1909, presumably before undertaking the sculpture, Matisse painted on a smaller scale his

233 *The Painter's Studio.*
1911.
Oil,
69 ¾ × 82 ¼".
Museum of Modern Western Art, Moscow

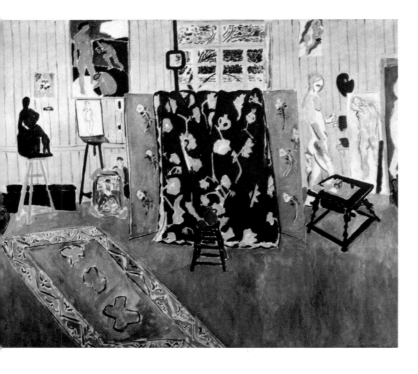

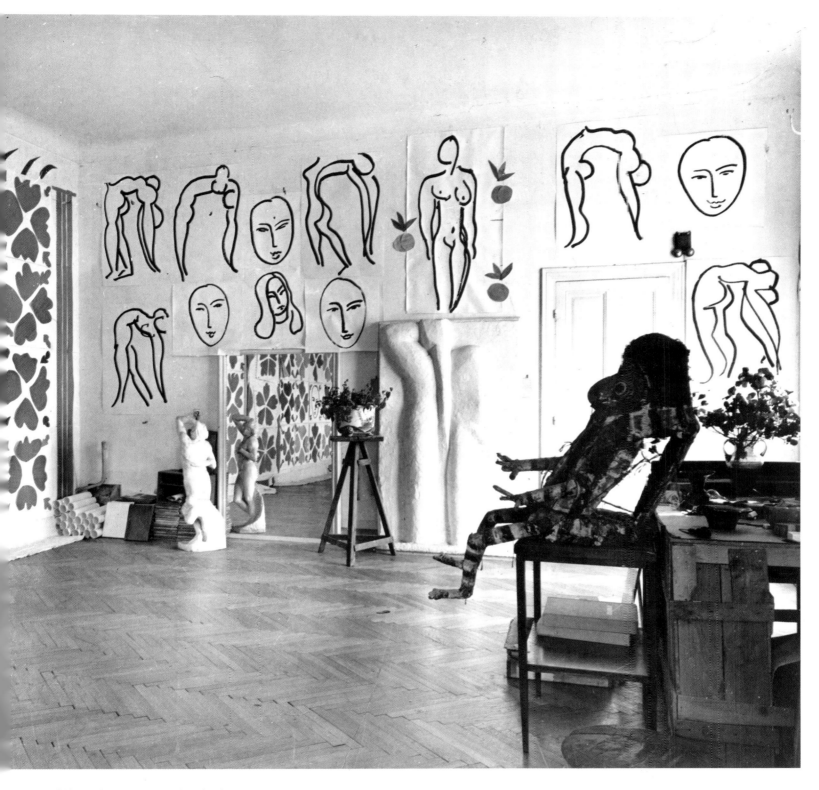

234 Matisse's studio in Nice showing
Back IV in plaster at the right and the cast
of Michelangelo's *Bound Slave* to the left of
the mirror. 1953

235 *Bather.*
1909.
Oil on canvas.
36 ½ × 29 ⅛".
The Museum of Modern Art, New York City.
Gift of Abby Aldrich Rockefeller

Bather (plate 235), now in the Museum of Modern Art, New York, which was of a motif and view of the body similar to that which he was to undertake in the relief. This painting may have contributed to his decision to undertake a subject whose viewpoint and scale seem to have no precedent in sculpture, although Mme Duthuit does not feel it was influential.

In 1908 Matisse made a small bas-relief of a full-length standing nude seen from the front (plate 236). This was perhaps his first idea for the project, and understandably he selected the conventional frontal view. Unlike Maillol and Duchamp-Villon, Matisse did not detach his figures almost completely from the rear plane, although, like them, he gives no reference to landscape and the background is unlocalized. Despite the relief's small scale it elicited a spirited, synoptic treatment of a postural cliché. The classical hipshot pose, closer to tradition than the upright woman in the *Luxe* paintings, gave the artist a simple body movement, an articulated framework upon which to dispose the projecting masses over the surface. Even in as small and cursory a project as this, the legs of the woman receive the most elaboration in terms of the musculature, securing the stance and the support of the figure's weight. The relief-like *Two Negresses* of the same year may have suggested the monumental possibilities of a woman's back.

What other causes turned Matisse from the admirable and time-tested conception of the *Standing Nude* bas-relief to the portrayal of a woman's back? Conceivably, as a teacher, Matisse shared the sentiments of Rodin on the limits of "official education," expressed before 1912 to a part-time painter and the Under Secretary of Fine Arts, Dujardin-Beaumetz. The student, Rodin complained, "doesn't see the back, or rather he sees it only when the model shows the back, and hides the face. And yet the spine is the principle armature, the very equilibrium of the human body. Does it surprise you, after this, that, in so many figures exhibited the length of the pilasters in our palaces of art, the backs are so rarely executed and so often dissimilated by artful draperies?"[99]

Rodin had himself modeled in relief the back of a *Siren* for a small ceramic vase manufactured at Sèvres between 1880 and 1882, and his sculpture, particularly in *The Gates of Hell*, contains many examples of powerfully modeled and expressive backs. He also made a small, half-length relief of a woman seen from the back which he titled *La Douleur* (plate 237), indicating that for him even this view did not inhibit the expression of the model's feeling. His archives reveal that he had a photograph of a model posed from the back.[100] Bartholomé and Dalou had also recognized the potential sculptural beauty of the feminine back (plates 238–39). Dalou executed a particularly sensitive plaster relief of this subject, which compromises the full-length back view by having the model turn her shoulders in order to present the head in profile. He created the illusion of the woman walking into depth, so that the left heel, compared with the right, is in high relief. In the Luxembourg Museum

177

236 *Standing Nude.*
1908.
Bronze bas relief,
9″ high.
Private collection

178

237 RODIN. *La Douleur (Despair).*
c. 1889.
Plaster,
12″ high.
Musée Rodin, Paris

238 BARTHOLOMÉ. *The Secret.*
1901.
Marble,
about 2′ high.
Whereabouts unknown

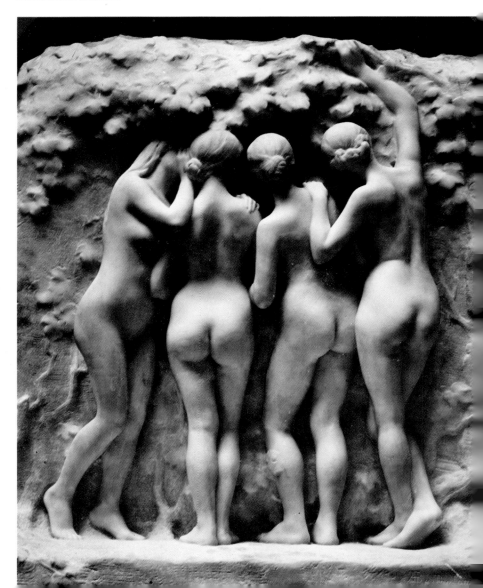

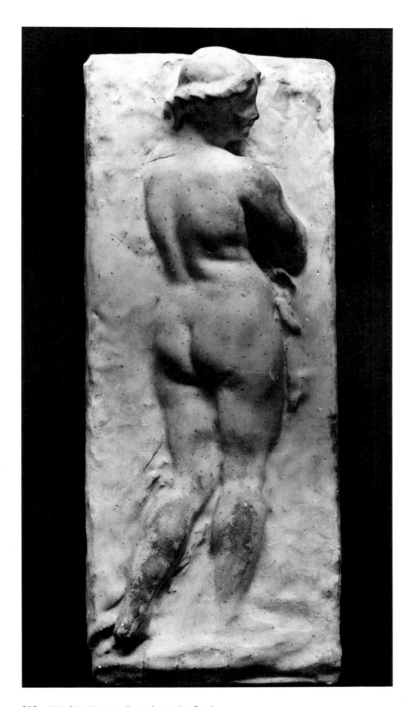

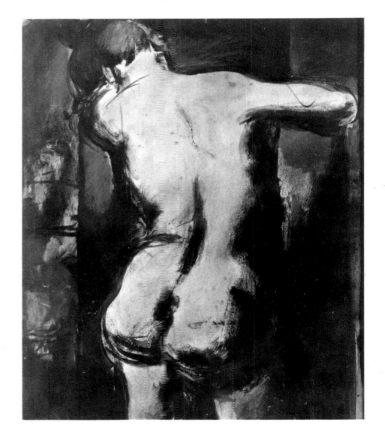

239 DALOU. *Woman Seen from the Back*.
Plaster relief.
Whereabouts unknown

240 ROUAULT. *Nude Torso*.
c. 1905.
Gouache,
15 3/8 × 12 3/4".
The Art Institute of Chicago.
The Olivia Shaler Swan Memoria Collection

241 MARQUET. *Model at the Bar*.
1906.
Charcoal,
8 ½ × 6 ½".
Collection Department of Prints and Drawings,
the Royal Museum of Fine Arts, Copenhagen

in Paris, Matisse probably saw Bartholomé's small relief for a fountain, in which a slender nude is seen from the back.[101] In the Salon of 1901, Bartholomé, best known for his *Monument to the Dead* in the Père Lachaise Cemetery, exhibited a beautiful small marble relief titled *The Secret*, in which three of his four nudes are shown from the back, as they gaze into some trees. Matisse was to forego these illusionistic and motivational or anecdotal devices in his own work, but it is interesting to know that in Paris at the time there were several small sculptural precedents for Matisse's point of view.

Closer to Matisse's immediate artistic world are the spirited drawings and paintings by his Fauve colleagues such as Manguin, Rouault, Marquet, and Puy. There are two paintings by Rouault of 1906 (in the Paris Museum of Modern Art and the Art Institute of Chicago) in which a fleshy model is shown from the rear as she rests her arms on a screen.[102] Rouault's obvious studio studies (plate 240) are close to the Matisse drawing of a fleshy model, *Study of a Model's Back* (plate 242). Alfred Barr first reproduced this drawing, done around the time of the first large relief; in it the woman rests by leaning against the studio wall. Matisse's close friend Albert Marquet did a drawing in 1906 (plate 241) in which the pose of the model is close to a second Matisse sketch in the Museum of Modern Art, New York, of the back of a woman at rest (plate 243). To these

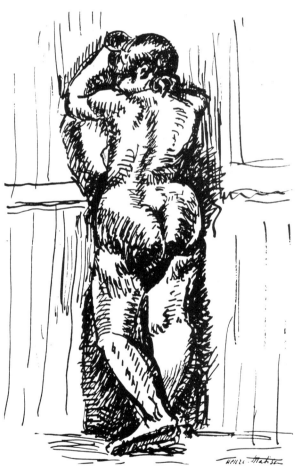

242 *Study of a Model's Back.*
c. 1910.
Pen and ink.
Whereabouts unknown

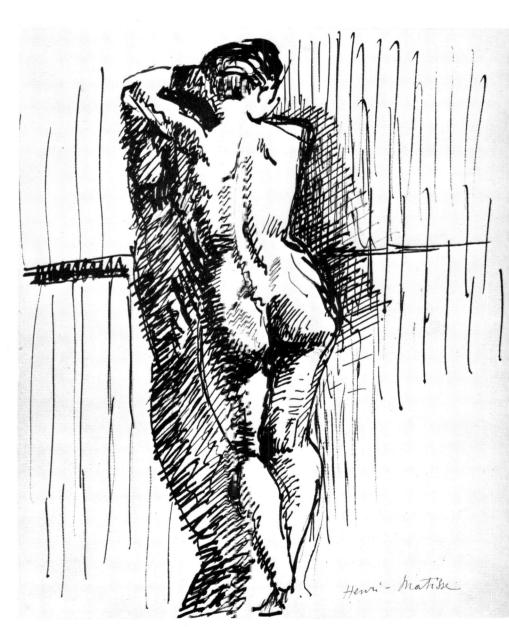

243 *Nude Study.*
1907.
Pen and ink,
10 ³⁄₈ × 8″.
The Museum of Modern Art, New York City.
Gift of Edward Steichen

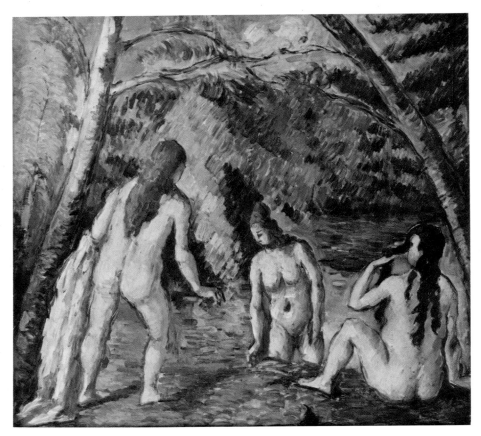

244 CÉZANNE. *Three Bathers (Trois Baigneuses)*.
1879–82.
Oil on canvas,
19 ¾ × 19 ¾".
Musée du Petit Palais, Paris

possible sources of ideas one could add all of the sculptures in which Matisse had made expressive backs, beginning with the *Jaguar* copy, and including *The Serf*, the *Dance*, the *Decorative Figure*, the *Serpentine*, the *Two Negresses*, and his paintings such as the *Seated Woman Combing Her Hair* of 1901 in the National Gallery, Washington, D.C. The Cézanne painting of *Three Bathers* (plate 244), which Matisse owned, had become interwoven with the fabric of his thought and formed part of the lineage of his 1909 painting of the *Bather*. That there was an abundance of sources upon which Matisse could have drawn does not distract from the audacity of his first monumental undertaking in sculpture.

The Five *Back*s

Since the death of Matisse we have grown accustomed to the idea of there being four large *Back*s, as they have often been cast in such an edition by the artist's family. Matisse had only remembered three when he was going over his life's work with Alfred Barr, the relief later numbered *Back II* having been forgotten in a Nice warehouse. In 1909, before moving it from the sculpture studio in his Paris school to the new studio at Issy, Matisse asked Druet, a restaurant and gallery owner and excellent art photographer, to photograph the first of his *Back*s. (Mme Duthuit says it was out of fear over possible damage in transit, as she does not believe that it had an armature.) From the photograph we can see that the first clay relief of this

subject (plate 245), to which the artist signed his name, is not the same that inaugurates the series in bronze. (It will be here labeled *Back 0* in view of the by now familiar numbering of I-IV of the bronze casts.) By itself it stands as a beautifu conception and accomplishment of modeling. The signature, the fact of being photographed, and the state of the clay surface strongly argue for its being a completed work in the eyes of the artist in 1909. There were, in effect, at least five *Back*s. That Matisse reworked the clay to achieve the second *Back* is possible, but not probable in view of his habit of keeping his different versions in separate casts. Mme Duthuit pointed out that her father worked in "soft plaster" to effect his changes.

BACK 0, 1909

Not surprisingly, the first of the reliefs, whose whereabouts today is not known, if indeed it still exists, is the most closely modeled in terms of its relation to the woman who posed for it. The ample fullness of the buttocks and contours, the creaselike spine traversing the middle of a smoothly and subtly articulated back, and the explanatory details of the legs in the area of the knees preserve the sensual appearance of the heavy model. It is the only *Back* which one feels has a fleshy quality, more through its overall aspect, softness of contour, and the tempered passages where there are creases formed by the musculature than in the facture itself. The second chronological relief, known as *Back I*, makes more sense as a reworking of an idea than as a beginning. and the series as a whole, rather than diminishing Matisse's effort, gains in scope and impressiveness of accomplishment.

In this first relief the problem Matisse set himself, in Alfred Barr's terms, was to study the "dynamic balance of forms on either side of the spine which, indicated by a deep furrow, follows the vertical median of the composition."[103] The problem might also be phrased in less abstract terms: how does one make an expressive, large-scale composition of a woman's back? This pose gave him the full-scale opportunity to demonstrate in sculpture that expression need not reside in the human face or gestures. By placing the figure's weight on her left leg, he was continuing the conventional solutions of Dalou and Bartholomé. Locating the left leg, which had been terminated above the ankle, in the relief's center accorded with Dalou's placement. But here the similarities end. Matisse was at first determined to avoid obvious solutions, such as symmetry, concealment of both hands and arms. and preserving the torso's isolation of contour by not showing the breasts.

He did show, however, selective acceptance of academic rules, notably by positioning the shoulders in relation to weight dispersal: "It is an academy rule that the shoulder of the leg upon which the body mainly is resting is always lower than the other."[104] This dictum, repeated to Matisse's pupils about the time he made the

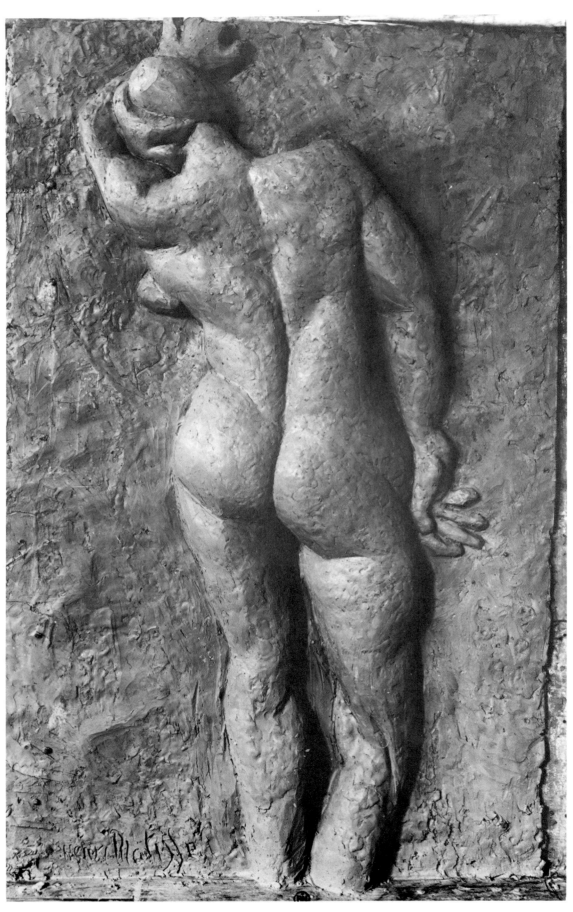

245 *Back* (first version, in clay).
Photographed by Druet,
c. 1909

first relief, abetted the asymmetry he wanted. But it was not enough
to satisfy him for long; presumably, still in 1909, having studied the
first realization of his conception, Matisse attacked the entire figure
in order to further aggravate its asymmetry and what may have
seemed too bland or unexpressive a treatment of the modeling.

BACK I, 1909

The second relief suggests that Matisse needed his own work,
rather than the model, to move his art into new areas of monumental
sculpture. The second version is more like a counterattack on nature
and his own first reactions (plates 246–47). Every contour was
rethought and for the most part rephrased, usually in a faceted
manner, as if he was cutting away the fat from his initial response to
harden and tighten the woman's form. The figure as a whole has
become more muscular, more articulated, less physically graceful
and centrally disposed within the relief's field. The differences
between the right and left side of the figure are maximized, although
the upper part of the spine is brought roughly more into accord with
the center of the neck. In the legs the artist has changed the altitude
of the left knee joint, aggravating the length of the weightless right
limb. Trimming away the flesh and tendon areas of the right knee
contracts the shape and clarifies the interval between the legs. The
upper part of the figure leans now more to the left, as it is further out
of plumb with the hip and supporting leg. The slight changes in the
left leg, which served to straighten it, gave a more stable anchorage
to the figure's center, but the curving spine is now contested as the
dominant direction as a result of the more rugged topography of its
adjacent areas. Matisse's more arbitrary proportioning and inflecting
of the back have introduced several new accents and axes which
diverge right and left of the spine.

If one takes the line of the shoulders, the creases in the back, and
the axes of the buttocks and knees, the result is a fan or open
divergence of movements. What he had in mind may have been
verbalized to his students when he said "One can divide one's work
by opposing lines (axes) which give the direction of the parts and
thus build up the body in a manner that at once suggests its general
character and movement."[105] The formal stability of the first relief is
in jeopardy; the sculptor's recognition of this was affirmed in the
succeeding reliefs.

Predictably the modeling of the second back has been termed
"Rodinesque." But this is not supported by the surface evidence
of the relief itself or its sculptural predecessors, as I have tried
to show earlier. Rodin's feminine backs such as La Douleur, have
a lithesome grace, a femininity of proportion, and a finesse of
facture without echo in Back 0 and Back I. Matisse's treatment
is broadly more Michelangelesque than Rodinesque. While Matisse
may have considered Michelangelo's work "decadent" in its
muscular display, he nevertheless was drawn to its vigorous

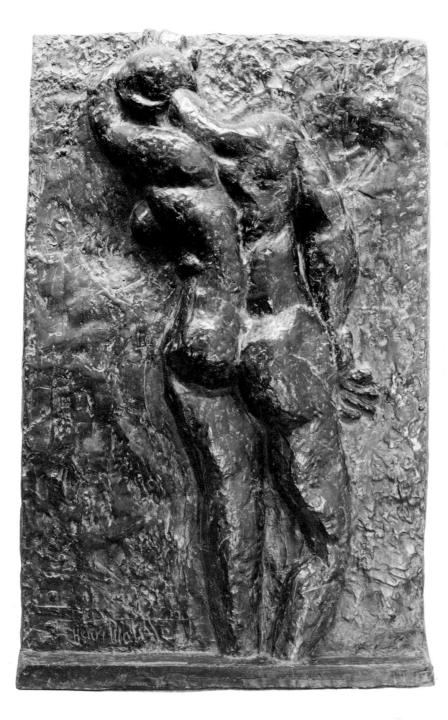

246 *Back I.*
1909.
Bronze,
74 ⅜ × 44 ½ × 6 ½''.
The Museum of Modern Art, New York City.
Mrs. Simon Guggenheim Fund

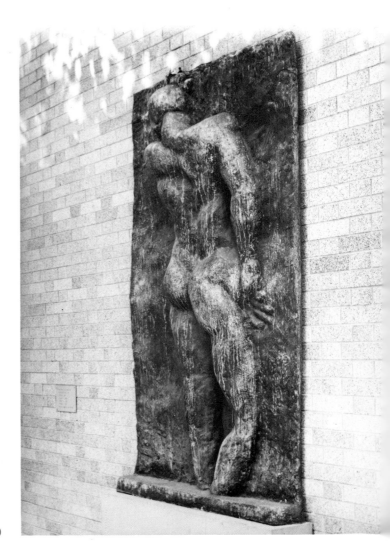

247 *Back I* (three-quarter view)

arabesques, such as he could have seen in the cast of the *Bound Slave*. He had previously reworked what he thought was Michelangelo's *Écorché*. He later parted from the cast of Michelangelo's *Bound Slave* in the *Checker Game*, *Piano Music*, and *Esclave à l'Intérieur* and hung a reproduction of *Night,* from which derived portions of the *Large Seated Nude*, in his Nice hotel room. The massively proportioned model he chose, perhaps with Michelangelo's women in mind, indicates that for a large relief Matisse did not feel a svelte model of *Serpentine*-like proportions were appropriate. There are views of this relief, specifically from the sides, in which the subject acquires an almost masculine massiveness and muscular quality. This mingling of masculine and feminine attributes Matisse could have seen in Michelangelo's work.

It is in the pose of the woman's right arm and hand that memories of Michelangelo are strongest. This arm is absent in the 1909 drawing. It is not a natural pose for the model to assume in this situation nor an *académie*, for the arm must be twisted in order to have the palm turned outward. This pronated gesture is to be found, of course, in Michelangelo's dead Christ in the Florentine *Pietà*, which Matisse undoubtedly saw in 1907. But this original inspired, although morbid, gesture had passed into sculpture and been vulgarized by artists like Baccio Bandinelli, so that it emerged at the end of the nineteenth century in such works as Rodin's *Young Girl Sitting by the Sea*. It is still possible that Matisse remembered Michelangelo's invention when he faced the problem of deepening the relief by separating the model's stomach from the wall, so that it would not seem embedded in the background.[106] Using the hand in this fashion cost Matisse the isolation of the hip's contour, which in his statuettes often leads to a partial figure. It is the only time in his sculpture that Matisse details the hand to this extent, and its treatment is in contrast to the mitten-like shape of the woman's left hand, which grips the top of the wall or screen. The gesture will lose its obtrusiveness only when Matisse later rereads it against the total decorative requirements of the relief and in the context of considerable overall reworking.

In older art, as Leo Steinberg has pointed out to me, Mary Magdalene was often shown naked and from the back. Rodin's *Christ and Mary Magdalene*, for example, shows the half-naked back of the Magdalene passionately clutching the crucified form of Christ. In my article on the *Back*s, I asked the question, "Did it occur to Matisse that the first relief could be interpreted as a grieving Mary Magdalene, who having helped lower the dead Christ, unconsciously assumes his gesture of death in Michelangelo's sculpture?" Mme Duthuit, in discussing this question, recounted a story of how a young German soldier once asked her father to let him have a relief of the *Back* for his own tomb. Matisse replied, "I have not made a *pleureuse*!"

When Matisse exhibited *Back I* in 1911, it was listed as "a sketch." This does not reassure us that at first Matisse contemplated more

than one relief. In view of his feelings against artists enlarging their sketches, however, his working out of the first version on the final scale, if it was intended as a sketch, was consistent. For reasons of economy of time and effort Matisse reworked the successive *Back*s from plaster casts. He probably added clay to the plaster where areas were to be built up, and as he cut this clay away he could have wiped it on the background, bringing figure and ground into textural accord.

BACK II, 1913

In the third relief Matisse moved in the direction of greater and more obvious stability of the figure and concision in its form (plate 248). He needed a strong central axis, and this was realized by straightening the spine so that it came more into line with the inside of the left leg. The leg itself was thickened in proportion, moving into the left area of the relief and coming more under the mid-point of the head. The effort of greater visual concision comprised reduction of silhouettes having several breaks to those having one or two continuous curves, as in the bather's legs and right shoulder. The exposed breast became more assimilated with the back and left shoulder, the neck muscles reached down to the spine, suggesting the plait for the next relief, and the head and left forearm fused. Many of the previous lines and axes of the back were expunged along with the more fleshy allusions. The roll of fat below the left breast was squared off. The intervals between the arms and body were reduced and simplified. The academy rule regarding weight and shoulder relationships was discarded when Matisse felt the imperative of linking the neck to the right wrist in a single arc of shorter radius than a raised shoulder permitted. This type of rounding off of the shoulder is also found in the portrait of *Yvonne Landsberg* of 1914 (plate 249). Both painting and sculpture have radiating arcs for the shoulder, in a sense a continuation from the *Bather* painting of 1909, in which Matisse left exposed his changes of mind. (With the intent to rework the picture?) In the sculpture the gash running from the right shoulder to the base of the spine may have been an effort to bring the two sides of the figure into greater harmony and perhaps came after his painting of the Landsberg portrait. Matisse had otherwise aggravated the discrepancies between the right and left halves of the figure, as can be seen by covering one side at a time. The figure seems to be moving in two different directions. This proved to be an abortive decision, however, perhaps because it drew attention away from the spine.

BACK III, 1916–17

It was not unusual for Matisse to begin an ambitious painting, encounter problems, and wait for years to resolve them, or to see ways of reworking what he had done some time before. While we

189

248 *Back II.*
1913.
Bronze,
74 ¼ × 47 ⅝ × 6″.
The Museum of Modern Art, New York City.
Mrs. Simon Guggenheim Fund

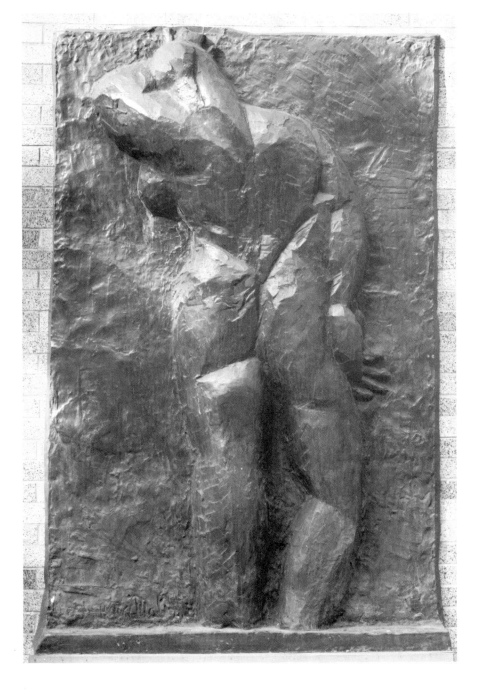

249 *Mlle Yvonne Landsberg.*
1914.
Oil on canvas,
58 × 38 ½″
Philadelphia Museum of Art.
The Louise and Walter Arensberg Collection

await publication of a catalogue *raisonné,* it would appear that the relief of *Back III* (plate 250) and the large *Bathers by a River* (plate 251) painting roughly coincide in the date of their final state, about 1916–17. The painting may have been initiated four years earlier. As has already been recognized, there are shared qualities in the composition and treatment of the painted and sculptured figures, which suggests Matisse was bringing to the solution of a sculptural problem ideas he had been working out in painting, particularly with regard to extending a reductive mode that stressed shallow curves and straightened edges, often joining both at abrupt angles.[107] This mode may have some relation to the Cubism of Picasso and Braque, but it might also be read as a fusion of the "feminine and masculine" modalities that appeared as early as 1906 in Matisse's own drawings, prints, and paintings. In 1908 Matisse had commented on the character of lines to his students: ". . . a curved line is more easily and securely established in its character by contrast with the straight one which so often accompanies it. . . . If you see all forms round they soon lose all character. The lines must play in harmony and return, as in music."[108]

Although he was talking about painting in 1936, Matisse gave to his friend E. Tériade a remarkable insight into how he criticized works done in series, which could explain what he was doing with the *Back*s: "My reaction at each stage is as important as the subject. . . . It is a continuous process until the moment when my work is in harmony with me. At each stage I reach a balance, a conclusion. The next time I return to the work, if I discover a weakness in the unity, I find my way back into the picture by means of the weakness—I return through the breach—and I conceive the whole afresh. Thus the whole thing comes alive again.[109]

The fourth relief, also built up from a plaster cast of its predecessor, shows the most vigor in terms of reformation of the conception ("returning through the breach"), and execution of the changes. A more decorative unity was imposed upon the body. A new chording was found for the back and its relation to the total relief surface. As Matisse had told his students in 1908, expression was by "masses in clear relation to one another and large sweeps of line. . . . All directions go to creating the sensation of the figure's erectness." Both relief and painting have been reconceived in terms of irregular, vertical zones, creating an explicit rhythmic series. The model's earlier slack stance of repose has been stiffened into one that is like a saluting figure at attention, which eliminates any need to show muscular tension. This change also squares off the main figural axes with the framing edges of the wall, but the upright head now extends slightly above the top of the relief. Recalling his own exhortation to his students concerning the rebuilding of the body, "It must have a spine," he has fashioned one sculpturally by means of the plait, which connects with the inside of the left buttock and leg, providing a hard, vertically inflected median for the relief. In this respect the bather at the far left of the painting of 1916–17 is

250 *Back III.*
1916–17 (?).
Bronze,
74 ½ × 44 × 6".
The Museum of Modern Art, New York City.
Mrs. Simon Guggenheim Fund

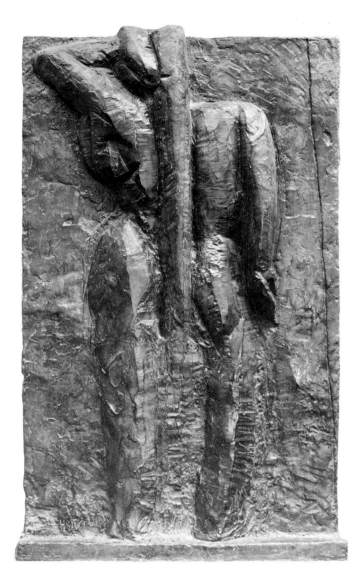

251 *Bathers by a River.*
1916–17.
Oil on canvas,
8' 7" × 12' 10".
The Art Institute of Chicago.
Worcester Collection

sister to the woman of the relief. Matisse even shaded the form of his painted figure to make more explicit the implications of her rounded silhouette. In the painting one senses the interaction of each figure's silhouette with an adjacent vertical zoning edge. So, too, in the relief, Matisse may have felt the need to introduce an engraved line at the right. James Rosati, who called this line to my attention, added that the mark was not from a crack in the plaster nor a casting fault, but represented an aesthetic decision which should be read against the new vertical combinations.[110] It may also have registered the thought of cutting down the relief on the right side or have been a "pastille" or "breach" to encourage reworking.

The vertical and diagonal directional accents have fallen into a clearer relationship favoring the former, as have the scale and number of shapes. Breast, back, and arm have become one; the hand is more of a "sign"; the left leg and buttock division is now indicated not by a crease, but by degrees of swelling and proportion. One should look at these reliefs from the side, not only to realize their considerable projection, but to see how thoughtful the sculptor was in varying their altitude from the back plane.

BACK IV, 1930

From a distance, the last relief of the *Back* series (plate 252) carries more clearly and completely but does not have the obvious vigor, evidence of chance-taking, and apparent formal richness of its ancestors. Returning to the series after many years, Matisse may have felt that in the fourth relief there was too much competition in expressiveness between large areas to achieve serenity, and the question of how much modeling to expose in relation to the total form had to be reconsidered. For the fifth time he organized his ideas, and the relief reflects the more nearly perfect order and clarity of his thought. All zones sustain each other more harmoniously. In this last transposition of the conception, each area impresses one as having been equally considered, and no single section is realized at the expense of another. The modeling softly animates and competes with the largeness of the form. The relief is more complex and sophisticated in its reductiveness than comparable figures in any of his previous drawings or paintings, such as the *Bathers by a River*. Matisse had extended himself beyond previous efforts to realize the body as a single form. The big masses and their relations were found deductively. He could not have foreseen the final simplified form in 1909, as the last contour presupposes all the previous irregularities literally underneath it (plates 253–56). Isolated and traced, the silhouette does not make the subject self-evident. The figure's identity needs both contours and the shaping of the full volumes, but as Mme Duthuit points out, the relief still retains "élégance féminine."

The final suggestive synthesis of the body is further tribute to Matisse's mind. There are three simple vertical areas, two of which

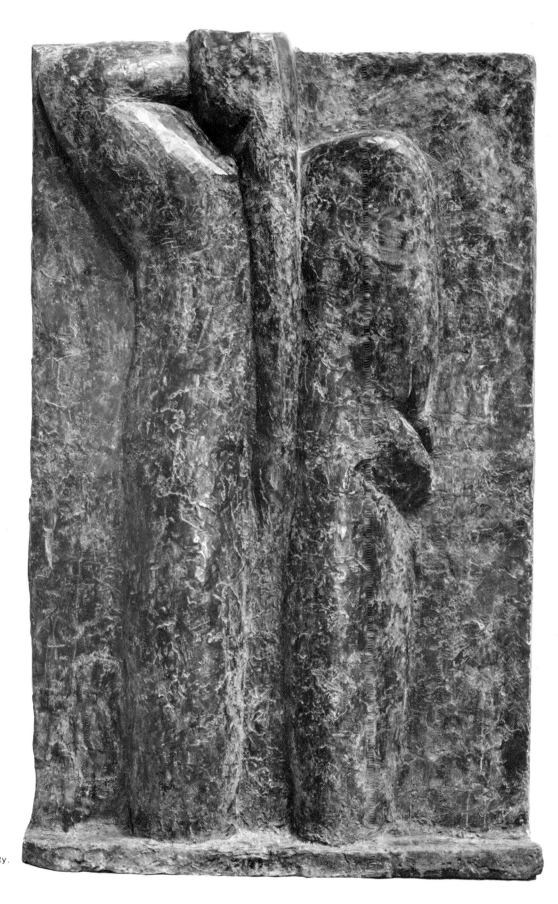

252
Back IV.
1930.
Bronze,
74 × 44 ¼ × 6″.
The Museum of Modern Art, New York City.
Mrs. Simon Guggenheim Fund

253 *Back I* (detail of right hand)

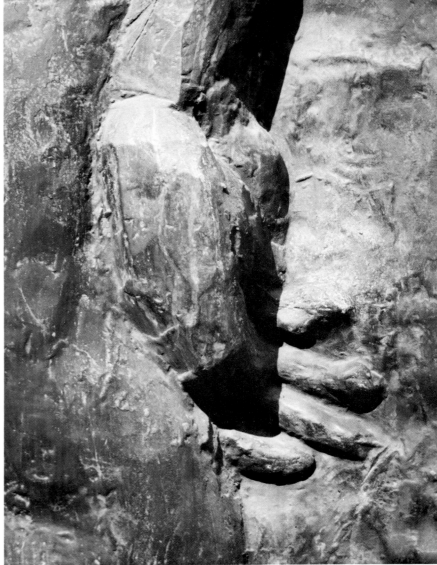

254 *Back II* (detail of right hand)

are subdivisions of one complex form; and that of the central section
is a fusion into one shape of three—head, hair, and spine. The joints
are truly "inherent parts of the limb." Hip bone and hand have left
their trace, but are now recomposed into the fugue of straight and
curved edges. Their reshaping gives character to the negative areas
of the relief, which in turn have taken on a more definite quality and
serve to lock the figure into the composition. Matisse showed here
his great gift for dividing up a rectangular area into sculptural shapes.

Like color in painting, he wanted the light to follow the form of the
volumes. Light no longer excavates or obscures the big masses.
Depressions have been reduced, as has steepness of gradient, to
enhance the volumes. The overall effect of plastering the surface
with his sculptor's tool assures homogeneity of figure and ground
and recalls Matisse's statement to his drawing students, "A shaded

drawing requires shading in the background to prevent its looking like a silhouette cut out and pasted on white paper."[111] Matisse must have been conscious that under strong side lighting, which his studio afforded, the already high relief of the body throws large shadows that make it seem deeper and less like the figure is embedded in the wall. When it is located out of doors natural light could be directly centered on the relief only for brief moments, flattening it out and making it seem that the figure is cut in half or embedded.

The plastered surface permits a discrete reference to the artist's hand, and in this last relief Matisse wanted the conception to be unrivaled by the evidence of execution. He permitted the final obliteration of his signature, seen in its entirety only in the first work, and then successively blocked as the left leg was thickened. For all

255 *Back III* (detail of right hand)

256 *Back IV* (detail of right hand)

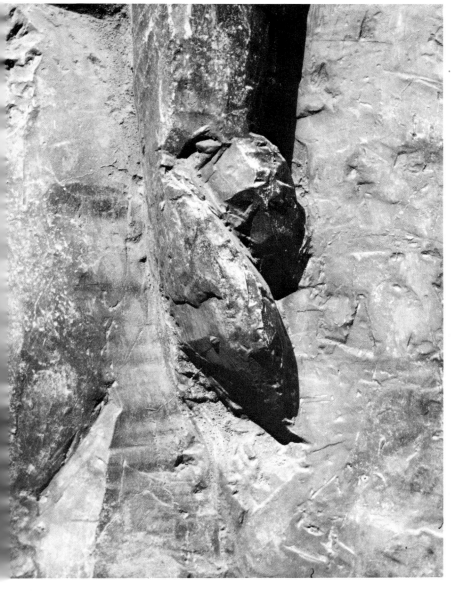
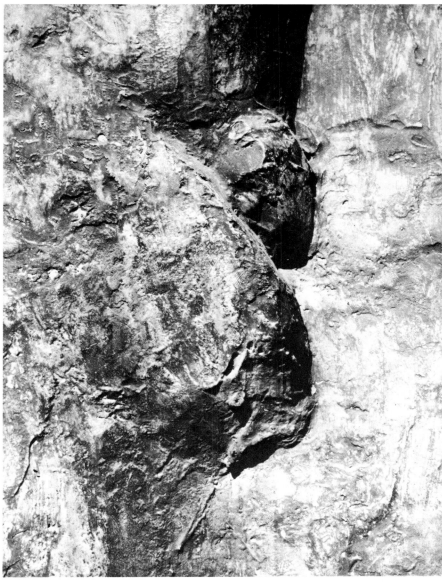

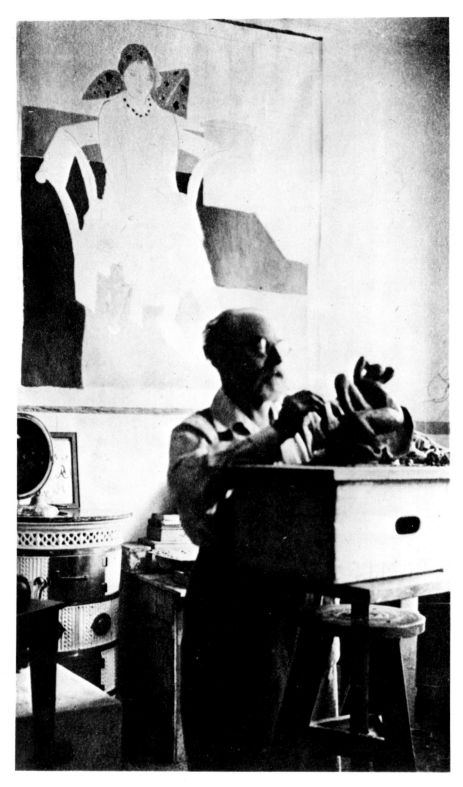

257 Matisse working on a later destroyed
sculpture of *Venus on a Shell*.
1929 (?)

his previous insistence upon feeling and intuition, Matisse seems to have wanted us to experience the result of his intellect in this last work. For this reason and the fact that he stored the third relief in a Nice warehouse for so many years that he forgot about it and the first when Alfred Barr was consulting him, it is conceivable that Matisse may not have wanted the last four reliefs to be seen together. They were only united in a public exhibition two years after his death. For purposes of history and information he might have agreed they were impressive together. But in the last relief, as in so many other sculptures and paintings upon which he lavished so much thought and work, it is doubtful that he wanted us to re-experience his twenty-year effort to perfectly coordinate his means, any more than a great poet, such as Baudelaire, would have thought of publishing simultaneously all the drafts of a poem. How soothing is it for one mental worker to experience the exertions of another? In a letter to Henry Clifford, which he wrote in 1940, Matisse said, "I have always tried to hide my efforts and wished my works to have the lightness and joyousness of a springtime which never lets anyone suspect the labors it has cost."[112]

Like Picasso, but to a lesser degree, Matisse could not follow a single line of development. "My destination is always the same but I work out a different route to get there."[113] He had solved a difficult problem to his satisfaction but had not thereby created the basis of a new style nor felt the compulsion to move to abstraction. This was not a failure of nerve, nor caution, nor timidity, but rather a desire to respond to different problems and a refusal to make sculptural clichés. When he undertook the *Seated Venus* sculptures, for example, he could remember the act of fusing breast with back and arm and the elimination of many directional axes, but a new pose and isolation of the figure created fresh problems to be solved.

Venus on a Shell, 1930, 1931

The primary origin of this motif in Matisse's art is a since-destroyed reclining figure on a shell with her arms over her head. A photograph taken no earlier than 1929, attested to by the painting behind the artist, shows him at work on this sculpture (plate 257), which undoubtedly was inspired by his earlier lithograph of *Night*, of 1924, which was in its turn a conscious reworking of Michelangelo's Medici tomb figure of that title. As in the lithograph, Matisse chose to preserve Michelangelo's expressive positioning of the legs (reversing the raised leg) and continuing the torsion of the torso, while raising the arms above the head (plates 258–59). This lost sculpture also links the *Large Seated Figure*, of which it is a paraphrase, with the seated Venus forms. One can only speculate on the reasons Matisse destroyed this work, but the most convincing explanation is to be found in its contrast with the more powerful and

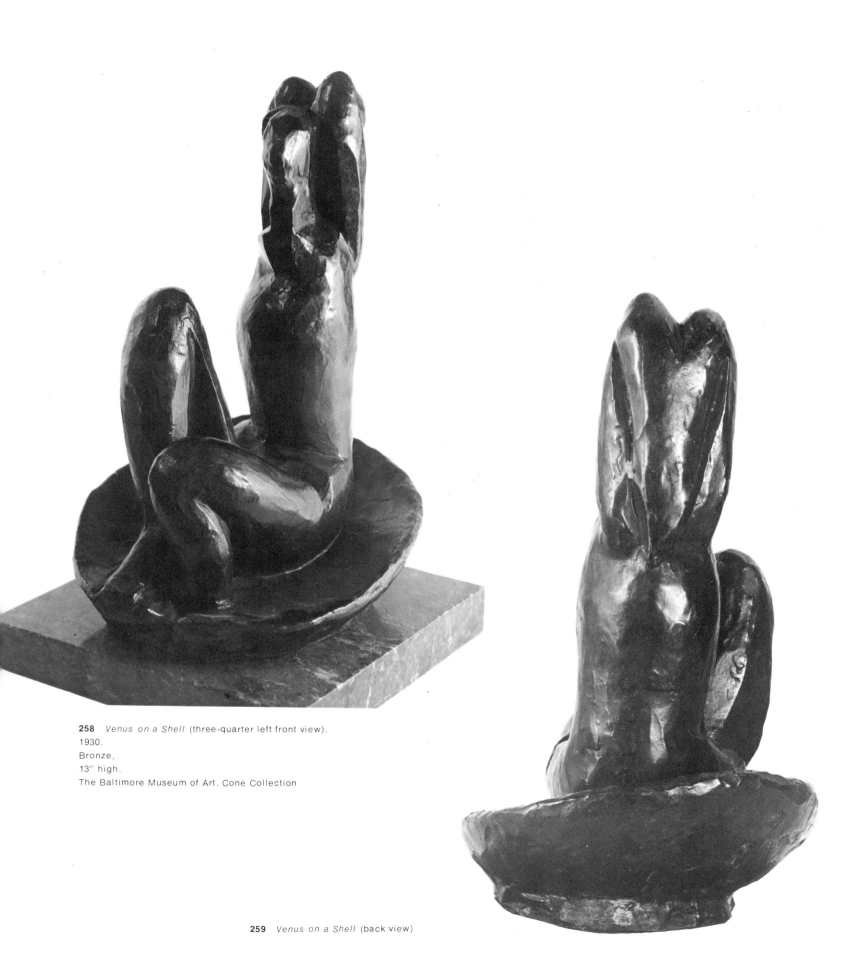

258 *Venus on a Shell* (three-quarter left front view).
1930.
Bronze,
13″ high.
The Baltimore Museum of Art. Cone Collection

259 *Venus on a Shell* (back view)

tersely stated Venus sculptures. From his many trips to the Louvre, Matisse may have recalled two small Hellenistic terra cottas (plates 260–61). In one Venus kneels, her arms extended to the sides, as she holds the ends of a girdle that circles her chest; the shell is raised behind her. In the other, Venus is sitting with her legs doubled under her, her arms in the position of pouring oil into a now lost container. There were no examples from antiquity of Venus sitting in the pose used by Matisse, with the arms folded over her head: his *Thorn Extractor* is another example of liberties taken with an ancient source. While omitting the sea shell's ribbing and reducing its size, Matisse preserved its outline and concavity, which prevents our confusing it with a Parisian floor tub. The shell became the actual base of the sculpture.

Bourdelle's *The Birth of Venus*, made in 1928 (plate 262), may have been known to Matisse and perhaps it reminded him of Hellenistic examples. Bourdelle transforms the holding of the girdle into a benedictional gesture. He is more faithful to the Louvre terra cottas, drawing the shell up behind the goddess and restoring the missing figure of Eros which had belonged to the sculpture of Venus pouring oil. Bourdelle imposed a hieratic formal symmetry on his work that was alien both to the ancient prototype and to the taste of Matisse. The *Caryatid* of 1930 (plate 263) by his greatly admired close friend Henri Laurens comes nearer to Matisse's taste. He owned a terra-cotta figure by this sculptor (plate 264), from which he made at least one drawing, and he was later to refuse the 1950 Biennale prize until it was shared with Laurens. Seen together, the two sculptures illuminate both our understanding of what Matisse admired in Laurens and the differences between a Cubist sculptor and one who had found a strong personal alternative. The *Caryatid* speaks at once of the desire of the artist for full and ripe forms to which nothing could be added and his Cubist inclination to alternate the curved and straight contours. The fulsome body is achieved by exaggerated proportion and a drastic reduction of details. The preliminary version of the *Large Seated Nude* resembles Laurens's treatment of the heavyset legs given to his figures, but before 1925 Laurens did not usually preserve uninflected roundness in the limbs, and there was still faceting from the crystalline phase of his Cubism. It is when we look at the respective silhouettes of the two sculptures that their differences are most marked. Matisse was impelled to put more twist into the legs to activate the composition. Laurens had the gift of achieving an immediate lucid revelation of the whole work that would have appealed to Matisse's "compulsive purism." It is not difficult to understand Matisse's affinity for the sensual and uncomplicated Cubism of Laurens.

Matisse's own *Venus* has a form so contracted as to have absorbed the breasts into one large swollen area of the chest, continuing the idea from the small torso of the year before. By not pulling the raised thigh to the stomach, he opened up the silhouette of his

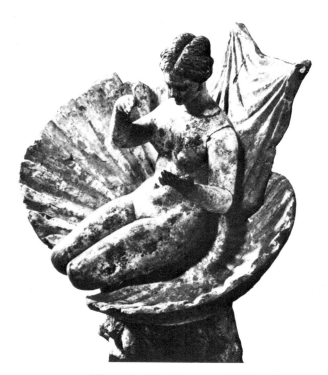

260 Hellenistic. *Venus on a Shell*.
Terra cotta.
The Louvre, Paris

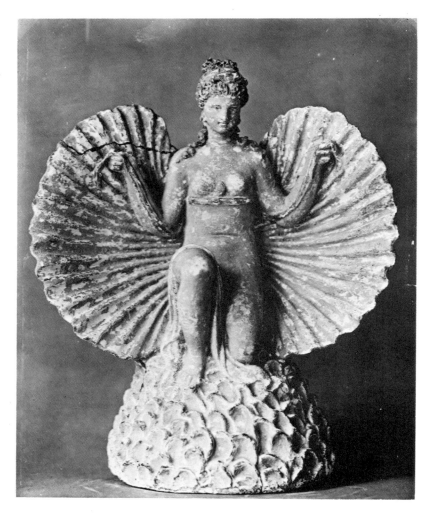

261 Hellenistic. *Venus on a Shell*.
Terra cotta.
The Louvre, Paris

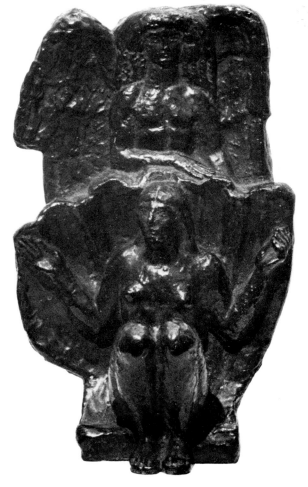

262 BOURDELLE. *The Birth of Venus*.
1928.
Bronze,
8″ high.
Collection Rhodia Dufet-Bourdelle, Paris

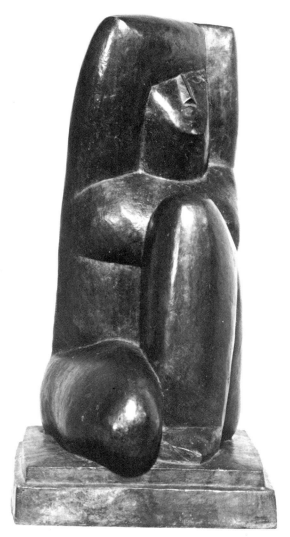

263 LAURENS. *Caryatid*.
1930.
Bronze,
36 ½″ high.
Musée National d'Art Moderne, Paris

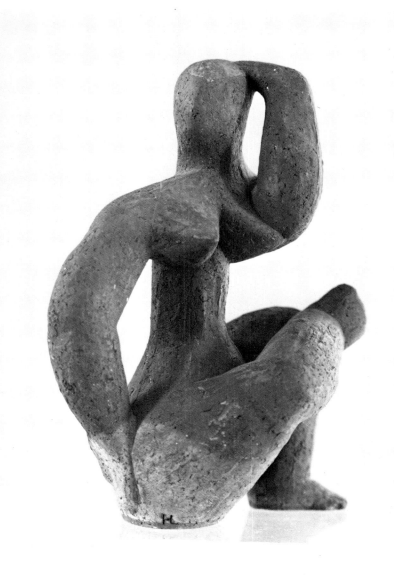

264 LAURENS. *Little Seated Nude*.
1932.
Terra cotta,
13 ¼″ high.
Musée Matisse, Nice-Cimiez

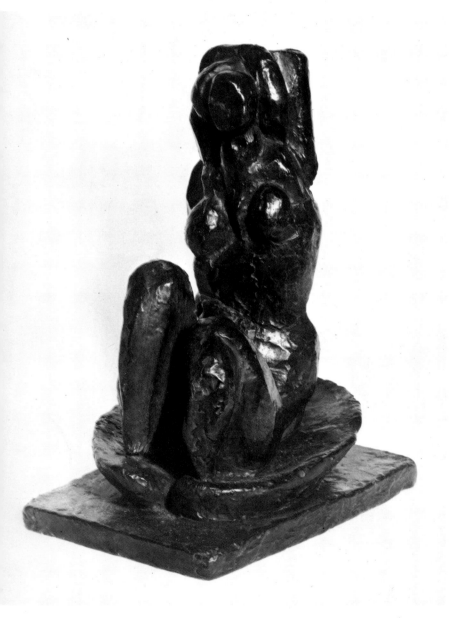

265 *Venus on a Shell II* (three-quarter left front view).
1932.
Bronze,
13 ¼″ high.
Joseph H. Hirshhorn Collection

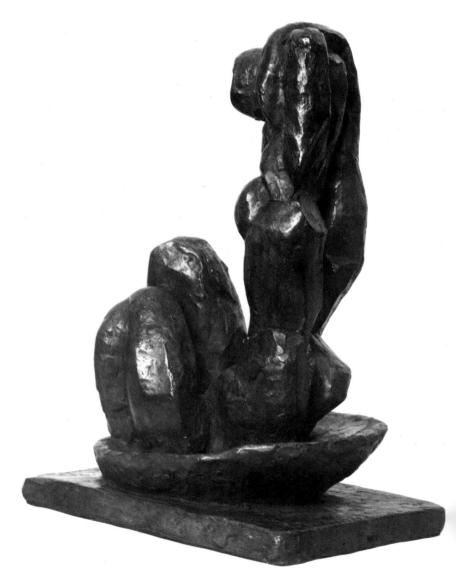

266 *Venus on a Shell II* (three-quarter left back view).
Collection Mrs. L. Shawzin, South Africa

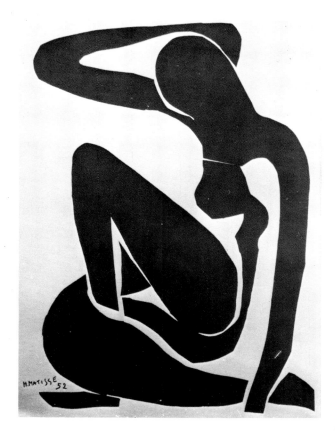

267 *Seated Blue Nude I*.
1952.
Gouache on cut and pasted paper.
41 ¾ × 30 ¾".
Collection E. Beyeler, Basel

sculpture so that the amphora-like taper of the torso was visible from the side. The suggestive erectness and shaping of the torso and arms may represent his unconsciously evolved sexual associations with Venus, carried over from the small phallic torso.

That Matisse still had not arrived in sculpture at an "ultimate method" was shown in 1932, when he did the startling second version of *Venus on a Shell* (plates 265–66). It was a rejection of the "cool mode" and centuries of accumulated formulas for celebrating the charms of Venus. He went to rawer, more rugged, blocky shapes, a masculine and aggressive mode. The back of the goddess has a quarried appearance and the deep spinal channel seen earlier in *Back III*. The second *Venus* has an overall squareness that comes closer to Laurens's sculpture than the preceding version. The slicing off of the face and the wedge cut in the lower back recall the brutality of the editing of the 1918 seated figure. This knotted, taut form inspired no sequel, but in fact ended the sequence of sculptures begun in 1924. Matisse began to paint again and did not return to sculpture until the late forties.

Sculpture and the Paper Cutouts

Beginning in 1931, in preparing for the Barnes murals, Matisse began to work with scissors and paper. In the last years of his life his stunning colored paper cutouts totally absorbed him. One of his great personal discoveries was the fusion of carving, drawing, and color in this mode of work. This economy of means sparked new liberality of invention. There are passages in the colored cutouts when the action of the scissors seems fostered not by his fingering and thumbing of clay, but by what he had earlier done with the sculpture knife, his own "carving." When he "drew" or "carved" with a scissors the faceted planes of a woman's stomach or back, there was the reminiscence of the profile of *Venus on a Shell II*. How many times must he have studied his sculptures against the light? When he contrasted the ragged and smooth profiles of his *Acrobats* or the raveled form and spindly proportions of raised arms with the generous trued shaping of a torso and legs (as in *Blue Nude, The Frog*, 1952), his cutout figures were backed by his sculpture (plates 267–68). The 1952 *Venus*, made by two pieces of blue paper, and the twin torsos in *Jazz*, are an extension of his modeled torsos. Isolating his cutout figures against the white background was like giving them the silhouettes of his sculptures that had to carry in space. Gowing writes, "The sharp edges he cut defined figure and ground both at once, as in a carved relief."[114] The absence of tangible support for his blue seated nudes of the early fifties echoed the modeled figures and their complete silhouettes emancipated from the traditional base. The sure sense of volume that is so convincing in his paper figures was made convincing by the sculptures.

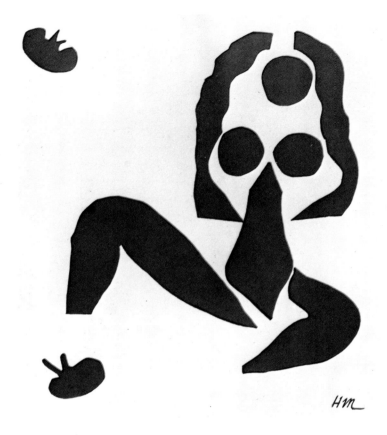

268 *Blue Nude, The Frog.*
1952.
Gouache on cut and pasted paper,
55 ½ × 52 ¾".
Collection Otto Preminger,
New York City

Seated Nude, Arm Raised, 1949

While working on the Vence Chapel, Matisse found time in 1949 to
make his *Seated Nude, Arm Raised* (plates 269–70). As in the late
paintings, there is here no energetic writhing of the torso. The
sculpture surprises in its uncompromising right angle treatment
of the legs and back. The *Decorative Figure on an Ornamental
Background* painting of 1927 had a similar treatment of the woman's
back, as if she were an extension of the room's architecture and
partially shaped by her support. The semaphoric gesture made by
the torso and the cipher for the arms show Matisse was still seeking
simplicity to gain sculptural strength rather than physical beauty for
his figures. This stiff-backed form and its successor, *Standing
Nude (Katia),* may reflect his many years of meditating on the cast
of the large archaic *kouros* in his studio.

The Crucifix, 1948–50

There seemed to be an anomaly in the fact that Matisse had formerly
made only uncommissioned sculpture for personal, pleasurable
purposes, and yet consented to the request of Père Couturier to
make a sculpture of the crucified Christ as part of his decoration
for the Vence Chapel. How could a man who wanted art to be like

205

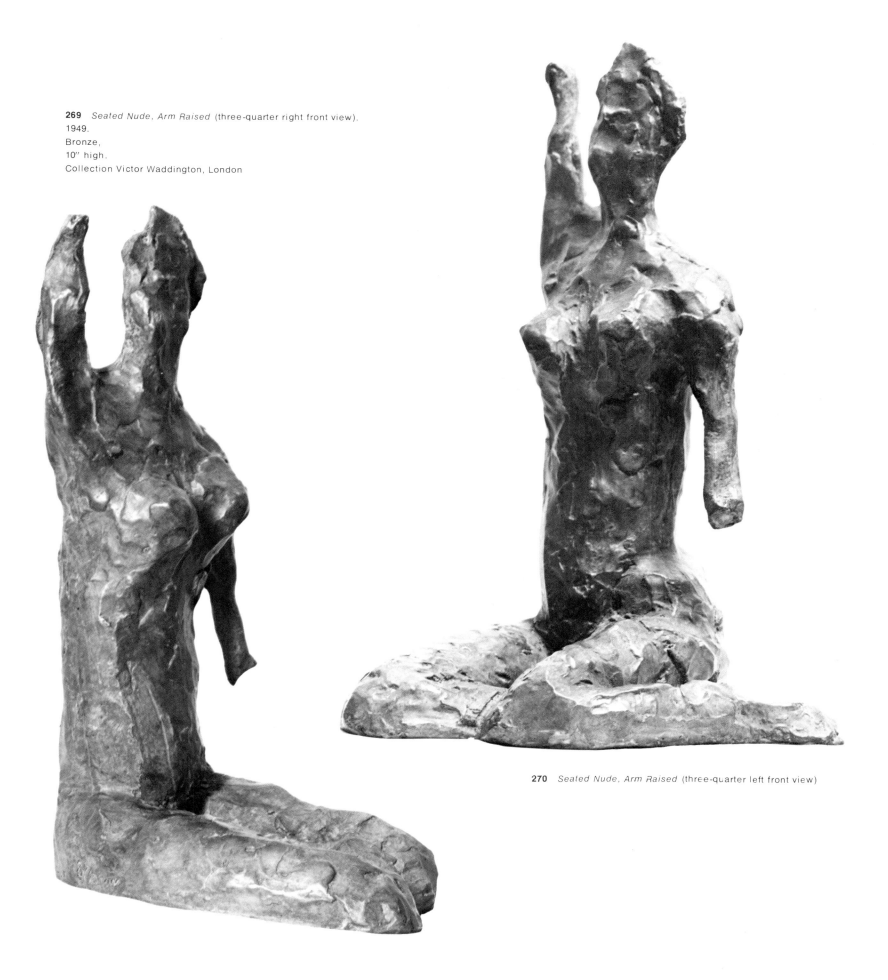

269 *Seated Nude, Arm Raised* (three-quarter right front view).
1949.
Bronze,
10″ high.
Collection Victor Waddington, London

270 *Seated Nude, Arm Raised* (three-quarter left front view)

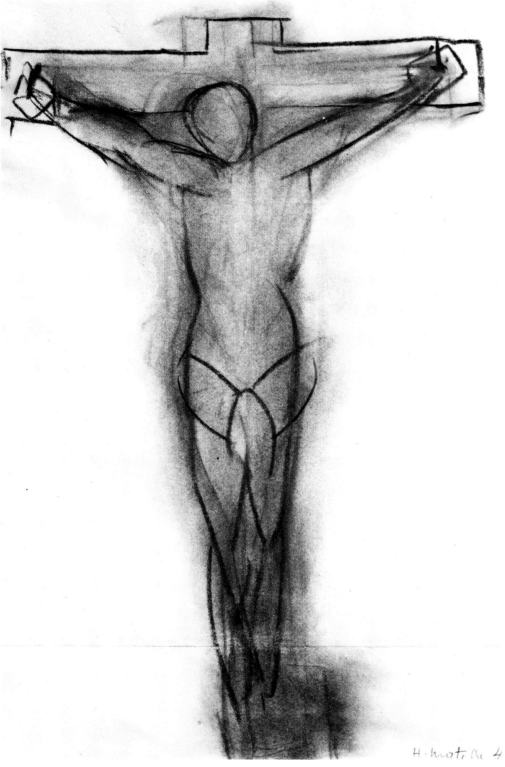

271 *Study for the Crucifix*
for the Altar in the Chapel of the Rosary, Vence.
1948.
Conté crayon,
18 ¾ × 13″.
Musée Matisse, Nice-Cimiez

272 *Study for the Crucifix.*
1948.
Pen and pencil,
17 × 13″.
Musée Matisse, Nice-Cimiez

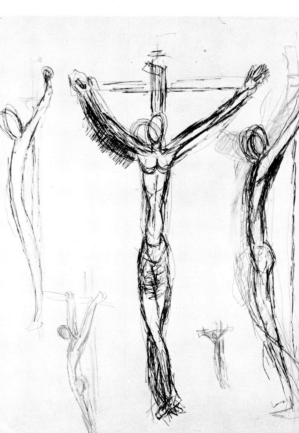

a good armchair agree to accept such a tragic theme? The male figure had been absent from his sculpture for some forty-five years. How appropriate was it for a sculptor who made art for home and studio to do a sculpture for a convent chapel? Matisse was not unlike Rodin in that he was in some ways a professional artist of the old school, and while he was not religious in the orthodox sense. he could still put his heart into the shaping of Christ as well as Venus. Both sculptors enjoyed the challenge of reinterpreting for themselves and their time great subjects of the past.

Before 1900 Matisse had copied in painting Philippe de Champagne's *Dead Christ*; and Barye's *Jaguar* had given him a taste of brutality in art. His own profane art had been an outlet for what he referred to as his "so-to-say religious feeling for life." The crucifixion theme drew Matisse to Grünewald's Isenheim Altarpiece, as it had Picasso in the early thirties. Unlike Picasso, Matisse found that his temperament (expressed in the resulting drawings) could not dwell upon the pathetic evidence of Christ's passion in the form of the agonized face, pinioned hands and feet, or brutal wooden cross. These dramatic details would have contravened his decorative ideal of not drawing attention to one area more than another.

Two drawings in the Matisse Museum at Cimiez (plates 271–72) disclose the way Matisse rethought the motif of the crucifixion, after having interpreted it in his mural of the *Stations of the Cross*. A drawing in charcoal shows a conventionally proportioned, faceless figure, arms rigidly outstretched with hands spiked to the thick, wooden cross. Mme Duthuit remembers that her father had a young man pose for him while he worked on the early stages of the crucifix. The second group of drawings, done in ball-point pen and pencil on a single sheet, are of the attenuated figure, bowed out from the cross. The pen drawings show his alternatives for the head in tilted and upright positions. Appropriately, the proportions of the cross itself have been narrowed. A ceramic tile (plate 273), which may have been rejected for the final mural of Christ's Passion, links the preliminary drawings and the sculpture of this subject to the project in painting. Its mode of drawing suggests that it was done before the sculpture of the same subject. Hélène Adant's photographs of Matisse working on two modeled forms (plate 274) indicate that he did not commit himself to the drawings. First, the figure is more slackly posed, and second, he modified the crescent profile line of the body so that the final arabesque is both stiff and supple. The last figure of Christ is like a mode of drawing that has neither the sweetness nor the harshness of the modes in which the two murals were done. Matisse rejected the simple, elegant curvature of the drawing, and while refining the proportions of the body, complicated its interaction with the cross. The figure of Christ has the graceful strength of a sapling (plates 275–78). (Matisse was very conscious of trees at the time.) The martyr is given a gentle manliness. The inclined head is a concession to death, but his upraised arms evoke

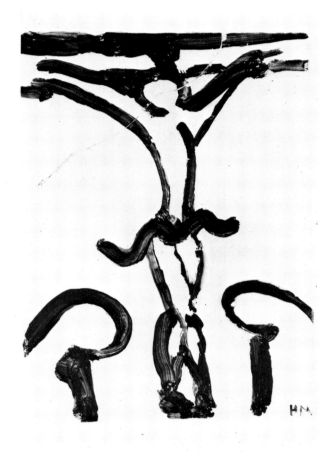

273 *The Crucifixion.*
1948 (?).
Painted tile.
Chapel of the Rosary, Vence

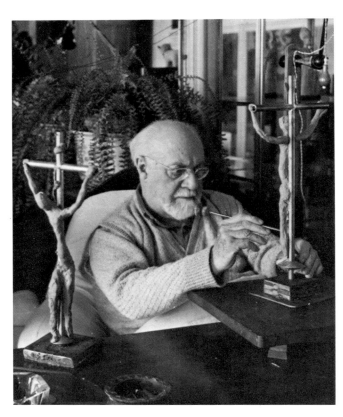

274 Matisse modeling a crucifix for the Chapel of the Rosary, Vence

Opposite

276 *The Crucifix.*
1950.
Bronze,
18 ¼" high.
Musée Matisse, Nice-Cimiez

275 View of the altar and murals in the Chapel of the Rosary, Vence

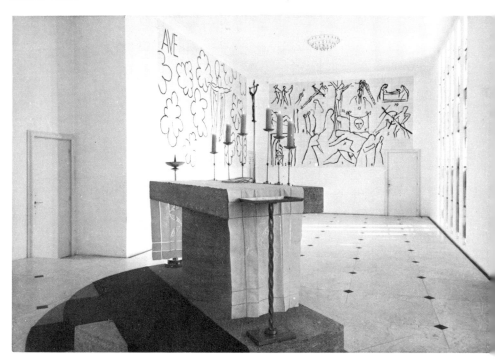

prayer rather than pain, not morbid thoughts but the joy of resurrection, and they enforce the gestures of the priest in the Mass.

The importance of his subject did not distract Matisse from the decorative demands of the altar's location and ensemble of objects. In deciding on the meaning of his work, Matisse was aware that the altar was not in the form of a tomb but of a table, symbolizing the Transubstantiation of the Eucharist rather than death. The slim proportions allow the figure to accord with the other objects of the altar, also designed by Matisse, and to make the gesture visible from the different sides and distances from which it is seen by the priest and nuns in the small chapel. Matisse felt here and in the ceramic murals near the altar the need to signify Christ's body, not to portray it as Rodin had, in order that the thoughts of the worshipper be attuned to the meaning rather than the means of Christ's tortured death. Thus Matisse did not contradict his aim of achieving purity, balance, and serenity. The chapel, like his own studio, was an ideal home for his art; for he had fashioned a total environment for silent, daily communion, a spiritual refuge from the outer world. To the end, his art fulfilled his conviction of the seriousness and importance of decoration for man's spiritual well being.

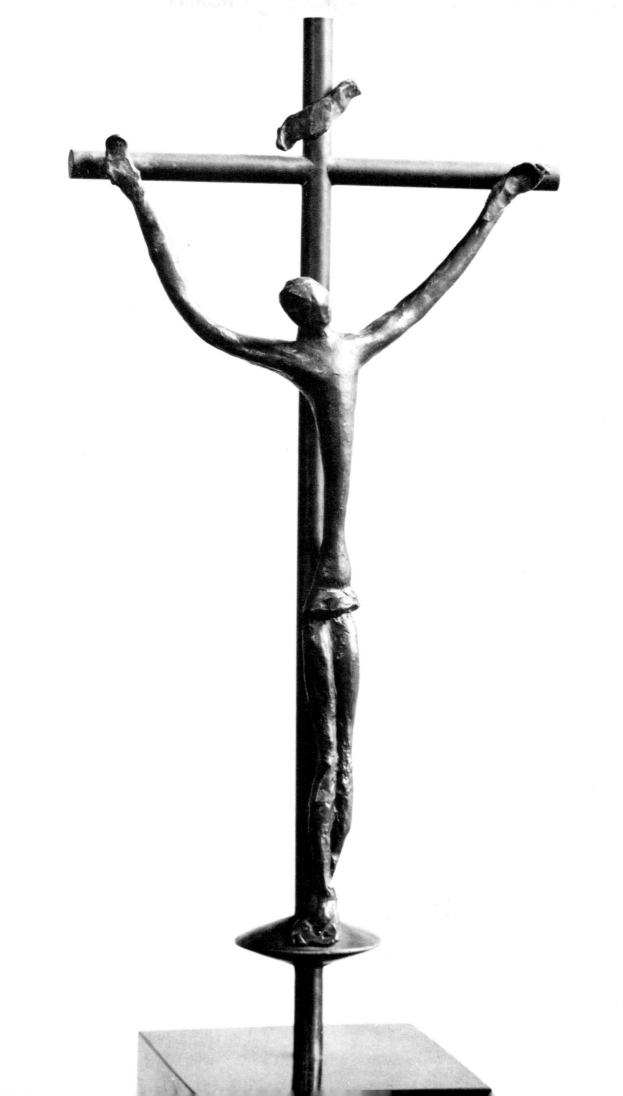

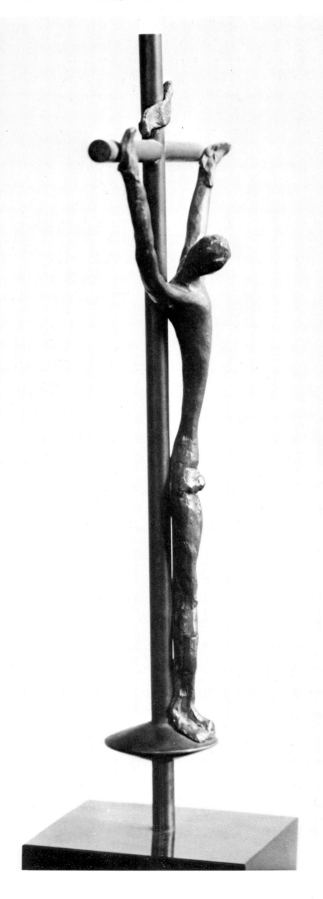

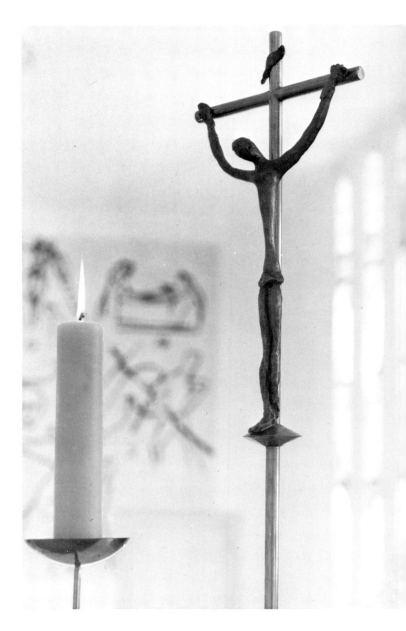

The Last Sculpture

Among the sculptures which have not been cast in bronze either during or after the artist's lifetime and which are presumably destroyed is a standing female figure with her legs together and arms over her head. A photograph of Matisse's studio taken in 1953 by Hélène Adant (plate 279) shows it standing with a group of sculptures on a table in front of a large mirror between the crouching *Écorché* and the *Seated Woman,* previously described. The drying out of the clay had contributed to its cracking, and a section of the woman's upper right side has been lost, which probably discouraged Matisse from casting it. The archaic stiffening of the body into an upright frontal posture thus preoccupied Matisse at least twice at the end of his work as a sculptor, for the last work, the *Standing Nude (Katia),* can be seen to the right of the broken sculpture (plates 280–81, 283), and from its surface it would seem to have been more recently modeled with the clay still retaining the moisture which resulted in its darker color. Right to the end Matisse was inclined to pair the treatment of a sculptural motif. It was not the damage to the first of the two standing figures that encouraged the second, but one can see new ideas concerning the treatment of the arms, breast, and pelvis.

To someone who had never before seen Matisse's sculpture, his last work, *Standing Nude (Katia),* of 1950, would appear at first to be the issue of aged and uncertain hands. To an artist, such as Pablo Picasso, the simplicity of the figure did not result from simple-mindedness, but presumably reflected the wisdom and continued fertility of Matisse's art. It is conceivable that as the result of one of his visits to Matisse in 1950, Picasso got the idea for his five and one-half inch *Woman with Raised Arms* of that same year (plate 282). Not surprisingly, Picasso accentuated his figure's voluptuousness and in a typical and un-Matisse-like gesture punctured the clay to create the eyes and nipples of the woman.

Viewed against his previous sculptures, *Katia* epitomizes Matisse's conservatism, his continuing to dare the obvious and put new wine in old amphorae. This meant the reworking of past problems; the restatement of familiar analogies or, indeed, platitudes, and possibly the renewing of old rivalries with fellow modelers. The problem was animating a static, symmetrical pose whose affinity was with an ancient urn, as had been previously interpreted in many Rodin drawings and by Bourdelle. Shortly after making this sculpture Matisse made a cutout in blue of a woman similarly posed, holding an urn above her head, *Woman with an Amphora*, 1952 (plate 284). Mme Duthuit believes that *Katia* was influenced by Matisse's interest at the time in the way that trees grow out of the ground and move upward: "*Katia* gave him the same feeling of elevation as a tree."

The sculpture dried and cracked while in Matisse's studio. The bronze founder Valsuani cast it in bronze and on Matisse's insistence

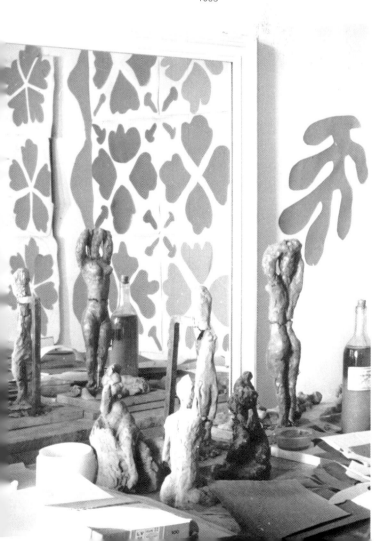

279 Matisse's studio in Nice: a portion of sculpture group on table. One of the group was never cast. 1953

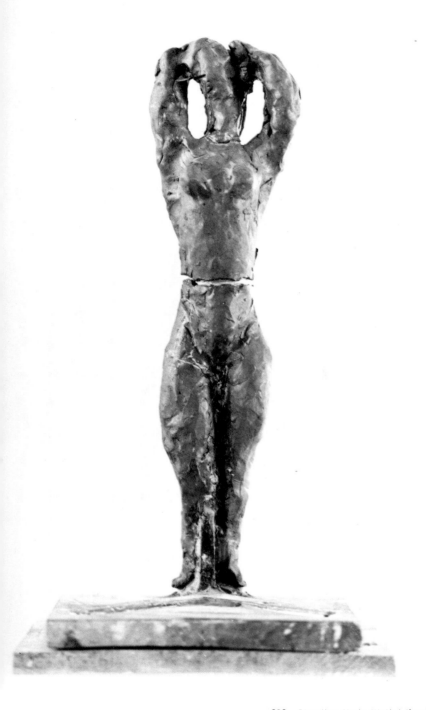

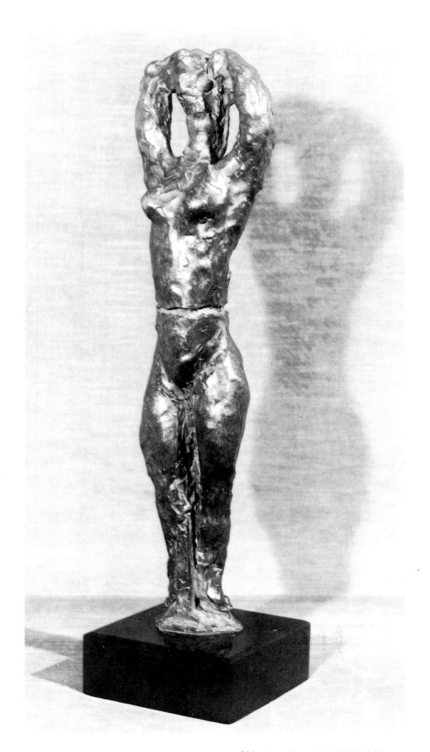

280 *Standing Nude (Katia)* (front view).
1950.
Dried clay on metal armature,
17 ¾" high.
Musée Matisse, Nice-Cimiez

281 *Standing Nude (Katia)* (three-
quarter right front view).
Bronze.
Paul Kantor Gallery, Los Angeles

213

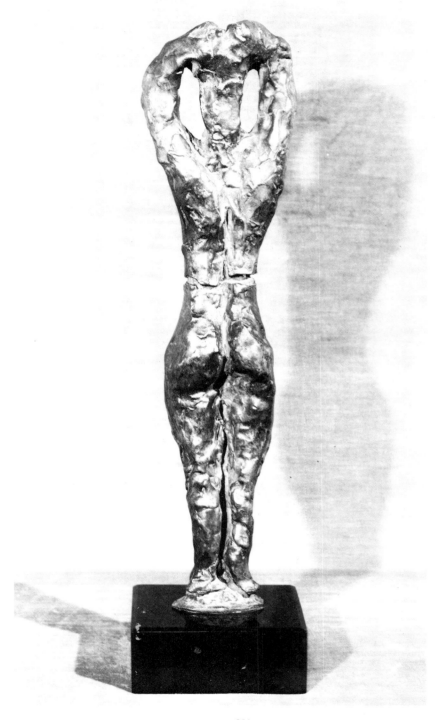

283 *Standing Nude (Katia)* (back view)

282 PICASSO. *Woman with Raised Arms.*
1950.
Bronze,
5 ½″ high.
Richard Gray Gallery, Chicago

284 *Woman with an Amphora*.
1952.
Gouache on cut and pasted paper,
64 ½ × 19".
Private collection, New York City

did not disguise the cracks. The artist had not changed his views on disguising accidents since the *Torso Without Arms or Head* of 1909. When it is held and carefully looked at, the seemingly negligent surface treatment of the *Standing Nude* becomes intricately but unexplainably articulated, avoiding descriptiveness or rationalization of the body. Matisse wanted us to feel the demands of volume and mass. "For the mental worker," all is revelation; there is no concealment of meaning or the means of remaking the body. It is as if he were saying: this is how the torso fits into the pelvis, like an amphora into its stand; if there are no knees and feet, elbows and hands are dispensable; a rib cage contour is worth sacrificing for a continuous undulating silhouette; within its concave contours the stretched torso has a reverse shape, and so on. The surface discloses no insistence upon tangible method, only intuition and feeling, that are parents to the touch. There is a final refusal of stylistic development, a last resistance to habits of the hand. Matisse still enacted the dream shared with Maillol of making sculpture as if for the first time. The modeling of *Katia* served the old artist as an outlet through his hands for a lifetime's experience of achieving comprehensive meaning in the human figure by fullness of actual mass and expressive contours. To have the right of freedom to simplify, Matisse felt "one must, of course, have one's entire experience behind one and not to have lost the freshness of instinct."[115] For Matisse, the body was always a joyous, provocative mystery that resisted mastery.

Summary

Sculpture was for Matisse the art of being able to express himself in modeling. To know his sculpture as well as his paintings and drawings is to understand the completeness of Matisse as an artist. From sculpture he spared only time, never intelligence, feeling, or perception. Sculpture served him by adding to the ways he could know the human form, which contained so much of what was needed to achieve expressive composition in his paintings. Modeling kept open his options with respect to style and its response to his successive self-reactions.[116] More than painting, it encouraged renewed contact with museum traditions of the figure, and disciplined study of them gave fresh reserves of strength and inspiration when needed during times of difficulty with painting. There was a mutuality between his means, so that drawing nourished and sustained painting and sculpture, and paintings could reciprocate by suggesting modeling in daring ventures with the arabesque, proportion, and finish.

More than Rodin, Matisse connects the sculpture of the past century, where the proper function of art was to interpret nature,

with that of our own, in so far as art is characterized by the artist's greater self-involvement and by a permissiveness in exaggeration of form in accord with the spirit of the work itself. For this reason *The Serf* is the first twentieth-century sculpture. Matisse showed at the start that he would not "turn his back on nature" nor bring to sculpture new themes, media, or means. His gift was an exceptional artistic intelligence and imagination—revitalizing traditional formats, motifs, and sculptural problems. Matisse reminds us, "There are no new truths." In his hands modeling and the figural tradition were carried beyond Rodin by responding exclusively to individual temperament. The modest size of so many of his sculptures warns us that sculptural power is not the prerogative of large scale. Yet one of his achievements was to bring a new monumentality to decorative sculpture in the *Back*s. In a time of so much bland painting and impersonal sculpture, Matisse's art is a refreshing evocation of what expression and individuality in art have so recently been.

Matisse demonstrated that a successful artist could remain apart from radical developments in the sculpture of his contemporaries, and that an artist's importance need not rest on influence. Despite his teachings based on "elementary principles," he did not create a sculpture that lent itself to codifying or imitation by systems of the hand. Rules, which he felt "have no existence outside of individuals," structured for him an invisible foundation, but in the last resort his personal ideals of perfection relied upon systems of the spirit and sensibility.[117]

Notes

1. The largest exhibition of Matisse sculptures was in 1959, at the Kunsthaus in Zurich; sixty-eight sculptures were shown. The catalogue, *Henri Matisse, Das Plastische Werk,* is prefaced by Ulf Linde. More recently there has been a large sculpture exhibition at the Tate Gallery in London; in 1966 the University of California at Los Angeles initiated an exhibition which explored Matisse's work in all media.

2. Two recent and eloquent testimonies to this influence can be found in William C. Seitz, "Rosati: Masses in Elevation," *Art News* (December, 1969; hereafter cited as Seitz, "Rosati"); and William Tucker's fine essay in the catalogue published by the Victor Waddington Gallery of London (1969) of a small show of Matisse sculptures. (The essay by Tucker was reproduced in the 1969 summer issue of *Studio International*; hereafter cited as Tucker, *Matisse.)*

3. Alfred H. Barr, Jr., *Matisse: His Art and His Public,* 1951, p. 295. (Hereafter cited as Barr, *Matisse.)* The present whereabouts of this painting, formerly in the Galerie Maeght, is not known. For reproductions of Moreau's sculpture, see Jean Selz, *Modern Sculpture: Origins and Evolution*, 1963, plates 135, 136.

4. There was also the example of Cézanne's still-life paintings which included the fragmented plaster sculpture of *Cupid* by Puget. One of these paintings is the *Still Life with Cupid*, 1895, in the Courtauld Collection, London. For a reproduction of this painting and an excellent analysis relevant to Matisse's own painting of sculpture in his still-life motifs, see Meyer Schapiro, *Paul Cézanne*, 1952, pp. 98–99.

5. I am indebted to Pierre Matisse for information regarding the source of the cast. The recounting of the history of Matisse's school is given in Barr, *Matisse*, pp. 103 ff.

6. The notes are given in their entirety in Barr, *Matisse,* pp. 550–52.

7. *Henri Matisse*, a catalogue of the retrospective exhibition of 1966, organized by the University of California at Los Angeles Art Council and Art Galleries, texts by Jean Leymarie, Sir Herbert Read, and William S. Lieberman, p. 20. (Hereafter cited as UCLA, *Matisse.)* It is interesting to read Rodin's own views on this subject: "When a good sculptor models a statue, whatever it is, he must first clearly conceive the general idea; then until his task is ended, he must keep this idea of the whole in his mind in order to subordinate and ally it to every detail of his work" (Rodin, *L'Art,* 1916, p. 154).

8. Reproduced in Jacques Lassaigne, *Matisse: Biographical and Critical Study*, 1959, p. 18. (Hereafter cited as Lassaigne, *Matisse.)*

9. Quoted in Raymond Escholier, *Matisse ce vivant*, 1956, p. 164. (Hereafter cited as Escholier, *Matisse.)*

10. Escholier, *Matisse*, p. 48.

11. Escholier, *Matisse*, p. 164.

12. UCLA, *Matisse*, p. 21. The somber mood of *The Serf* may in part have reflected the mood of the artist during those financially difficult years at the turn of the century.

13. Louis Aragon, *Matisse en France*, 1943, unpaged. Estimates very, beginning at five hundred hours.

14. In his article "Two Early Drawings by Henri Matisse," published in the December, 1962, *Gazette des Beaux-Arts*, Henry Geldzahler alleges that this drawing shows the model "in the aggressive striding attitude of *The Walking Man*." This argument is based on a misreading of the pose in the drawing, in which the model's widespread feet are at right angles to each other. The closest Matisse comes to Rodin's *The Walking Man* in terms of movement is a painted sketch of a *Male Model* reproduced in Barr, *Matisse*, p. 304. George H. Hamilton writes of Matisse's "taking over the stance of *The Walking Man*, as well as Rodin's modeled surfaces" (*Painting and Sculpture in Europe, 1880–1940*, 1967, p. 109).

15. In the spring of 1967 I talked to Jean Matisse at his home in Pontoise; he did not recall modeled studies for *The Serf*.

16. Barr, *Matisse*, p. 120.

17. Meyer Schapiro, "Matisse and Impressionism: A Review of Matisse at the Museum of Modern Art, New York, November, 1931," *Androcles I* (February 1, 1932). This excellent article is too little known and rarely referred to in the Matisse literature. (Hereafter cited as Schapiro, *Matisse.)*

18. See above, fn. 14. Sir Herbert Read wrote that the poses of *The Serf* and Rodin's *John the Baptist* were "exactly the same." UCLA, *Matisse*, p. 20. *The Walking Man* was not exhibited until June of 1900.

19. Escholier, *Matisse*, p. 80.

20. Paul Gsell, "Chez Rodin," *L'Art et les artistes* (January, 1907), p. 406.

21. Barr, *Matisse*, pp. 120–21.

22. I have discussed the evolution of this premise and its ramifications for modern sculpture in my *The Partial Figure in Modern Sculpture: From Rodin to 1969*, 1969. (See in this regard the first section on Rodin, pp. 16–28.)

23. Mme Duthuit is also of the view that the arms were lost in an accident.

24. Barr, *Matisse*, pp. 119, 120, 121. Gustave Moreau, Matisse's teacher from 1892 to 1897, was known to

have told his students that "Nature is only an excuse for the artist to express himself." The concept of art as self-expression coming from an École des Beaux-Arts instructor was unusual for the time. This quotation was given without source by Jean-Albert Cartier, "Gustave Moreau, Professeur à l'École des Beaux-Arts," *Gazette des Beaux-Arts* (May–June, 1963), p. 352.

25. Barr, *Matisse*, p. 551.

26. Barr, *Matisse*, p. 550.

27. Barr, *Matisse,* pp. 120, 122, 551.

28. Barr, *Matisse*, pp. 550–51.

29. Albert Elsen, in collaboration with Henry Moore, "Rodin's Walking Man As Seen by Henry Moore," *Studio International* (July–August, 1967).

30. Barr, *Matisse*, p. 551.

31. Walter Pach, *Queer Thing Painting*, 1938, p. 145.

32. Gaston Varenne, *Antoine Bourdelle, par lui-même,* 1937.

33. Barr, *Matisse*, p. 122.

34. Irving Lavin, "Bozzetti and Modelli," *Stil und Überlieferung in der Kunst des Abendlandes*, vol. 3 (1960), p. 100. (I am grateful to my colleague Lorenz Eitner for calling this reference to my attention.)

35. Escholier, *Matisse*, p. 166.

36. Clara T. MacChesney, "A Talk with Matisse, Leader of the Post-Impressionists," *New York Times,* (March 9, 1913).

37. Escholier, *Matisse*, p. 163.

38. Quoted without its source by Bernard Denvir, "London Letter," *Art International* (September, 1969), p. 68.

39. Barr, *Matisse*, p. 122.

40. Barr, *Matisse*, p. 551.

41. Barr, *Matisse*, p. 551.

42. The most complete reproduction of Duchamp-Villon's sculpture is to be found in George H. Hamilton and William Agee's *Raymond Duchamp-Villon*, 1967.

43. Fred Licht, *Sculpture, Nineteenth and Twentieth Centuries*, 1967, pp. 25, 27. This curious book is filled with such statements. To prove his point about the "homelessness of modern sculpture," Licht poses what he feels is an unanswerable question: "Where, for instance, does [Canova's] *Paolina Borghesa* belong?" It would appear that this dedicated Baroque scholar had never visited the Borghese Palace in Rome. I have reviewed this book in the *Burlington Magazine* (April, 1968). (Hereafter cited as Licht, *Sculpture*.)

44. Escholier, *Matisse*, p. 146.

45. Barr, *Matisse*, p. 122.

46. Barr reproduces on pp. 295 and 303 a drawing and a painting which relate to the problems posed in the sculpture.

47. Barr, *Matisse*, p. 123.

48. Lectures on modern art at Columbia University, 1950. I find the use of the terms "optical" and "tactile" confusing if not misleading in describing the ways in which Matisse worked. For one thing, it is hard to remember which is which in a given sculpture. Second, they imply a separation of the experience of the senses, both in the artist who creates and in the responding viewer, that I find difficult to agree to. We do not need to touch a sculpture to appreciate its tactile virtues, and it is often pleasant to handle a sculpture that has been described as purely optical in source and intent. Matisse did not make his sculptures blindfolded, as he once drew for Brassai on a door of his studio. That Matisse would alternate his different modalities within a single sculpture makes the neat division of optical and tactile unwieldly to apply. Of all who have applied these terms to the sculpture of Matisse I find William Tucker's analysis most convincing, and Lawrence Gowing's inspired writings on the paintings of Matisse are the most persuasive and helpful to describe modalities in this medium.

49. Following a lecture I had given on the sculpture of Matisse in the spring of 1968 at the New York Studio School of Drawing, Painting and Sculpture, Sidney Geist made the connection more explicitly than I had done.

50. Robert Goldwater, *Primitivism in Modern Art*, 1967, p. 99. Professor Goldwater's analysis of the figure in Fauve art is still the best written. (Hereafter cited as Goldwater, *Primitivism*.)

51. It is possible that this sculpture was inspired by ancient Roman sculptures such as that of a reclining *Supplicant* in the Palazzo Barberini, in which a partially draped figure is to be seen. The *Sleeping Ariadne* figure, to which De Chirico was attracted, is another possible source. More notable is the frequency of the model in a shift as seen in the work of such Fauve artists as Henri Manguin, particularly his *Model in the Studio* (1905), *The Rocking Chair*, and *The Siesta*. These are reproduced in Pierre Cabanne's *Henri Manguin*, 1964.

52. For the history of this sculpture, see Barr, *Matisse,* p. 94.

53. Barr, *Matisse*, p. 551.

54. Alfred Barr reproduces a 4×5′ ceramic tile (1907?), on which Matisse had painted the outline of this sculpture. Barr, *Matisse*, p. 337.

55. Lassaigne, *Matisse,* p. 66.

56. Lawrence Gowing, *Henri Matisse: Sixty-four Paintings*, 1966, p. 42. Gowing's is one of the finest, most perceptive, and inspired essays written on the art of Matisse. (Hereafter cited as Gowing, *Matisse*.)

57. This painting by Derain belongs to Robert Lebel and is reproduced in *Le Fauvisme français et les débuts de l'Expressionisme allemand*, catalogue of an exhibition jointly sponsored by the Musée National d'Art Moderne, Paris, and Haus der Kunst, Munich, January–March, 1966, p. 71.

58. Goldwater, *Primitivism*, p. 98.

59. Tucker mentions this photograph but does not reproduce it with his essay. This photograph and the two others here mentioned are in the possession of Mme Georges Duthuit. I am most grateful to her for permitting their reproduction.

60. Goldwater, *Primitivism*, p. 248.

61. Barr, Matisse, pp. 138–39.

62. Quoted in Richard A. Moore, *The Dialectic Norm of Nineteenth and Twentieth Century Art, 1968*, in his essay, "Henri Matisse and the Corrected Aplomb," p. 68. This is an interesting essay which goes into the influence of the artist's academic background on his painting and sculpture. (Hereafter cited as Moore, *Matisse*.)

63. Escholier, *Matisse*, p. 79.

64. Barr, *Matisse,* pp. 550–51, and Henri Matisse, "Modernism and Tradition," *Studio* (1935), p. 258.

65. Goldwater writes concerning Negro influence in Matisse's sculpture: "In these figures its effect appears to have been to turn Matisse toward a more marked punctuation and staccato emphasis of his own naturally smoother modeling and sense of arabesque" (Goldwater, *Primitivism*, p. 228). Matisse's modalities show that smoother modeling was no more natural to him than rougher surfaces. Faceting begins in *The Serf*.

66. Schapiro, *Matisse*, p. 36.

67. William Moore gives an apt account of the reworking of the *Decorative Figure* when inserted in the painting *Piano Lesson* of 1916–17: "Typical of previous practice, the artist introduced one of his pieces of sculpture in a functionally decisive way, so as to structurally orient the composition in terms of the corrected *aplomb*. This time the stabilizing control produced is even more comprehensive. The *Decorative Figure* . . . has been willfully interjected into the bottom left corner of the picture, creating, as it leans to the left, a buttressing accent whose physically poised weight, concentrated on the right angle of the arm, dramatizes the aesthetic purity of the long vertical edge of the picture" (Moore, *Matisse*, p. 75).

68. Tucker, *Matisse*, unpaged.

69. Barr, *Matisse*, p. 139.

70. Gowing, *Matisse*, p. 42.

71. Licht, *Sculpture*, p. 177.

72. Escholier, *Matisse*, pp. 163–64. Maillol's sculptural style comes out of his Nabis-inspired tapestry designs, drawings, and paintings rather than from an initial and conscious imitation of ancient sculpture.

73. Seitz, "Rosati," p. 41.

74. Escholier, *Matisse*, p. 146.

75. Escholier, *Matisse*, pp. 189–90.

76. Barr, *Matisse*, p. 135.

77. The reader who is interested in academic ideals concerning sculpture is referred to Charles Blanc, *Grammaire des arts du dessin: Architecture, sculpture, peinture,* published in numerous editions.

78. Escholier, *Matisse*, pp. 189–90.

79. I am indebted to Mme Duthuit for this identification. I had hoped to find photographs of Matisse's portrait subjects at the time he worked from them, but so far this has not been possible.

80. A discussion of these theories and their relevance to Matisse's work is given by Barr, *Matisse*, pp. 140–41. The differences between the trained hands of a professional artist and those of blind persons is not considered. These theories are not consistently applied to Matisse's sculptures and one wonders how their proponents would analyze Rodin's sculpture.

81. Barr, *Matisse*, p. 550.

82. Alfred Barr took up the subject of the protruding eyes with Dr. Eric P. Mosse, a psychiatrist who, presumably not having seen the self-portrait, concluded that Matisse may have unconsciously projected his own features into the faces of his subjects and "in the act of concentrating to revive the inner image, the feeling of his own strained eyes is projected into the sculpture of the girl" (Barr, *Matisse*, p. 538). Matisse observed that successive confrontations with the model led to the effacement of the first impressions and allowed him to see "the most important traits, the living substance of the work" (Escholier, *Matisse*, p. 192).

83. Alfred Barr cites a number of interesting suggestions for the origin of this effect other than my own. To my mind insufficient attention has been paid to previous editing of the faces of Matisse's sculptures.

84. Louis Aragon, "À la rencontre de Matisse," in the catalogue of the same title published by the Fondation Maeght, 1969, p. 12.

85. Barr, *Matisse*, p. 120.

86. Barr, *Matisse*, p. 551.

87. William Agee makes this suggestion (Agee and Hamilton, *Duchamp-Villon*, p. 61).

88. George H. Hamilton writes regarding *Maggy*: "Beside it, Matisse's only slightly earlier *Jeannette V* seems arbitrary and old-fashioned" (*Painting and Sculpture in Europe, 1880–1940*, p. 175).

89. Gowing, *Matisse*, p. 28.

90. Barr, *Matisse*, p. 551.

91. Gowing, *Matisse*, p. 25.

92. Moore, *Matisse*, p. 77.

93. Tucker, *Matisse*, unpaged.

94. Tucker, *Matisse*, unpaged.

95. Gowing, *Matisse*, p. 28.

96. Hilton Kramer, "Matisse as a Sculptor," *Bulletin: Museum of Fine Arts, Boston*, vol. LXIV, no. 336 (1966), p. 53. It is unjust to refer to this interesting essay only in the negative.

97. Escholier, *Matisse*, p. 87.

98. In Matisse's 1911 painting of his studio (Moscow, Museum of Modern Western Art; Barr, *Matisse*, p. 375) at the far right is what appears to be one of the *Back*s, but its smaller size relative to objects around it suggests that it might have been a large drawing, or painted sketch on a stretched canvas.

99. This is to be found in my anthology, *Auguste Rodin: Readings on His Life and Work*, 1965, p. 160.

100. Robert Descharnes and Jean-François Chabrun, *Auguste Rodin*, 1967, p. 233.

101. Maurice Demaison, "Bartholomé et le monument aux morts," *La Revue de l'art* (1900), p. 278.

102. The Paris version is reproduced in Jean-Paul Crespelle, *The Fauves*, 1962, plate 60. In this context one might mention Manguin's painting *Large Nude with Robe* (Pierre Cabanne, *Henri Manguin*, 1964, p. 120); also Jean Puy's pencil study *Nude Seen from the Back*, accessioned between 1907 and 1910, the Grenoble Musée de Peinture et de Sculpture. (This work is reproduced in that museum's catalogue *Dessins modernes* by Gabrielle Kueny and Germain Viatte, Paris, 1963, No.199.) The Grenoble Museum also has an early Matisse drawing, reproduced in their catalogue as No.131, *Femme Nue, Vue de Dos*, showing a standing, but not leaning, naked model viewed from the back, drawn in ink with a scribbled mode he used shortly after 1900.

103. Barr, *Matisse*, p. 142.

104. Barr, *Matisse*, p. 550.

105. Barr, *Matisse*, p. 551.

106. Miss Tanya Neufeld, a member of the staff of *Artforum*, made the observation that the arrangement of the hand could have been to separate the right hip from the wall in front of it.

107. The connection between this relief and the painting of the *Bathers by a River* was noted by Pierre Matisse and Margaret Miller (Barr, *Matisse*, p. 545).

108. Barr, *Matisse*, p. 551.

109. Gowing, *Matisse*, p. 15.

110. Rosati has studied these reliefs for years; his own *Galley* series derives from them.

111. Barr, *Matisse*, p. 551.

112. UCLA, *Matisse*, p. 7.

113. Barr, *Matisse*, p. 119.

114. Gowing, *Matisse*, p. 41.

115. UCLA, *Matisse*, p. 7.

116. Lawrence Gowing admirably summarizes the value of sculpture to Matisse: "Matisse was guarding for painting a quality that was specifically visual and sculpture came to have for him a double function. In the first decade of the century he often used sculpture to draw off the formal solidity of art into its appropriate medium, so as to leave behind in painting the strictly visual residue, flat and still. Form and formal metamorphosis were canalized into sculpture and preserved there, in case they were needed, as they eventually were. . . . Nothing was lost in sculpture; every stage between the realism of 1900 and the serene architectural resolution of 1930 was cast and preserved. Moreover, sculpture, which offered him at intervals another fulfillment of an imaginary ideal, could also give back ideal forms to painting when they were needed again—as they were at the end of the 1920s" (Gowing, *Matisse*, p. 12).

117. At the conclusion of my articles on Matisse in the December, 1969, issue of *Artforum*, in an author's note, I listed what I felt were the shortcomings of the articles. Where possible I have tried to correct these deficiencies. We still await the publication of a catalogue of Matisse's work, hundreds of letters in private hands, and even more detailed biographical information than is now available. The publications during the centenary of the artist's birth should be of great assistance in this regard.

Bibliography

Aragon, Louis. "A la rencontre de Matisse," in the catalogue of the same title published by the Fondation Maeght, 1969.

———. "Matisse en France," in *Henri Matisse, dessins: Thèmes et variations.* Paris: M. Fabiani, 1943.

Barr, Alfred H., Jr. *Henri Matisse, His Art and His Public.* New York: Museum of Modern Art, 1951.

Blanc, Charles. *Grammaire des arts du dessin, architecture, sculpture, peinture.* Published in several editions by Laurens, Paris.

Cabanne, Pierre. *Henri Manguin.* Neuchâtel, 1964.

———. *Le Fauvisme français et les débuts de l'Expressionisme allemand.* Catalogue of an exhibition held jointly by the Musée National d'Art Moderne in Paris and the Haus der Kunst in Munich, January–March, 1966.

Cartier, Jean-Albert. "Gustave Moreau, professeur à l'École des Beaux-Arts," *Gazette des Beaux-Arts* (May–June, 1963).

Crespelle, J. P. *The Fauves.* Translated by Anita Brookner. Greenwich, Conn.: New York Graphic Society, 1962.

Demaison, Maurice. "Bartholomé et le monument aux morts," *La Revue de l'Art* (1900), p. 278.

Denvir, Bernard. "London Letter," *Art International* (September, 1969).

Descharnes, R., and Chabrun, J.-F. *Auguste Rodin.* New York: Macmillan, 1967.

Elsen, Albert. *Auguste Rodin, Readings on His Life and Work.* Englewood Cliffs, N.J.: Prentice-Hall, 1965.

———. "The Sculpture of Henri Matisse," a series of four articles, *Artforum* (September–December, 1968).

———. "Rodin's Walking Man As Seen by Henry Moore," *Studio International* (July–August, 1967).

———. *The Partial Figure in Modern Sculpture: From Rodin to 1969.* Baltimore: Baltimore Museum of Art, 1969.

Escholier, Raymond. *Matisse ce vivant.* Paris: Librairie Arthème Fayard, 1956.

Geldzahler, Henry. "Two Early Drawings by Henri Matisse," *Gazette des Beaux-Arts,* (December, 1962).

Goldwater, Robert. *Primitivism in Modern Art.* New York: Vintage Books, 1967.

Gowing, Lawrence. *Henri Matisse: Sixty-four Paintings.* New York: Museum of Modern Art, 1966.

Gsell, Paul. "Chez Rodin," *L'Art et les artistes* (January, 1907).

Guéguen, Pierre. "The Sculpture of a Great Painter," *Twentieth Century,* no. 4 (December, 1938).

Hamilton, G., and Agee, W. *Raymond Duchamp-Villon.* New York: Walker, 1967.

Hamilton, George H. *Painting and Sculpture in Europe, 1880–1940.* Baltimore: Penguin, 1967.

Herrmann, Erich S. An unpublished scrapbook of photographs of Henri Matisse, in the Library of the Museum of Modern Art, New York.

Hüttinger, B., and Linde, U. (Preface). *Henri Matisse, Das Plastische Werk.* Catalogue of an exhibition held at the Kunsthaus, Zurich, 1959.

Kramer, Hilton. "Matisse as a Sculptor," *Bulletin: Museum of Fine Arts, Boston,* vol. LXIV, no. 336 (1966).

Kueny, Gabrielle, and Viatte, Germain. *Dessins modernes.* A catalogue of the Grenoble Museum, Paris, 1963.

Lassaigne, Jacques. *Matisse, Biographical and Critical Study.* New York: Skira, 1959.

Lavin, Irving. "Bozzetti and Modelli," *Stil und Überlieferung in der Kunst des Abendlandes,* vol. 3 (1960).

Leymarie, J., Read, H., and Lieberman, W. *Henri Matisse.* Catalogue of a retrospective of his art organized by the UCLA Council and UCLA Art Galleries, 1966.

Licht, Fred. *Sculpture, Nineteenth and Twentieth Centuries.* London: Michael Joseph, 1967.

MacChesney, Clara T. "A Talk with Matisse, Leader of the Post-Impressionists," *New York Times* (March 9, 1913).

Moore, Richard A. "Henri Matisse and the Corrected Aplomb," *The Dialectic Norm of Nineteenth and Twentieth Century Art,* Research Paper No. 20, School of Arts and Sciences Research Papers, Georgia State College Atlanta, Georgia, 1968.

Pach, Walter. *Queer Thing Painting: Forty Years in the World of Art.* New York: Harper, 1938.

Poulain, Gaston. "Sculpture by Matisse," *Formes* (Paris), no. 9 (1930).

Schapiro, Meyer. "Matisse and Impressionism—A Review of Matisse at the Museum of Modern Art, New York, November, 1931," *Androcles I* (February 1, 1932).

Schneider, Pierre. *Henri Matisse, Exposition du Centenaire.* The catalogue of the great exhibition at the Grand Palais held from April to September, 1970. Ministère d'Etat Affaires Culturelles Réunion des Musées Nationaux.

Seitz, William. "Rosati, Masses in Elevation," *Art News* (December, 1969).

Sylvester, David. "The Sculpture of Matisse," *The Listener* (London), vol. 49, no. 1248 (January 29, 1953), pp. 190–91.

Tucker, William. *Henri Matisse Sculpture.* Catalogue of a sculpture exhibition held at the Victor Waddington Gallery in London, 1969.

Varenne, Gaston. *Antoine Bourdelle, par lui-même: Sa pensée et son art.* Paris, 1937.

Wheeler, Monroe. *The Last Works of Henri Matisse: Large Cutout Gouaches.* New York: Museum of Modern Art, 1961.

———. Catalogue of Forty-nine Bronzes by Matisse (sale of the Ahrenberg Collection). Sotheby & Company, July, 1960.

Index

All numbers refer to pages. Asterisks (178) refer to illustrations.*

Photo Credits

(Numbers refer to plates.)

Hélène Adant, Paris, 50, 233, 273; 274 (courtesy *Art News*); 275, 277, 279, 284; Alinari, Florence, 76; Archives Photographiques, Paris, 47, 181; A.V.E.S. Photographic Laboratories, St. Paul, Minn., 260; Bernès, Marouteau, Paris, 237; Bulloz, Paris, 13, 43, 112, 124, 244; Cercle d'Art, Paris, 59; Geoffrey Clements, New York City, 131, 201; The Condé Nast Publications, Inc. (Vanity Fair), New York City, 196; Druet (Bibliothèque Nationale, Paris), 28, 72, 91, 128, 138, 147, 156, 164, 245; Mme Georges Duthuit, Paris, 17, 19, 117; Claude Frossard, Le Cannet, 3, 5–6, 8, 10, 14, 87, 97–99, 103, 120, 185, 208–9, 215, 230, 232, 264, 271–72, 276, 278, 280; Galerie Claude Bernard, Paris, 121, 262; Claude Gaspari (©Galerie Maeght, Paris), 236; Giraudon, Paris, 7, 15, 79–80, 132, 146, 191, 239; Marc Lenoir (courtesy Mme Duthuit, Paris), 212; Pierre Matisse, New York City, 145; Henry Moore, 41; The Museum of Modern Art Archives, New York City, 257; O. E. Nelson, New York City, 26, 104, 109, 123, 151; Novosti Press Agency, Moscow, 234; La Photothèque, Paris, 84; Claude Poilbarbe, Paris, 48; Eric Pollitzer, New York City, 142, 149, 217, 247, 253–56, 268; Hans Purrmann (The Museum of Modern Art Library, New York City), 1, 32, 194, 222, 224; Roger-Viollet, Paris, 57–58, 71, 83, 92, 113, 193, 238; Service Photographique, Versailles, 108, 206, 263; Edward Steichen (The Museum of Modern Art, New York City), 119; Walter Steinkopf, Berlin, 23; Charles Uht, New York City, 150; O. Vaering, 93; Kirk Varnedoe, 90, 202, 218; Marc Vaux, Paris, 2, 9; Vizzavona, Paris, 27; 49 (courtesy Wildenstein Gallery); Victor Waddington, London, 22, 24–25, 77–78, 118, 135, 152, 161–62, 199–200, 207, 210, 226–27, 266, 269–70; Etienne Bertrand Weill, Courbevoie, 11–12, 163; 106, 126, 197–98 (courtesy Mme Duthuit, Paris).